EXHIBITING BLACKNESS

EXHIBITING

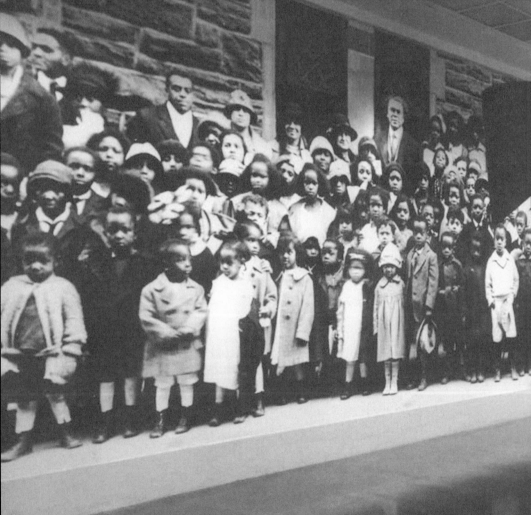

UNIVERSITY OF MASSACHUSETTS PRESS Amherst and Boston

BLACKNESS

African Americans and the American Art Museum

BRIDGET R. COOKS

Copyright © 2011 by University of Massachusetts Press
All rights reserved
Printed in the United States of America

LC 2011021565
ISBN 978-1-55849-875-4

Designed by Sally Nichols
Set in Arno Pro and Kolosso
Printed and bound by Thomson-Shore, Inc.

Library of Congress Cataloging-in-Publication Data

Cooks, Bridget R., 1972–
 Exhibiting blackness : African Americans and the American art
museum / Bridget R. Cooks.
 p. cm.
 Includes bibliographical references and index.
 ISBN 978-1-55849-875-4 (pbk. : alk. paper) 1. Art museums—Social
aspects—United States. 2. African American art—Exhibitions—
Social aspects. 3. Art and society—United States. 4. Art and race.
 I. Title. II. Title: African Americans and the American art museum.
 N510.C67 2011
 704.03'96073—dc23

 2011021565

British Library Cataloguing in Publication data are available.

Title page photograph: "1900–1919: From White to Black Harlem," from *Harlem
on My Mind: Cultural Capital of Black America, 1900–1968*. Gallery Installation:
Photographed March 25, 1969; The Metropolitan Museum of Art. Image © The
Metropolitan Museum of Art.

Cover photograph: on exhibition at the Los Angeles County Museum of Art:
Left: Mary Cassatt, *Mother About to Wash Her Sleepy Child*, 1880. Oil on canvas,
39 7/16 x 25 7/8 in. (100.3 x 65.8 cm). Mrs. Fred Hathaway Bixby Bequest (M.62.8.14).
Photo © 2011 Museum Associates / LACMA. *Center:* Winslow Homer, *The Cotton
Pickers*, 1876. Oil on canvas, 24 1/16 x 38 1/8 in. (61.12 x 96.84 cm). Acquisition made
possible through Museum Trustees: Robert O. Anderson, R. Stanton Avery, B. Gerald
Cantor, Edward W. Carter, Justin Dart, Charles E. Ducommun, Camilla Chandler
Frost, Julian Ganz, Jr., Dr. Armand Hammer, Harry Lenart, Dr. Franklin D. Murphy,
Mrs. Joan Palevsky, Richard E. Sherwood, Maynard J. Toll, and Hal B. Wallis (M.77.68).
Photo © 2011 Museum Associates / LACMA.

For Mom, Dad, Linda, and Joe

CONTENTS

ACKNOWLEDGMENTS

The publication of this book is as much the product of the generosity of time, spirit, and resources of many people as it is the result of years of solitary research and self-determination. I am grateful to have a formal space to thank those people here.

Some of the core ideas for this book were conceived during my years as a graduate student in the Visual and Cultural Studies Program at the University of Rochester. Key faculty who discussed ideas about art, museums, critical theory, race, and exhibitions with me were Kamran Ali, Douglas Crimp, Deborah R. Grayson, Michael Ann Holly, Jeffrey Allen Tucker, and Sharon Willis. The encouragement and empowerment I received from my adviser Douglas were invaluable. Thank you to my comrades and friends with whom I read, wrote, watched movies at The Little Theatre, danced, and enjoyed the hours through the long Rochester winters: Ondine Chavoya, Lisa A. Finn, Eloy J. Hernández, O. Funmilayo Makarah, Jeanette Roan, Tina Takemoto, and Lisa Viñolo.

I received funding to help with much of the costs incurred to conduct the research necessary to complete this book. The Luce Dissertation Fellowship in American Art, Academic Senate Council on Research, Computing and Libraries (CORCL), University of California, Irvine, and the Individual Research Project Grant, Humanities Center, UC Irvine, provided grants that allowed me see this project through.

Much of the analysis in the following chapters was dependent upon the cooperation of people to be interviewed. Each gave of their time to think about their participation in the art world, cultural politics, and personal histories. Some dug through their personal archives to find materials that would help this history's factual correctness and let me dig alongside them. Thanks to Bill Arnett, Matt Arnett, Paul Arnett, Mary Ann Bendolph, Mary Lee Bendolph, Louisiana Bendolph, Aurelia Brooks, David C. Driskell, Cecil Fergerson, Thelma Golden, Richard Mayhew, John Outterbridge, Leonard Simon, Timothy E. Washington, Robert Wilson, and Lloyd Yearwood.

ACKNOWLEDGMENTS

I have benefited from the encouragement of a wide range of artists, curators, scholars, and writers who have invigorated me through their conversation, and by example. My gratitude goes to Abraham Agonafir, Arthé A. Anthony, Renée Ater, Juliette Bethea, Sheila Pree Bright, Adrienne Childs, Linda Day Clark, Huey Copeland, David C. Driskell, Ruth Fine, Cheryl Finley, Jacqueline Francis, Jennifer A. González, Lisa Henry, Ginger Hill, Kellie Jones, Titus Kaphar, Amy Kirschke, Cynthia Moody, Charmaine Nelson, Howardena Pindell, Kymberly Pinder, Richard J. Powell, Franklin Sirmans, Margaret Rose Vendryes, Alan Wallach, Carla Williams, Deborah Willis, and Judith Wilson. Their encouragement and interest in my project has been uplifting.

The professionalism of dozens of staff members of museums, libraries, and archives across the country has made the research and documentation in this book accessible. The following people have assisted me with efficiency and often an informed intuition that led me to important materials that shaped this text: Margaret Rose Vendryes, curator, Brenda Square, director of Archives, and Christopher Harter, director of Library and Reference Services, Amistad Research Center; Aimee Marshall, manager of Rights Licensing, Art Institute of Chicago; Alisa Adona, Artis Lane studio manager; Márta Fodor, Ann Handler, Elizabeth Huffer, Timothy McCarthy, Tricia Smith, and Robin Stolf, Art Resource; Amanda Hamilton, Rights and Reproductions assistant, and Emily Rafferty, associate librarian and Archives, Baltimore Museum of Art; Patricia Hills, professor, Boston University; Tara Cuthbert, Archives assistant, and Angie Park, archivist and manager of Special Library Collections, Library and Archives, Brooklyn Museum; Tammy Carter and Marianna Pegno, Rights and Reproductions, Center for Creative Photography; Debbie Vaughan, Research Center, Chicago History Museum; Lisa L. Crane, trustee of the Hayden Family Revocable Art Trust; Maxine Wright, executive assistant to the president, and John Wells, director of Development and Alumni Relations, International House; Austen Bailly, associate curator of American Art, Meagan Blake, intern, Oral History Program, Peter Brenner, supervising photographer, Diana Folsom, manager, Art & Education Systems and Collection Information, Renee Montgomery, assistant director of Collections Information and Risk Management, Maia November, intern, Oral History Program, Cheryle T. Robertson, manager, Rights and Reproductions, Breanne Sallee, administrative assistant, Photographic Services, Piper Wynn Serverence, Rights and Reproductions, and

Kristi Y. Yuzuki, program specialist/cataloger, Research Library, Los Angeles County Museum of Art; Erica Vareta Rights and Permissions, *Los Angeles Times*; Lisa M. Messinger, assistant curator, Department of Nineteenth-Century, Modern, and Contemporary Art, Jeri Wagner, coordinator, and Julie Zeftel, head of Licensing, The Image Library, The Metropolitan Museum of Art; Amy Scott Mobley, archivist, Museum of Fine Arts, Houston; Sheelagh Bevan, assistant librarian, and Jennifer Sellar, digital imaging archivist, Museum of Modern Art; Luis Aristondo and Meghan Keller, NBC News Archives; Edgar Alonso Castillo, digital coordinator, and Irene Cho, administrative director, Photography & Imaging, New York University; Heather Palmer, The Pace Gallery; Jennifer Marshall and Grace Lee, Pars International Corporation; Debra Royer, library director, Portland Art Museum; Kalia Brooks, studio manager, Power House; Randolph Wright, president, Pyramid Films; Cecilia Chin, Smithsonian Library, National Museum of American Art and the National Portrait Gallery; Pilar Castillo, Social and Public Art Resource Center (SPARC); Mark Dabney, Exhibitions and Collections manager, and Brenda Miller, administrative assistant, I. P. Stanback Museum and Planetarium, South Carolina State University; Andrew Tullis, copyright manager, Tate; Simon Elliott, Manuscripts Division, University of California, Los Angeles, Library, Department of Special Collections; and Anita Duquette and Kiowa Hammons, Rights and Reproductions, Whitney Museum of American Art. Thank you also to artists Cedric Adams, Linda Day Clark, Lyle Ashton Harris, Artis Lane, John Outterbridge, Timothy E. Washington, and Fred Wilson, who gave me permission to publish images of their work directly.

A special thanks to my editor, Clark Dougan, senior editor, University of Massachusetts Press, whose enthusiasm and confidence about my manuscript made the publishing process a true pleasure. Thanks also to Carol Betsch, managing editor, for seeing my manuscript through to publication, and Sally Nichols, for the beautiful design and layout of the book. My gratitude goes to Kay Scheuer, who did excellent work copyediting this text, and Linda Cooks and Randi Hokett for carefully proofreading it. My thanks also go to Michael Taber for providing the index.

Key staff, faculty, and graduate students at the University of California, Irvine, have helped me as a scholar in strategic ways. I have benefited from their experience, optimism, and intellect. Thank you to Christine Balance, Lindon Barrett, Julia Bryan-Wilson, Roberta J. Geier, Anna Gonosová, Douglas Haynes, Jim Herbert, Donna Iliescu, Victoria E. Johnson, Arlene

ACKNOWLEDGMENTS

Keizer, June F. Kurata, Catherine Liu, Lyle Massey, Jessica Millward, Bob Moeller, Annamarie Newton, Alka Patel, Amy Powell, Vicki Ruiz, Jared C. Sexton, Jeanne Scheper, Sally Stein, Mary Trent, Linda Vo, Cécile Whiting, Frank B. Wilderson, III, Tiffany Willoughby-Herard, Judith Wilson, Bert Winther-Tamaki, and Roberta Wue.

I have fulfilled a life goal through the mentor/mentee relationships cultivated with undergraduate students over the years. Michelle Dezember, Sarah Mitchell, and TeKeyia Armstrong all served as outstanding research assistants in the service of this book. Thank you for your contribution and for allowing me to contribute one-on-one to the next generation of scholars and activists.

Before joining the faculty at UC Irvine, I was an assistant professor at Santa Clara University. I had many wonderful colleagues, some of whom truly became my friends. I am most grateful for the professional and personal bonds I have with Juliana Chang, Laura Ellingson, Linda Garber, Francisco Jiménez, and Gratia Rankin.

My friends have played a crucial role in my perseverance, emotional well-being, enjoyment of the absurd, and capacity for kindness. I am profoundly thankful for Barbara Blinick, Alicia M. Brown, Regina Z. Chang, Josephine Daño, Constantine del Rosario, Ivan del Sol, Michelle Dezember, Louise Scheele Ellilng, Linda Garber, Randi Hokett, Karen Kienzle, Siyeon Kim, Ximena Martín, Thais McDowell, Darryl Morris, Cherryl Nugas-Shelby, Charles Ortega, Roberta Barrero Ortega, John Ott, Juanita Purner, Jeanette Roan, Roger Rocha, Karen Satzman, Bette Tran Vovan, and Jen Wagelie.

My parents, Jerry and Blandenia Cooks, sacrificed many things for my personal and professional development. Their guidance and love have been unconditional, and the stable home life they provided gave me the confidence to grow and take risks. Thank you. My sister, Linda Cooks, helped create that loving environment and has consistently shared her enthusiasm and excitement about my life and career. I am grateful to her for a lifetime of love. My cousin Tamara Woolery has been my honorary agent and could not be more proud of me. I am thankful for the selfless support of my great-grandmother Lucy Booker, grandparents Doc and Eva Wadley, uncles and aunts Roland and Nancy Harper and Anna and Howard Robinson, and my husband's mother Jeanette Cumbo; they did not live to see the publication of this book, but nurtured and encouraged me as if they already knew this moment would arrive. My family and I have adopted two key members:

Kathy White and Lynn Hammeras. Kathy opened a crucial door to my future by asking me, "Have you ever thought of going to graduate school?" a question I was afraid to answer because, at age nineteen, I did not know what graduate school was. She did everything she could to fill in the blanks, and I am indebted to her and Lynn for their activism and love in sending me on my academic adventure and remaining a constant source of support and inspiration. Together, they have been a model of sisterhood and generosity.

The fulfillment of peace, joy, and balance in my life is all because of Joseph Patrick Cumbo. His daily support and understanding have motivated me and given me courage. His great capacity for love, compassion, and humor has captivated me.

A NOTE ON TERMINOLOGY

In the interests of greater historical accuracy, in this book I use the terms "Negro," "Colored," and "Black" in discussing the periods during which they were utilized by African Americans. The political act of naming is significant as it demonstrates the struggle for racial self-representation and efforts to transform the perception of African Americans throughout the twentieth century. I have also capitalized the terms "Black" and "White" to suggest the extent to which the social realities they imply have shaped the representation of African American art.

EXHIBITING BLACKNESS

INTRODUCTION
African Americans Enter
the Art Museum

I

In *Exhibiting Blackness* I offer a critical exploration of the discourse of African American art and culture in American art museums. The exhibition strategies for representation vary as the narratives of each exhibition strive for their claims on the historical and contemporary representation of Black art and culture. My goal is to explore the assertions made in the unequal and often contested relationship between African American artists, curators, visitors, and critics in the mainstream art world.

Exhibitions of African American art in American art museums have been curated through two guiding methodologies: the anthropological approach, which displays the difference of racial Blackness from the elevated White "norm," and the corrective narrative, which aims to present the work of significant and overlooked African American artists to a mainstream audience. The former methodology reflects an institutional curiosity concerning the presence of racial otherness, commonly coupled with a desire to perpetuate the superiority of mainstream White culture through its contrast to a Black difference defined as inherently inferior. The latter methodology was formed out of the necessity to present the art of African Americans and correct for its historical absence and misrepresentation in mainstream art museums. Within these exhibitions are key tensions that pull in constant negotiation with each other: the desire for group exhibitions of art to serve as catalysts for social change; the compulsion to place Black artists within a framework of

discovery and primitivism; and the assertion of the historical and contemporary legitimacy of Black artists in America. The strains among these tensions shift in prominence within the discourse of each exhibition. However, each of these tensions is consistently represented through the roles of the curators, artists, critics, and visitors. Regardless of the intentions of the curators, exhibitions of art by African Americans are often perceived through a limiting "either/or" paradigm: through a lens of *either* anthropological study *or* aesthetic value. African American artists still face an art world in which the exhibition and reception of their work can depend upon proof of their value as artists *despite* their racial identity.

I analyze the curatorial strategies, challenges, and public and critical receptions of the most significant exhibitions of African American art and culture in American art museums. Beginning with exhibitions of African American art in the 1930s, each chapter illuminates critical episodes in the relationships between African American artists, art museum exhibitions, curators, visitors, and critics. The chapters explore exhibitions that are significant because of their ambitious and strategic approaches to representing African American art and culture. These exhibitions have not been the only exhibitions of African American art and culture in mainstream American art museums; however, they were chosen for either their particular complicity with or their challenges to limiting frameworks for exhibiting work by African American artists. As case studies, these exhibitions demonstrate what is at stake in narrow definitions of Black ability that not only pervade the art world, but also encompass the world around it through social norms of American life.

Through this book I discuss the methodological strategies of each exhibition and argue for more exhibitions that demonstrate the understanding of artistic merit and Black identity as interdependent instead of mutually exclusive categories. Indeed, the greatest and most consistent feature in the criticism of exhibitions of art by African Americans has been an inability to reconcile artistic achievement with Black identity.

Museum exhibitions have crucial significance for African Americans, who not only have been historically marginal to the art museum as artists, visitors, and museum professionals, but whose image in American art has served a didactic and often supportive role in national history and art history. In his introduction to *Exhibiting Contradiction: Essays on Art Museums in the United States,* author Alan Wallach writes of his realization about the

role of the art museum exhibition, "It became evident to me that, by walking through a gallery space hung with pictures, museum visitors acted out, and thus in some sense internalized, a version of art history."[1] Wallach crystallizes a social truth about the role of art museums as instructive institutions: The exhibition space is a powerful one that does more than fulfill the seemingly simple function of displaying objects of creative expression. Exhibitions also have pedagogical roles, teaching the values of art, cultures, social movements, and national histories. Because of this particular significance, the exhibition space has been a contested one for African Americans. Narratives of cultural history and art history internalized by the visiting public have made museum galleries critical spaces for Black representation, participation, and, as this book will argue, intervention. In *Exhibiting Blackness* I explore this demand for inclusion in the American art scene in historical and contemporary exhibition practices.

II

The case of the first museum exhibition of art by African Americans is in many ways emblematic of the fraught situation of African American art in museums throughout the twentieth century. In 1927, the Chicago Art Institute presented *The Negro in Art Week: Exhibition of Primitive African Sculpture, Modern Paintings, Sculpture, Drawings, Applied Art, and Books*. This was not the first exhibition opportunity for African American artists; however, it marked the first time that an exhibition of art made by African Americans was presented in an art museum.[2] It served as the first theater for curators, artists, visitors, and critics to act out anxieties around racial difference in American art museums that continue in our contemporary moment.

Conceived by the philosopher and cultural leader Alain Locke and organized by the Chicago Woman's Club, *The Negro in Art Week* boasted 205 artworks: 116 objects by unnamed African sculptors, and eighty-nine objects by twenty-two Negro artists including sculptors Richmond Barthé and Meta Vaux Warrick Fuller, painters Edward Mitchell Bannister, Henry Ossawa Tanner, and Hale Woodruff, and photographer K. D. Ganaway.[3] The art exhibition was an opportunity for Locke and the Chicago Woman's Club to present evidence of Negro equality through the arts to encourage

social equity between the races. Indeed, this notion of exploring the arts as an avenue for social change was part of the New Negro movement as defined by Alain Locke in his manifesto essay "The New Negro" (1925). Locke prescribed the emerging role of Negro artists in the 1920s as crucial to improving the problem between the races in America, writing, "The especially cultural recognition they win should in turn prove the key to that revaluation of the Negro which must precede or accompany any considerable further betterment of race relationships."[4] And yet, for Negroes, the visibility and mobility of cross-cultural exposure through the arts were limited. The artistic fields in which cultural recognition would be won maintained racial segregation.[5] From the effort to enter the modern art museum, concerns about quality, class, beauty, racial hierarchy, and the preservation of a White cultural nationalism emerged.

The coupled presentation of African and Negro American art in the exhibition allowed Locke and the Chicago Woman's Club to claim an African heritage for the New Negro. For middle-class Negroes seeking acceptance into White mainstream culture, it was important that the art world recognize a particular understanding of the relationship between the art of the New Negro and African sculpture. The sculpture of the Etoumbi peoples of Central Africa and Dan peoples of West Africa had been fundamental to the development of Cubist aesthetics in modern art and was transformed into valuable objects d'art by the international art market.[6] Simultaneously, and contradictorily, the subtitle of the exhibition announced the modern art of Negroes as distinct from the "primitive" sculpture of Africa, distinguishing the New Negro as a contributing and productive member of society clearly evolved from what was widely perceived as an uncivilized and undeveloped African past.

The cover art of *The Negro in Art Week* exhibition catalogue calls on another connection with an African culture to define the New Negro (figure 1). On the left side of Charles C. Dawson's drawing, an Egyptian pharaoh raises his head in a gesture of racial uplift. His muscular left arm lifts a scroll which provides the location and date information for the two-part exhibition held in the Children's Museum section of the Chicago Art Institute and the Chicago Woman's Club. As if sending a spiritual blessing from the past to the present, his right arm stretches down rigidly along his torso. His fingers spread over a group of male, presumably New Negro, singers silhouetted in tuxedoes below. A similarly silhouetted female pianist and male violinist accompany the

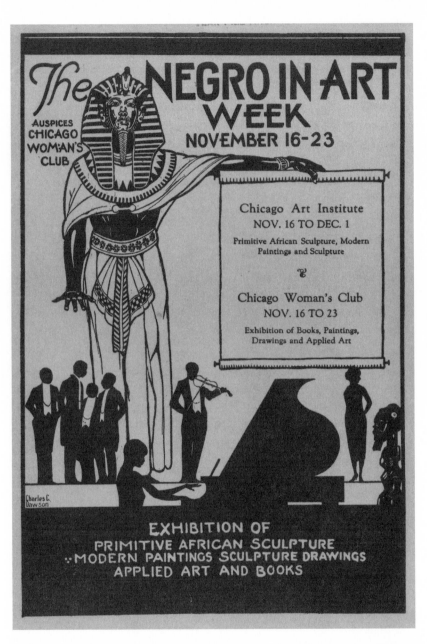

Figure 1.
The Negro in Art Week, November 16–23.
Chicago Art Institute, 1927, catalogue cover.
Reproduction, The Art Institute of Chicago.

singers. At the right edge of the scene, a woman standing in a simple sheath dress, perhaps the vocalist of the group, looks downward at a large figurative African sculpture that seems to listen intently to the music performed before it. Visually mapped between the massive protection of ancient Egypt above and the comparatively diminutive "black Africa" below, New Negroes perform their identity on stage for an imagined audience. The silhouetted figures in Dawson's drawing are not visual artists but musicians, reinforcing the absence of African American visual artists on the cultural scene.

Although *The Negro in Art Week* exhibition consisted of artworks diverse in media and content, selected artists were required by the director of the Institute to "conform as near as possible to standards set by regular [read Eurocentric] art museum exhibitions and exhibition galleries."[7] This enforced conformity reflected the common belief held by mainstream art world critics and curators that art by African Americans means art that is inferior in quality.[8] To avoid an exhibition that lowered the Institute's high standards and waylay the fear of what Negro art might be, this institutional mandate became a criterion of the exhibition stated in the call for submission to Negro artists. Further, it is quite plausible that the Institute decided that the Children's Museum was the most appropriate place for the exhibition based on its low expectations of the quality of Negro art. The director's enforced criteria for *The Negro in Art Week* reflect an assumption that unless conformity was required, the art would not meet the Institute's high Eurocentric standards. Trained at the same academies as European and White American artists both in the United States and abroad, Negro artists in the 1920s were indoctrinated in the traditions of the great European masters and trained to continue those traditions. The emergence of the New Negro movement and Locke's call to Negro artists to look toward their African ancestry for inspiration to create modern Negro art proved to be a threat to the status of the Institute.

In order to participate in the exhibition, New Negro artists had to choose the path of Eurocentric expression acceptable to nineteenth-century (not contemporary) European aesthetic tradition. These New Negro artists were caught in an either/or paradox with the gatekeepers of the art museum. For the Institute, art that maintained the museum's high standard *and* reflected some evidence of the Negro identity of its maker was not a possibility. As curator and author Lowery Stokes Sims has noted, "The greatest challenge to recognizing the contributions of black people to modernity would, ironic-

ally, be encountered within contemporary art circles. Despite the fact that modernist genres such as abstraction were grounded in African art, and given that black dance and music had ushered in a modern sound and sense of the body, African-American artists of African descent were positioned as followers and imitators of white artists recognized as the pioneers of modernism."[9] In this case, the art museum positioned Negro artists as imitators of Eurocentric aesthetics as a requirement of their inclusion. The notion that, as modern artists, Negroes were participating in contemporary American artistic culture, rather than imitating Eurocentric aesthetics, was not considered. Instead, the contributions of Negro artists on the contemporary scene were devalued as derivate.

While European aesthetics were clearly central in exhibited works such as Tanner's *The Three Marys* (1910) and *The Flight into Egypt* (1923), Woodruff's *Twilight* (1926), and William A. Harper's *Landscape* (n.d.), *The Negro in Art Week* was not considered by art critics as a serious art exhibition or reviewed in the art review sections of the press.[10] The Chicago Woman's Club did not receive requests from art institutions interested in mounting the show. However, the Club did receive requests from interracial committees and religious societies to travel the exhibition, further confirming that it was perceived in sociological, not aesthetic terms. Certainly, the Chicago Woman's Club took on the burdensome challenge of the New Negro renaissance, to represent and redefine Negro people to the world. Yet, for critics, the Negro-ness of the artists (not the art, which was chosen for its Eurocentric conformity) proved overwhelming, prohibiting consideration of the art itself.

The first exhibition of art by African Americans within the sacred space of the American art museum is too significant to be dismissed as just another show. As the historian and critic Carol Duncan has argued, "Indeed, in the modern world, art museums constitute one of those sites in which politically organized and socially institutionalized power most avidly seeks to realize its desire to appear as beautiful, natural, and legitimate. Museums are therefore excellent fields in which to study the intersection of power and the history of cultural forms."[11] The exhibition of artworks by African Americans in art museums transgresses traditionally acceptable forms of power, aesthetics, and social order, not due to any features of the works of art, but because the definitions of what is "beautiful, natural, and legitimate" have excluded African Americans. The inclusion of African American

people in the modern art museum—the institution that validates and upholds these aesthetic categories—marks an interruption of the status quo. Duncan elaborates on the power that museums have to define the communities they represent, saying, "What we see and do not see in art museums—and on what terms and by whose authority we do or do not see it—is closely linked to larger questions about who constitutes the community and who defines its identity."[12] Thus the challenge of what is seen in museums and who holds the power to decide its exhibition is intricately linked to the social standing and cultural definition of African American people. The exhibition of art by non-White artists in art museums is an affront to racial boundaries set to enforce and protect the myth of a racial hierarchy.

Maintained by veiled rhetoric of objectivity and debates about quality, the tradition of racial exclusivity in mainstream art museums is based on a hierarchy of humanity and aesthetics in the discipline of art history traceable to one of its founders, Johann Winckelmann. As the art historian Hugh Honor discusses in *The Image of the Black in Western Art*, Winckelmann believed that aesthetics are dependent upon a natural hierarchy of race: "According to Johann Joachim Winckelmann, the physical beauty of the ancient Greeks accounted for the excellence of their art. The ancient Egyptians had been handicapped by their own physical appearance which lacked the features that could stimulate the artist through an ideal of higher beauty."[13] This racial bias has been a guiding principle for the basis of selecting, collecting, and exhibiting artwork in America's most renowned art museums.[14] What is at stake in the challenge of dismantling White privilege in the American art museum is much more than the display of objects; it is the survival and proliferation of the diversity of a nation's cultural life. The significance of this task for Negro, Colored, Black, and African American artists has persisted throughout the social, political, and aesthetic changes reflected by the various names of this racial group.

III

Since the eighteenth century, African Americans have been visible in popular visual culture and fine art through caricature, watercolor and oil painting, etchings, and sculpture. However, the activities of African American

fine artists before the Civil War were less commonly known. African Americans' skill and creativity have persisted through the visual and material production of quilt making, architecture, ironwork, and furniture making. Yet, the first artwork attributed to an African American artist, Scipio Moorhead, dates from the late eighteenth century: the frontispiece portrait of poet and slave Phillis Wheatley, the single image in the first publication by an African American poet, *Poems of Various Subjects Religious and Moral* (1773).[15] Because of forced exclusion from the proper academic training required of professional artists until the late nineteenth century, the number of African Americans who worked as painters and limners was quite small. For slaves who were able to access informal artistic training by way of their masters or, for free Blacks, attaining opportunities to study art in college, serve as apprentices, learn drafting, lithography, and daguerreotypy skills, visit art exhibitions, and even join art groups in the North, the scarce possibilities to exhibit their work posed another challenge.

As a result of abolitionist pressures mounted in political and social spheres in the 1850s and 1860s, opportunities for training and exhibition increased in the United States for a small number of African American artists such as sculptor Edmonia Lewis and painter Robert Douglass, Jr., who benefited from formal art training in the 1860s, and Henry Ossawa Tanner, who began academic training in 1879.[16] Because artistic training was largely inaccessible to African Americans owing to economic and racial barriers, several aspiring artists who had the economic means sought education in Europe.[17] Beginning in the 1870s, the massive popularity of World's Expositions offered a new exhibition venue for American artists. These temporary spectacles celebrated milestones of American history and offered visibility for art by Negroes on a national platform. In the 1876 Philadelphia Centennial Exposition, Edmonia Lewis first exhibited her stunning sculpture *The Death of Cleopatra* (1875), and landscape and seascape painter Edward Mitchell Bannister (1826–1901) won a prize for his painting *Under the Oaks* (1876).[18] Tanner exhibited *Point Judith* (c. 1880) in the World's Industrial and Cotton Centennial Exhibition, Louisville, in 1880 and *The Battle of Life* (1884) in the Coloured Races Department of the World's Industrial and Cotton Centennial Exhibition, New Orleans (1884). However, the inclusion of art by Negroes in national expositions was sparse and inconsistent.

On occasion, art by a Negro who belonged to the same regional art club or attended the same art academy as White American artists would be

included in a group exhibition. However, Negro inclusion was not the norm for exposition, gallery, or museum exhibitions. It was not until social organizations identified art exhibitions as useful ways to demonstrate Negro value and artistic contribution to the nation that interest in showing artwork by Negroes became part of a program for social change. The energy behind this function of Negro art and its practical contextualization in the larger goal of social parity came from social organizations such as the National Association for the Advancement of Colored People (NAACP), Federal Council of Churches of Christ in America, and Commission on Race Relations.

At the turn of the twentieth century, the Colored Branches of the Young Men's Christian Association (YMCA) took a leading role in hosting the intellectual and artistic events of the Negro communities in New York. These segregated community centers provided the multi-purpose spaces necessary for groups attending a variety of social events. In 1905, the Brooklyn branch of the YMCA organized its first art exhibition of Negro artists to inspire Negroes to explore their potential contributions to the visual arts.[19] Under the leadership of bibliophile Arthur Schomburg, exhibitions of art by Negroes appeared at the 135th Street branch of the New York Public Library in Harlem beginning in 1921. These social organizations stood ready to support the artistic creativity of Negroes and developed a Negro art world outside of the mainstream. Throughout the early twentieth century, these art exhibitions fulfilled a community desire to see the talents of Negro artists and served as featured events at meetings of the NAACP, an organization which sought to improve the social standing of Negroes and encourage their acceptance as equal members of the larger national body.

The pressure to show the art of Negroes in museums was introduced from *outside* the art and museum worlds. Several Negro, White, and interracial groups sought to organize all-Negro exhibitions in museums not only to meet their social goals of Negro acceptance into mainstream society, but also as a conceptual strategy to market a new and unique idea for exhibition—one that might appeal to museum administrators because, with the exception of Tanner, and sculptors Meta Warrick Fuller and May Howard Jackson, Negroes were not recognized as artists by museums.[20] During and after World War I, new employment opportunities, the Great Migration, and the influx of African sculpture into the New York art market brought new interest from art museums and galleries in the art and culture of

African Americans. The combination of these factors fostered an increase of opportunities for art sponsorship and exhibition for Negro artists.

From the teens through the 1930s, African Americans continued to show their art at high schools, libraries, YMCAs, art schools, galleries, expositions, and homes in inconsequential numbers. As with *The Negro in Art Week* exhibition, museums sometimes showed Negro art with African sculpture to justify the exhibition of Negro artists by connecting them with pre-modern cultures. Through the lens of Locke's aspirations for the New Negro, the joint exhibition of African sculpture with Negro art marked a distinct classical tradition from which Negro artists could claim, develop, and find inspiration to create modern art. Indeed, it was primarily the influence of Locke's aesthetic goals for a quintessential Negro art combined with the focused actions by social organizations that resulted in the exhibition of art by Negroes in museums.

The most influential social organization of the twentieth century that promoted and exhibited art by Negroes was the brainchild of Locke, who convinced real estate mogul William E. Harmon to invest in Negro creativity by establishing the Harmon Foundation in 1922. The Harmon Foundation was the major resource for the financial support of Negro artists from 1926 to 1933. The foundation was initiated "to recognize and promote the overlooked achievements of African Americans, and respond to the increase of racial tension in America."[21] Its mission for social uplift through the arts did not just address "the Negro problem." As a private foundation, the Harmon Foundation provided financial support to a fairly idiosyncratic group of communities. Harmon awards were given to a crew of remarkable individuals from five major categories: Negroes, the blind, cartoonists, model farmers, and Africans. Its support of Negro achievement was the most extensive.

The foundation did not promote the exhibition of art by Negro and White artists; instead it promoted Negro art as separate from Whites. This desire to group Negro artists together for exhibition came from two groups with different perspectives about racial difference but with a shared goal of group exhibitions of works by Negro artists. The all-Negro exhibit reflected the desire of Locke, the Harmon Foundation, and some Negro artists to announce a unique Negro American art as a diverse community of creative producers. For museums, all-Negro exhibitions were a way to set aside an autonomous space to exhibit Negro art without affecting their

regular exhibition programs. It also prevented the recurrence of awkward situations in which White viewers felt tricked into appreciating the art of a Negro.[22] For the conservative institution, this clarifying exhibition strategy, directly or indirectly, supported the belief in the inherent differences of ability between the races.

The Harmon Foundation exhibitions were heavily criticized. Not all viewers, artists, and critics regarded them as serious art displays, but rather as unrefined sociological experiments produced through White beneficence. However, these exhibitions were successful in offering exposure for Negro artists' work and opportunities to study art abroad for winners of the annual art competitions.

In the 1920s and '30s, proposals for Negro exhibitions from social organizations received mixed responses from art museums. Because the proposals did not come from within the art world *and* they requested inclusion of an excluded racial group, they were often perceived as impositions to fulfill a liberal social obligation instead of opportunities to fulfill missions already in place for exhibiting high-quality aesthetic materials. For some museums, exhibiting Negro art provided an opportunity to explore an artistic movement that had generated excitement outside of the art world through the Harmon Foundation Annual exhibitions. For other museums, these requests piqued curiosity in art by Negroes as a novelty with the potential to examine America's own modern primitives. "Chapter 1: African American Art in the Modern Art Museum" begins in this moment of converging desires for the role of Negro art in American museums.

Chapter 1 considers two exhibitions of African American art in American art museums in the 1930s: *Exhibition of Sculpture by William Edmondson* (1937), organized by the Museum of Modern Art (MoMA), and *Contemporary Negro Art* (1939), organized by the Baltimore Museum of Art (BMA). These exhibitions demonstrate the contestation over the meaning of exhibitions of Negro art in the modern art museum that are still present in the exhibition of African American art. The Harmon Foundation, Alain Locke, American Scene painting, and the brief popularity of "primitive" art in the modern art museum each stake a claim in defining Negro art and national identity through exhibition.

This chapter also explores the exhibition of painter Jacob Lawrence's major work *The Migration of the Negro* (1940–1941) by MoMA and the Phillips Memorial Gallery. The exhibition of Lawrence's work fulfilled the competing

desires for the role of Negro art in museums to be both perpetually primitive and contemporary. Lawrence's folk art aesthetic appealed to the 1930s and '40s interest in Negroes as "modern primitive" people. Yet his racially grounded and contemporary subject matter served as a corrective to the invisibility of Negro history and culture in museums. The blend of his unique style and iconography in *Migration* announced a leading Negro artist on the art scene, fulfilling Locke's prescription for a unique non-imitative Negro art. This groundbreaking exhibition set the stage for other mainstream American art museums to seriously consider the work of modern Negro artists through solo exhibitions.

In the latter half of the twentieth century, mainstream public interest in Black communities began in part because of the Civil Rights Movement and Black American demands for social and economic parity with Whites. Beginning in the mid-1950s through the early 1970s, the visibility of Black Americans in the news media sensitized viewers and readers to the difficulties of Black survival in southern and northern, urban and rural, and distant and local communities.[23] Audiences were moved worldwide by nonviolent tactics met with violent responses and civil protest met by brutal confrontation. The dignity of Black leadership and courage of everyday Black people turned the heads of even the staunchest supporters of segregation and stood in resistance to the maintenance of racial hierarchies in the United States government, institutions of higher learning, public schools, libraries, and the arts. Black Americans commanded the world's attention and insisted on increased public awareness of their history, national contributions, capabilities, and achievements in the United States. This desire for Black recognition took many forms. In literature it emerged in the Black Arts movement through authors such as Amiri Baraka and Nikki Giovanni. In politics Shirley Chisholm and Angela Davis ran for presidential office. Carl Stokes became the first Black mayor of a major American city, and Tom Bradley, Maynard Jackson, and Coleman Young became the first African American mayors of Los Angeles, Atlanta, and Detroit respectively. In music Motown harmonics celebrated love and unity, and funk music created its own musical universe celebrating the uniqueness of Black identity. In the visual arts, artists, curators, and art activists responded to the social ills of poverty, racism, and war of the 1950s and 1960s through the prolific production of abstract, social realist, and narrative artworks in sculpture, on canvas, on paper, and through strategic collaborative explosions on the walls of urban

buildings; the formation of artist groups and exhibitions about the social upheaval necessary to meet the challenges of the Civil Rights Movement; the founding of museums and galleries dedicated to the visual expressions of Black peoples; and the confrontation of mainstream art museums that repeatedly ignored the history of African American art and culture.

Chapter 2 begins at the end of the Civil Rights Movement when the Metropolitan Museum of Art (Met) organized *Harlem on My Mind: Cultural Capital of Black America, 1900–1968* (1969), an exhibition that sought to trace the history and value of the predominantly Black community of Harlem in New York City. In organizing one of the most controversial exhibitions in United States history, the Metropolitan decided to exclude Harlemites from participating in the planning and to exclude artwork by Harlem's thriving artist community. The museum justified these decisions by arguing that Harlem itself was a work of art and the inclusion of artworks in *Harlem on My Mind* would only detract from the overall exhibition.[24] Public frustration with the selection of objects and depiction of cross-cultural relationships led to boycotts of the exhibition before it even opened. This chapter examines the role of cultural ethnography in an exhibition of Black culture through photography. It also focuses on the activism of the Black Emergency Cultural Coalition (B.E.C.C.), the organization of Black artists led by Benny Andrews that formed to protest the absence of art by Black Americans in the exhibition.

Chapter 3 discusses *Two Centuries of Black American Art* (1976), the first historically comprehensive exhibition of art by African Americans at a mainstream art museum. Curated by the dean of African American art history, David C. Driskell, this exhibition stunned many visitors by displaying visual evidence of a history of African American art production previously omitted from most accounts of American art. *Two Centuries* responded to the demeaning slight of art by Black Americans in *Harlem on My Mind* at the Met by presenting the depth and variety of their art. The exhibition and its widely distributed catalogue provided visual evidence that the rich history of Black artists had been blatantly ignored, not just by the mainstream art world but by the entire discipline of art history. This chapter tells the stories behind the show, including the Los Angeles County Museum of Art's original conception for it and the curatorial objectives and critical reception of this historic exhibition. It analyzes the narrative of African American art told through the selection of artworks in the exhibition and addresses the exhibition's impact on museums' practices of racial exclusion.

Chapter 4 examines the Whitney Museum of American Art's multimedia exhibition that explored the image of Black men in American art and popular culture since 1968. *Black Male: Representations of Black Masculinity in Contemporary American Art* (1994) received a great deal of attention and criticism because of its ambitious theme and complex subject matter. Because there have been comparably few exhibitions shown in mainstream institutions that address Black culture, and none focused specifically on masculinity, the exhibition bore the impossible pressure of reflecting visitors' individual definitions of Black masculinity since 1968. Upon the exhibition's arrival at the Armand Hammer Museum in Los Angeles, former Los Angeles County Museum of Art curatorial assistant and community activist Cecil Fergerson created a series of alternative exhibitions titled *African American Representations of Masculinity* (*AARM*) to express his dissatisfaction with the discourse of Black masculinity presented in *Black Male*. This chapter addresses the intentions of the exhibition curator Thelma Golden and examines the support and contestation of *Black Male* within Black art communities. As indicated by its title, *Black Male* mixed anthropological and artistic methodologies. The chapter analyzes these approaches to Black representation and self-representation that were crucial for both the *Black Male* and the *AARM* exhibitions.

Chapter 5 maps the persistence of the anthropological interpretation of African American creativity through the popular traveling show *The Quilts of Gee's Bend* (2002) organized by the Museum of Fine Arts, Houston, and Tinwood Alliance, Atlanta. The art museum's appropriation of the traditional practice of quilt making engages in typical modernist discussions of transgressing the hierarchical boundaries of high and low art. This practice is not new to the art world; however, the comparative discussions of affinities (comparisons explored in reviews of the exhibition and the exhibition catalogue) are usually reserved for artifacts made by "non-Western" groups instead of contemporary African American women.

The chapter offers a close analysis of the exhibition through its wall text, object labels, and documentary Farm Security Administration photographs by Arthur Rothstein and Marion Post Wolcott. It is also informed by interviews with the quilters about their experience of becoming exhibiting artists in the mainstream art world. Important to this discussion is the "discovery" and exceptional marketing of the quilts made by the women of Gee's Bend by collector William Arnett and Tinwood Media. In Chapter 5

INTRODUCTION

I discuss what is lost, gained, and learned by recontextualizing the quilts in mainstream art museums. I argue that although the Gee's Bend quilts are treated as artwork, the women who created them are not treated as artists. *The Quilts of Gee's Bend* exhibits contemporary material culture of African American women, similar to the 1927 and 1939 Negro Art exhibitions in Chicago and Baltimore, yet evokes the lens of anthropological discovery used to introduce the sculpture of William Edmondson in 1937.

NEGRO ART
IN THE MODERN
ART MUSEUM

At the end of the 1930s, two exhibitions of art by Negroes were organized by major American art museums, *Exhibition of Sculpture by William Edmondson* (1937) at the Museum of Modern Art and *Contemporary Negro Art* (1939) at the Baltimore Museum of Art. Both exhibitions were the first exhibitions of Negro art at their respective institutions. Both featured the most recent work by living artists on view. And both addressed the role of the Negro in the contemporary art world. However, each institution offered different interpretations of what Negro art was and what Negro artists could contribute to the modern art scene. The museums' approaches to presenting Negro art served contradictory functions. For MoMA, Edmondson's sculpture presented an opportunity to reconnect with America's primitive soul, a Negro soul, which fit into the New Deal's American Scene as an anachronistic pre-modern ancestor. For the BMA, contemporary Negro art represented the development of a group of trained artists ready to take their place among the democratic ranks of contemporary American artists.

At stake in these exhibitions was a larger definition of the role of Negroes in the national fabric. How could the nation's 1930s theme of progress include a population of people who had been deemed uncivilized and inferior to Whites for hundreds of years? How could this group be re-imagined as

an integral part of the future of America, not solely as laborers, but as equal members of a democratic society? How could the nation boost morale amid the deplorable economic conditions of the Great Depression and consider the beauty of Negro Americans as part of its intellectual value and national aesthetic? The art world's answers to these questions were conflicted and reflected the larger social struggle over how to include Negroes in America's political economy. Negroes were positioned as either perpetual outsiders, primitive artists because of their race, or, as contemporary artists whose work was exhibited to prove the true democracy of America that only existed as an idealized goal. This discussion of where Negro artists were allowed to exhibit their work and how the exhibitions were justified illustrates the paradoxical engagements between understandings of Blackness and modernism, beauty and cultural equality, and democracy and nationalism in America's art world of the 1930s and into the 1940s.

Exhibition of Sculpture by William Edmondson and *Contemporary Negro Art* presented divergent perceptions of Negro artists in America. On one hand there was an art world that could only recover the value of Negroness as atavistic, curious, and separate from itself; and on the other was a struggle by Negroes to be seen as relevant contemporary artists. These frameworks of primitive Negro art and modernity are key to understanding the paradoxical positions of Negro art exhibitions from the period. In this chapter I examine these remarkable shows and the social and artistic contexts for exhibitions of Negro art in the 1930s. The influential exhibitions and the discourse around them present issues that continue to beleaguer museums in the twenty-first century, and are still relevant to the exhibition and interpretation of African American art. The political environment of the 1930s allowed new opportunities for Negro artists to show in mainstream museums. At the same time, reasons for the inclusion of Negro art and a common understanding of the value and usefulness of the art were up for debate. Negro artists and Negro communities shared the understanding of Negro art exhibitions as not just art shows, but instead as opportunities to demonstrate the value and equality of Negroes to a larger mainstream audience. Gains were made regarding the exposure of Negro talent and cooperation between the art world and the Negro communities that sought representation on the gallery walls. However, praise for the aesthetic and technical value of Negro art, from the hosting museums, critics, and viewing audiences, was inconsistent and often patronizing.

The Harmon Foundation in the Art Museum

Capitalizing on the proliferation of Negro creativity in the visual arts during the 1920s, the privately funded Harmon Foundation came to dominate the promotion and production of exhibitions of Negro art at the beginning of the 1930s. Founded in 1922 to promote the creative production of Negro Americans, the Harmon Foundation worked to gather, exhibit, and award prizes for exemplary artworks made by Negroes. Their five-year exhibition program announced the presence of Negro artists as a developing community of creative producers eager to be included in the modern American art scene. The Harmon Foundation strove to keep the momentum of excitement around Negro American culture from the Harlem Renaissance and turn it into a narrative of social progress during the late 1920s and into the 1930s. It began its renowned annual competition and exhibition program in New York in 1928, and in 1929 organized its first touring exhibition of Negro art. The 1929 exhibition, *An Exhibition of Paintings and Sculpture by American Negro Artists,* was held at International House on the upper west side of Manhattan. Across the northern and southern regions of the country, twelve institutions including eight museum spaces hosted a smaller version of the show through the rest of the year.[1]

An Exhibition of Paintings and Sculpture presented seventy-one artworks by twenty-eight artists from the East Coast and Midwest. According to the Harmon Foundation, the exhibition was organized for "acquainting and interesting the public more generally in the creative accomplishments in fine arts by Negroes" and "not only to encourage the Negro in creative expression of a high order, but to assist him [*sic*] to a more sound and satisfactory economic position in the field of art."[2] The Interracial Committee on Race Relations of the Washington Federation of Churches and the Harmon Foundation shared the goal of social change and racial parity through Negro art and jointly sponsored the exhibition.

International House served as a residential hall for American and international graduate students and as the exhibition space for the Harmon Foundation for its first three fine arts exhibitions from 1928 until 1930. In the 1920s and '30s, International House hosted educational events to promote cross-cultural understanding toward the goal of world peace. Mary Beattie Brady, administrator of the Harmon Foundation, explained her choice of International House for the Harmon exhibitions, writing: "I held

the Exhibit there for several reasons: first, because I wanted to be sure and have a place where the two races would meet under the most harmonious circumstances; and, second, I did not want to rush into too extensive an Exhibit until we were reasonably sure of getting a quality of material which would justify the extensive public interest we would like to draw to these Exhibits."[3] Additional reasons may have equally influenced Brady's choice of International House for the 1929 exhibition. Given the success of exhibitions of art by Negroes regularly held at the YMCA in New York and the New York Public Library, particularly in the late 1920s, Brady's choice of a "harmonious" venue may suggest criticism of these Colored spaces as inharmonious. In 1929, 525 students lived in International House; one third of the residents were American, and the others were from China, Germany, Canada, Japan, and the Philippines.[4] Certainly, International House situated the exhibition in a new location easily accessible to a built-in international student audience gathered for educational and humanistic reasons. This relocation fulfilled the foundation's goals of reaching a public unacquainted with Negro creativity in the visual arts.

International House created a new frame in which to experience Negro art in terms of location and philosophical context. Brady attempted to place the art beyond Blackness spatially and philosophically to appeal to a new audience. Away from the Black Mecca of Harlem, she worked to relocate, redefine, and control the presentation of Negro art under her own terms and through the lens of foreign novelty. Negroes were already structured as outsiders to the national body in terms of institutional and political power. International House was a strategic choice to highlight the racial difference of American Negroes through international appeal and entice viewers into looking at their art from a cosmopolitan perspective. The popularity of the show at International House, which Brady recalls was viewed by 6,500 people in its first three weeks, encouraged her to tour it for the rest of the year.[5]

An Exhibition of Paintings and Sculpture by American Negro Artists was the first all-Negro group show for all of the museums that hosted it, and its presence marked a noticeable departure from the usual curatorial practices of each institution. Its mixture of art by experienced and up-and-coming Negro artists was poised to potentially disrupt the racially exclusive narrative of American art as it had been seen in museums. At the National Gallery of Art, the exhibition crossed a line previously separating the legitimacy of cultures

in the museum world.[6] However, the exhibition only crossed over the museum's threshold. Featured in the National Gallery's foyer, it was separated by its informal placement from the exhibition galleries, and its art was signified as unequal and lesser.[7]

Unlike many museums on either side of the Mason-Dixon Line, the National Gallery was not closed to Negro visitors. Further, once, in 1928, it had exhibited a work by the Negro artist and scholar James A. Porter alongside paintings by fellow White artists in the Washington Water Color Club.[8] It was logical to exhibit work by Negroes, as they were accomplished artists and occasional visitors to the museum. However, because of the race of its artists and its location in the lobby, the all-Negro exhibition was not seriously considered as part of the identity of the museum and its art exhibition program. The single review of the installation was published in the art review section of the *Washington Post*. Articles about Negro artists were not commonly found in the art review section of the newspaper, and the review's placement highlighted the legitimacy of the show as an art exhibition. In the article "Negro Art Exhibition Has Merit," the reviewer, Ada Rainey, highlights contributions by the painter Archibald Motley, Jr., and discusses effective aspects of a wide range of subject matter in compositions by George L. Johnson, Hale Woodruff, and E. S. Campbell, and sculpture by May Howard Jackson, to substantiate the seemingly surprising and remarkable claim of the review's title. A telling mistake in Rainey's review, however, reveals insight into her interpretation of the exhibition. She states that the exhibition was previously installed at "Neighborhood House in New York" instead of the more prestigious sounding, and accurate, International House. For Rainey, *An Exhibition of Paintings and Sculpture by American Negro Artists* demonstrated artistic merit, but was seen as a neighborhood project instead of a significant exhibition that could potentially transform the exclusive practices of the hosting museum. Her review articulates the disconnect between the foundation's goal of cultivating new audiences for Negro art and its posing a structural challenge to the exhibition programs of major museums needed to realize racial parity in the art world. Concluding that "there is much latent talent in the negro race," Rainey commends the Harmon Foundation for its efforts to "encourage and foster their [Negroes'] creative effort,"[9] suggesting that the exhibition of Negro art should be credited solely to the Harmon Foundation, separately from the National Gallery of Art's role as host institution. The lobby

installation of the exhibition, instead of incorporation into a gallery, encouraged this interpretation of the show as separate from the institution. The National Gallery's inclusion of the exhibition in its schedule helped expose a national audience to the work of Negro artists at the same time that it marginalized them within that space in its brief ten days on view.

The Harmon Foundation's promotion, marketing, and exhibition of Negro art defined the role of Negro artists as limited by their status as a racially distinct community. The Harmon Foundation cannot be blamed for the structural disparity in the societal positions of Negroes and Whites in America. However, its presentation of Negro artists through exhibition did not present a serious challenge to that disparity in the art world. Instead of individual Negro artists being introduced through the appropriate aesthetic styles and iconographic concerns that reflected the diversity of their art, the artists were promoted as a group based on a racial difference that maintained their status as separate from the art world, even as they were included in it. The foundation's exhibitions were a model for museums to understand how to incorporate Negro art without making change. Presented as a sociological project, the packaged shows made it easy for museums, like the National Gallery of Art, to insert the Negro art exhibition into their exhibition program and remove it, without its having had any impact on the museum's identity. This is a major part of the Harmon Foundation's role in shaping Negro art exhibitions in the national discourse.

The Federal Art Project and the American Scene

When the Harmon Foundation ended its annual Negro art exhibitions in 1933, Negro artists voiced their critiques of the foundation for its patronizing attitude. One of the most poignant critical texts was penned by the artist Romare Bearden who called the effects of the Harmon Foundation on Negro artists "disastrous," saying in 1934, "It has encouraged the artist to exhibit long before he [sic] has mastered the technical equipment of his medium. By its choice of the type of work it favors, it has allowed the Negro artist to accept standards that are both artificial and corrupt."[10] Bearden laments that the Negro artist has not taken advantage of expressing the experiences of "the Negro scene" in the art, but rather "proudly exhibit[s] his 'Scandinavian Landscape'[,] a locale that is entirely alien to him."[11]

Shortly after the end of the Harmon Foundation exhibition program, President Roosevelt established the New Deal for artists through the Federal Art Project (FAP) of the Works Progress Administration (WPA) in 1935. This program sought to lift the morale of the country by stabilizing a sense of national identity through the arts. The FAP provided economic relief to American artists and encouraged cultural expression through community art centers where artists taught art and art history courses and had ample exhibition and studio space. FAP art centers were developed to cultivate the local artistic styles of communities in regions across America. The FAP sought to discover distinctive artistic styles from various communities and promote the art in a national celebration of America's diverse and unique identity known as the American Scene. Reflecting modern life in contemporary America with a sense of nostalgia for the agrarian culture of the nation's past, the American Scene encompassed the regional expressions of art in America.

In addition to the FAP art centers, the Depression era ushered in an increase of opportunities for Negroes and a greater inclusion of Negro artists in museum exhibitions and mainstream art organizations than ever before. In 1932, the sculpture *Congolais* (1932) by Nancy Elizabeth Prophet was purchased by the Whitney Museum of American Art. In 1932, the sculptor Richmond Barthé exhibited in the Whitney's first annual exhibition and his work *Blackberry Woman* (1932) was acquired by the museum. Painter Cloyd Boykin founded and directed the Boykin School of Arts and Crafts in Greenwich Village and Harlem from 1929 to 1935.[12] Sculptor and mentor Augusta Savage founded the Savage School of Arts and Crafts in Harlem in 1931. She was inducted into the National Association of Women Painters and Sculptors in 1934, a first for a Negro artist.[13] In Manhattan in 1933, the Adult Education Committee of the New York Public Library sponsored the Harlem Art Workshop and Studio at 270 West 136th Street, a place for the creation and exhibition of art directed by James Lesesne Wells.[14] Artists who worked at the Workshop were known as the 306 Group after the building number of its location. The Harlem Art Workshop was one of the greatest contributions made to the development of Negro artists. It became a gathering place where visual artists such as Charles Alston, Romare Bearden, Grace Richardson, Jacob Lawrence, and Gwendolyn Knight interacted with literary greats Langston Hughes and Ralph Ellison, filmmaker Orson Welles, and others.

In 1934, the painter Aaron Douglas completed his influential mural series *Aspects of Negro Life* at the 135th Street branch of the New York Public Library. The following year, Douglas became the first president of the Harlem Artists Guild, co-founded by Charles Alston, Augusta Savage, Arthur Schomburg, and Elba Lightfoot.[15] This collective formed in the interest of promoting Negro artists independently from the Harmon Foundation and the Artists' Union in New York. Alonzo Aden, curator of Howard University Gallery of Art, organized the exhibition of thirty-eight artworks by Negroes in the segregated Hall of Negro Life at the Texas Centennial Exposition of 1936, celebrating the 100-year anniversary of Texas's independence from Mexican rule. Under the leadership of painter Charles Alston in 1936, an interracial group of artists completed the Harlem Hospital Murals that were criticized by the White administrators of the hospital for having too much Negro content.[16]

Negro artists were active in forming their own autonomous organizations and participating in opportunities to display their work through government and private patronage. Autonomous projects such as the Savage School of Arts and Crafts and the Harlem Artists Guild formed a community-based system of instruction, criticism, and exhibition. These organizations were invested in a multigenerational development of Negro artists to cultivate talent in its youth and allow adults serious study, mentorship, and freedom of expression away from pressures to create Negro art as defined by outside patrons. Gathering places for Negro artists in Harlem were increasingly important in the 1930s as centers for self-recognition and validation. As the visibility and activity of Negro artists aided by government support became more widespread in the 1930s, the question of the role of Negro art in the art world became more urgent for Negroes and Whites alike.

The Museum of Modern Art "Discovers" Negro Art

The Museum of Modern Art took up the question of the role of Negro art in its quest to define and exhibit modern and contemporary American art. Within the first several years of its founding in 1929, young MoMA director Alfred Barr presented exhibitions of non-Eurocentric sculpture, *American Sources of Modern Art* (1933), which displayed work of the Aztec, Maya, and Inca, and *African Negro Art* (1935), which displayed the work of fourteen

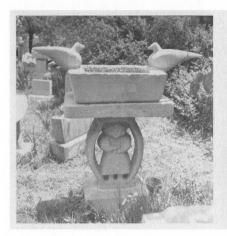

Figure 2.
Sculpture, William Edmondson (1933).
Photograph by Louise Dahl-Wolfe.
Collection Center for Creative Photography, University of Arizona,
© 1989 Arizona Board of Regents.

West African peoples as the primitive source material for European modernism.[17] Soon after, between 1936 and 1943, Barr and Holger Cahill, curator and director of the Federal Art Project, organized a series of exhibitions of American folk art, unknown painters, and untrained artists.[18] These exhibitions formed a context for understanding the role of William Edmondson's art, unknown to MoMA and the art world at large until the year of his historic 1937 exhibition. During this brief period, self-taught and academically trained artists were allowed to occupy the galleries at MoMA. However, the only work displayed by an American Negro during this period was by Edmondson, an untrained sculptor whose work was displayed as evidence of the primitive roots of modern American art.

William Edmondson was born in 1874 in Davidson County near Nashville, Tennessee, where he lived and worked his entire life. He began carving limestone for tombstone ornament around 1933, when he was inspired by God to carve.[19] Edmondson displayed many of his works in his yard where they were seen by Nashville-based poet and Vanderbilt University professor Sidney Hirsch in 1936.[20] Hirsch was connected with prominent literary and artistic circles that served as the primary network for spreading word about Edmondson into the art world. Introduced to Edmondson around 1936, *Harper's Bazaar* fashion photographer Louise Dahl-Wolfe took photographs

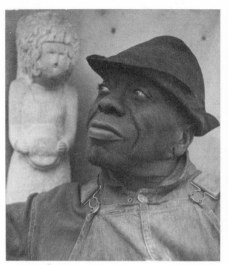 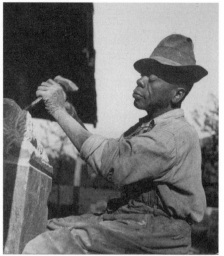

Figure 3.
William Edmondson, Sculptor,
Nashville, Tennessee (1937).
Photograph by Louise Dahl-Wolfe.
Collection Center for Creative Photography,
University of Arizona, © 1989 Arizona Board
of Regents.

Figure 4.
William Edmondson, Sculptor,
Nashville (1937, ca. 1933).
Photograph by Louise Dahl-Wolfe.
Collection Center for Creative Photography,
University of Arizona, © 1989 Arizona Board
of Regents.

of his sculptures and made portraits of him at his home. She introduced Barr
to Edmondson's work through her photographs in 1937.

The sentimental quality of her photographs of Edmondson is undeniable.
Dahl-Wolfe captures the rural setting of Edmondson's overgrown, grassy
yard filled with various tombstone designs and the bluntly carved, shal-
lowly incised sculptures of women and birds for which he is known (figure
2). In what has become the most widely circulated portrait of Edmondson,
Dahl-Wolfe depicts him with one of his sculptures (figure 3). In this pho-
tograph, Edmondson dons a short-brimmed hat folded up on the sides, a
dark shirt, and overalls while looking curiously at something outside of the
picture. His upward gaze combined with the sculpted angel looking toward
him over his right shoulder reminds the viewer of the spiritual influence on
Edmondson's work that the art world found so fascinating, and highlights
the novelty of Edmondson's status in the art world.[21]

Several of Dahl-Wolfe's photographs show Edmondson directly engag-
ing with the work, either sculpting with a hammer and chisel in his studio
or touching his work (figures 4 and 5). These photographs support the art
world's construction of Edmondson as an artist; however in the context of

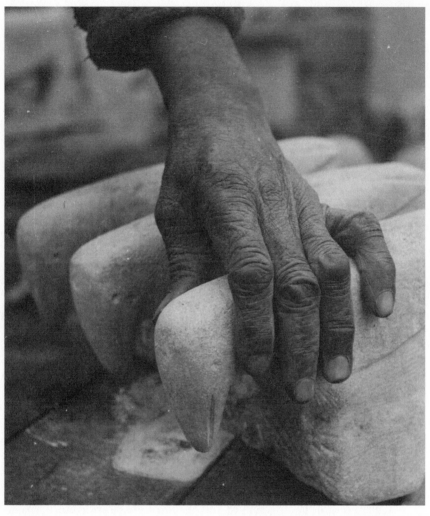

Figure 5.
Sculpture, William Edmondson (1933).
Photograph by Louise Dahl-Wolfe.
Collection Center for Creative Photography,
University of Arizona, © 1989 Arizona Board of Regents.

the majority of Dahl-Wolfe's Edmondson portfolio, they reinforce his status as racially, economically, and geographically outside of the modern art world. Most modern sculptors in the 1930s worked in clay and then presented their final sculptures in museums in bronze. Although Dahl-Wolfe shows Edmondson sculpting, his medium and method are decidedly ancient. In

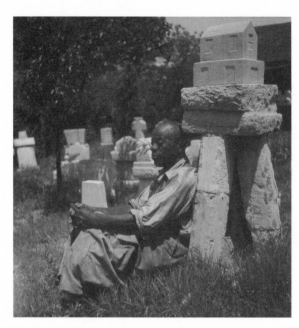

Figure 6.
Untitled (1933).
Photograph by Louise Dahl-Wolfe.
Posthumous digital reproduction
from original negative.
Louise Dahl-Wolfe Archive,
Center for Creative Photography, University
of Arizona, © 1989 Arizona Board of Regents.

other photographs where he is shown with his work, the photographs appear highly contrived. For example, in *Untitled* (figure 6), Edmondson sits on the ground leaning against the base for his sculpture *Noah's Ark*. His eyes are closed and fingers are interlaced around one knee as if he is relaxing in his yard. However, the hot sun reflected on his exposed head and the precarious balance of the sculpture on the makeshift pedestal make the scene unconvincing as a realistic moment between the artist and his work.

Likewise, three photographs of Edmondson standing with one of his animal sculptures show him worrying over the work (figure 7). In each pose, he touches the work with a look of exhaustion, or perhaps fear, on his face. It is unclear what Edmondson is doing. The awkwardness of his poses suggests that he was directed by Dahl-Wolfe how to engage with the work. This physical interaction with the sculptures show viewers that Edmondson's creations are not as precious as works of art revered in a museum setting, which would not be touched for fear of damage. Dahl-Wolfe constructs Edmondson as an artist whose work is inherently inferior to fine modern art. Her photographs construct a narrative of discovery for his work by depicting him and his sculptures as primitive. Her staging of the photographs reassures viewers that in the age of American progress, Negroes appropriately remain fixed as

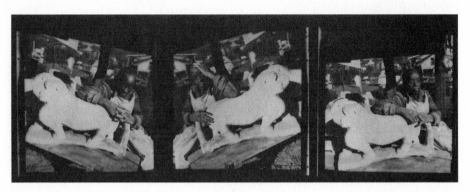

Figure 7.
Untitled (1933).
Photograph by Louise Dahl-Wolfe.
Posthumous digital reproduction from original negative.

a marginalized group. Though Edmondson was unnaturally posed, the images have a documentary-like reality effect of exposing Negroes for what they *really* were in America's social order. Dahl-Wolfe's—and eventually the art world's—Edmondson was an exemplary native and naïve artist perfect for "elevation" as primitive in the modern art world.

Unlike Negro artists working through the Harlem Renaissance, FAP, and 306 Group, Edmondson did not consider himself an artist and did not sculpt with aspirations for recognition by the art museum world. This did not deter Dahl-Wolfe or Barr, who saw him as ripe for picking out and up from his Negro community and recontextualizing as a spectacle from a perpetually unmodern Southern Negro America. Likewise, the aesthetic and social implications of organizing the first solo exhibition of work by a Negro at MoMA as modern primitivism did not dissuade Dahl-Wolfe and Barr. Instead, their concern was the appropriation of Edmondson's art for the purpose of creating an ancestry for American modern art. When Edmondson's use value as pre-modern specimen was over, his art was again placed on the margins, outside of modernism, and outside of the modern art museum. MoMA never purchased any of Edmondson's sculptures for its permanent collection. The only representations of his work at MoMA are in two photographs taken by modernist photographer Edward Weston. The artistic documentation of Edmondson through the documentary and, arguably, ethnographic lens of the modern artist is what has received lasting validation from MoMA.[22]

Edmondson's class, race, rural location, and spiritual inspiration, which once endeared him to the modern art world, were also the characteristics that kept him artistically and socially outside of it.

Edmondson's sculptures were not formed in or inspired by the artistic training of urban cosmopolitan centers. His distance from the New York art worlds, Negro and White, was part of his appeal to Barr. The authenticity of "real" Negro art was something lamented by art critics who reviewed all-Negro exhibitions in the 1920s and 1930s. If there was nothing the critics could mark as visibly and legibly Negro in the art by Negroes, the point of the work and its value as art was somehow lost. The blunt and blocky nature of Edmondson's works in stone demonstrated for MoMA and art critics that the great works by Negro artists were clearly and distinctly primitive, a quality that could be immediately distinguished upon viewing.

One of MoMA's press releases for the upcoming Edmondson exhibition announced it with biographical information about the sculptor and the note that "his work comes within that category loosely called 'modern primitive.'" The tone in the press release is skeptical as the text emphasizes Edmondson's anomalous artist background, noting twice that Edmondson is a Negro and referring to the spiritual inspiration for his work with blatant condescension. The author goes as far as to state, "He has had no art training and very little education, and has probably never seen a piece of sculpture except his own."[23] The release seems more like an argument against the exhibition than a promotional text for it. It certainly set the tone for reviews of the show in the mainstream press. A presumably later and more extensive MoMA press release adds, "His life in Nashville has been that of the average Negro of his generation in the South. He is simple, almost illiterate, entirely unspoiled, and happy in his work."[24] The racial and class differences between Edmondson and the art world are celebrated in terms that recall the mythological sambo character. A caricature type of a male slave, the sambo is lazy, happy, and entirely unaware (and unconcerned) with the serious aspects of life, namely economics, politics, and his own democratic and ontological freedom. Quotations from Edmondson reproduced in the press release and art reviews are written in Black dialect, emphasizing the perception of Edmondson's strangeness and racialized difference from the New York art world.[25]

The nostalgic presentation of Edmondson and his work was further highlighted by the other MoMA exhibition opening at the same time as the Edmondson show, *The Town of Tomorrow—1937 and 1927*. This paired exhibi-

tion featured futuristic architectural designs for houses to be built for the up-coming 1939 New York World's Fair, and circa 1927 houses by designers such as Gropius, Mies van der Rohe, and Le Corbusier. The exhibition allowed viewers to compare the past and future designs by these noted architects. By contrast, *The Town of Tomorrow* further distanced Edmondson's poor Negro world from the modern and futuristic qualities of avant-garde design.

The solo exhibition of Edmondson's work was a popular national news story that received coverage in West Coast, New York, and Southern news-papers as well as *Life* and *Time* magazines. Most articles are announcements of the exhibition, rather than reviews, which focus on Edmondson's bio-graphy, offer quotations from Edmondson describing his spiritual visions, and recount the discovery narrative between him and Dahl-Wolfe. These articles mirror the incredulous tone of MoMA's press releases with titles such as, "Negro Who Turned Sculptor at God's Command Gets Manhattan Exhibition," "Former Negro Errand Boy Honored as Great Sculptor," "Negro Sculptor's Work Acclaimed by Art Museum," and "Museum of Modern Art Honors Work of Negro."[26]

The Art Digest addressed audiences' mixed reaction to the exhibition, noting that while some thought MoMA was valuing primitive art too much, other viewers enjoyed the work. Critics in the *New York Times*, *The Art News*, and the *World Telegram* appreciated the authenticity of Edmondson's vision and his command of symbolic language akin to the an-cient Assyrians, Egyptians, and Maya.[27] More than one reviewer describes Edmondson as "a good-natured, middle-aged Negro" "who ran errands and did odd jobs for his white neighbors in Nashville."[28] Letters to the editor of the *Baltimore Sun* and *The Art Digest* argued that Edmondson's exhibition was the sign of art museums' low standards and proof that the celebrated European masters of modernism are of little value if untrained Negro art-ists and children can make art similar to the avant garde.[29] A reviewer in the *New Yorker* speculated that although Edmondson's sculptures were powerful, "it is likely that after the show closes, on December 1st, they and Mr. Edmondson will soon be forgotten." Although his work was pleasur-able to some, the viewing public was not convinced of its relevance as great and noteworthy art. The Edmondson exhibition at the nation's leading modern art museum presented what the curator and art historian Lowery Stokes Sims has called the "vanguardist dilemma." Edmondson's sculpture was admired for the qualities of "'innocence', 'lack of sophistication' and

formal simplicity" that many modern artists desired in their own work.[30] Yet Edmondson himself did not have the same pedigree as the vanguard artists that MoMA constructed as his modern descendants. For these reasons, he was marginalized by the mainstream art world, not considered an equal to modern contemporary artists.

The responses to Edmondson by the two leading scholars of Negro art were conflicted. The art world's celebration of Edmondson's primitivism reinforced a connection between contemporary American Negroes and what were perceived by Negroes and Whites as African "savages," a connection that Sims has argued undermined the Negro intelligentsia's efforts toward Negro incorporation into the democratic national body as aesthetic, social, and intellectual equals. Edmondson's sculptures do not show markers of Negro racial characteristics, derogatory or otherwise, nor do they show the trained skill and tradition of West and Central African sculpture. But the construction of Edmondson as an artist and his work as primitive were just as distasteful to some Negroes as the exaggerated racial characteristics of figures in the work of Negro artist Palmer Hayden.[31]

The artist and art historian James A. Porter remarked on the enchanting nature of art by untrained artists in his 1943 book *Modern Negro Art*. Regarding Edmondson in particular, he found the work to be the childlike expressions of "symbols of half-articulated meaning familiar to the race-mind." This harsh and self-condemning judgment is confusing at best. Porter shares the same race as Edmondson but presumably hopes to distinguish the old Negro from the new Negro through this statement.[32] The philosopher and cultural leader Alain Locke did not discuss Edmondson's sculpture in his writings. However, he did include two of Edmondson's sculptures in his book *The Negro in Art: A Pictorial Record of the Negro Artist and of the Negro Theme in Art* (1940) and in the 1941 exhibition *American Negro Art: Nineteenth and Twentieth Centuries* at Downtown Gallery in New York. These inclusions indicate Locke's recognition of Edmondson's work and suggest his approval of them as Negro art and American art within modernism. The art world's appropriation of Edmondson as a modern primitive may have appealed to Locke's desire for recognition of a unique Negro art.

Through MoMA's historic 1937 show, a stronger, newer, and more compelling narrative celebrating Negroes admirably as inherently unmodern and primitive displaced the Harmon Foundation's goal of social progress through the promotion of Negro art. This reframing of Negroes and their art set aside

efforts by artists, art historians, and art and social organizations to prove the cultural and intellectual parity of Negroes within modern society. The art world capitalized on the notion of the primitive Negro to support its effort to define American identity, nationalism, and the rhetoric of progress during a time of economic despair and increasing nativist fears. The narrative of Edmondson's authenticity legitimized the identity of American art by supporting the country's traditional values and social order, which may have provided hope and a sense of national stability for many Americans suffering through the Depression. The consideration of Negroes as modern people was dismissed for a more familiar model of the inequality between Negroes and Whites reinvigorated through a nostalgic presentation of the happy, disengaged sambo. As primitive art gained cosmopolitan cachet, the art museum recognized Negro artists through the lens of inescapable primitive characteristics and anachronistic source material for modern art.

Not subdued, however, by the racial barrier-breaking solo exhibition of Edmondson's sculpture at MoMA, Negro artists maintained their aspirations to be accepted as equal within the nation's narrative of modernity. Instead of being defined by the 1930s art world as outsiders within their own country, Negro artists sought to create work that would be recognized as valuable contributions within the American art world. There is no evidence that Negro artists held any jealousy or animosity toward the success of Edmondson or his art. Negro artists, Locke, and Porter had a larger systematic concern. At stake was the art world's regard for the diversity of Negro artists as modern people creating modern art, instead of its embrace of Negroes as modern primitives creating primitive art. Negroes understood their "twoness" of being American yet considered inferior because of racial difference. They understood their exclusion from the national narrative of modernity and MoMA's interpretation of Negro art as primitive as the latest example of America's problem of racial inequality. Undeterred, they continued to develop their art in schools and community centers and exhibit their work inside and outside of the museum world.

Contemporary Negro Art

In 1939, the Baltimore Museum of Art offered a different understanding of Negro art as modern art. The Harmon Foundation aided Charles R.

Figure 8.
Group of women viewing Malvin Johnson paintings with Ronald Moody's *Midonz* at right.
Contemporary Negro Art exhibition, The Baltimore Museum of Art, 1939.
Archives and Manuscripts Collections: The Baltimore Museum of Art. AN6.41.

Rogers, assistant director of the BMA, in the organization of the exhibition *Contemporary Negro Art,* which presented art by Negroes as aesthetically relevant, modern, and critical to the democratic ideals of the nation. Although the Harmon Foundation ended its competitions for awards in Fine Arts in 1930, it continued to organize, exhibit, and travel Negro art through the 1930s. Unlike its treatment of previous museum exhibitions of Negro art, the foundation did not approach the museum with the exhibition proposal; instead, the Baltimore Museum of Art approached the foundation for support of the exhibition. Most artworks were borrowed directly from the artists, demonstrating a shift in the autonomy of Negro artists from previous exhibitions sponsored by the foundation.[33] The exhibition was the result of the museum's new democratic method for determining its exhibition program through what Alain Locke called in the foreword to the catalogue "a progressive policy changing the role of the museum from that of a treasure storehouse of the past to that of a clearing house for the contemporary artist."[34]

In 1937 BMA director Henry E. Treide sent letters to 225 city organiza-

tions soliciting their input as to what the BMA could do for them.[35] The museum formed committees from the 192 organizations that responded and asked each committee to state what kind of support they wanted from the museum for their organizations. The committees' reports suggested a number of exhibitions to be presented by the BMA. The Negro Citizens' Art Committee's suggestion resulted in *Contemporary Negro Art* (figure 8).[36] Headed by Mrs. Sarah C. Fernandis, president of the Co-Operative Women's Civic League, the Negro Citizens' Art Committee was treated by Rogers with respect as important supporters of the exhibition. The committee members were kept informed of the progress of the exhibition as it developed and expressed their gratitude to Rogers and Treide for accepting the mandate for the exhibition by Negroes of Baltimore and for their efforts in curating the exhibition.[37]

For the BMA, the purpose of the exhibition was less to correct an art historical narrative of American art and more to refocus the priorities of a traditional American museum from one that served constituents of a "private patron class" to one that served interests of its broader public. In this way, the exhibition served to redefine the role of the municipal art museum and American art as it had been exhibited by the art museum world. According to Locke, *Contemporary Negro Art* was organized to present the work of significant and up-and-coming Negro artists in order to "have American art fully document American life and experience, and thus more adequately reflect America."[38] To emphasize the significant role that Negro artists played in the contemporary art scene, Rogers sought the most recent work available by rising Negro artists such as Jacob Lawrence and the latest work by accomplished artists such as Richmond Barthé (Barthé's work was selected for exhibition before it was completed).[39] Impressed by the BMA's committee selection process for its exhibitions, Locke supported Rogers's goals for the exhibition, stating, "Primarily it may serve to acquaint the general public with what the Negro artist is doing, but more fundamentally it serves as a declaration of principles as to what art should and must be in a democracy and as a gauge of how far in this particular province we have gone and may need to go in the direction of representative native art."[40] The Negro show was justified as an exploration of the expressions of American people and a representation of the art of a community of people in Baltimore who wished to be acknowledged and valued by its municipal institution.

Rogers's objective for *Contemporary Negro Art,* to present a more inclusive

Figure 9.
Exhibition entrance with *Wohin* (1935) on pedestal. In case from left to right: (top row)
Child's Head (1938), *Annie Portrait* (1938), *Seated Figure* (1938); (bottom row) *Ripple*
(1937), *Une Tête* (1937), and *Le Repos* (1937). All sculptures by Ronald Moody.
Contemporary Negro Art exhibition, The Baltimore Museum of Art, 1939.
Archives and Manuscripts Collections: The Baltimore Museum of Art. AN6.39.

and therefore accurate reflection of American art, was more democratic than Locke's prescription for what Negro art should be. In his *Opportunity* review of the exhibition, Locke candidly expressed his disappointment with works in the exhibition for not being reflective enough of Negro life or African ancestry, and not exemplary of successful Negro art. The difference between his foreword in the exhibition catalogue and his exhibition review in *Opportunity* is striking. In his foreword, Locke takes a celebratory tone as spokesperson for Negro art, lender to the exhibition, and catalogue author. In his review, "Advance on the Art Front," he speaks as cultural critic in the pages of the Negro press, clearly addressing a different audience, separate from the White art world. In his review, Locke uses the metaphor of military strategy to report on the advances of Negroes on the art front and prescribe what is needed to continue to gain and maintain ground in the war between Negro art and racial discrimination in the mainstream art world. The goal of the war for Locke is racial parity, and his strategy for

Figure 10.
Two young children looking up at Ronald Moody's *Midonz*.
Contemporary Negro Art exhibition, The Baltimore Museum of Art, 1939.
Archives and Manuscripts Collections: The Baltimore Museum of Art. AN6.40.

winning through the arts is the exhibition of a Negro art that displays specific signifiers of Negro culture for a White audience. For Locke, successful Negro art depicts visual evidence of Negro life and ancestry. Locke's Negro artist must be a native informant willing to educate the viewer through the visual manifestation of personal or cultural anthropology that can be legible as Negro.

In his remarks about the sculpture of Jamaican-born newcomer Ronald Moody, he praises the "healthy primitivism" in the work but concludes by suggesting, "His talent would undoubtedly benefit from closer contact with racial types, either West Indian or American" (figures 9 and 10).[41] Locke gives a very specific prescription for Moody to engage in anthropological study to improve his art—meaning, to fulfill Locke's vision of what Negro artists should be doing and the sociological impact that their art should make. What a healthy dose of primitivism is for Locke (and whom it is healthy for) is undefined, but the primitive element in Negro art certainly reflects his philosophy of appealing to mainstream expectations of what Negroness is. Perhaps Locke thought that the primitive quality of Negro art would contribute to the health of White viewers by confirming their notions of what Negro art looked like, and ease anxieties about how to identify it.

For Locke, Negro art could meet an undefined standard of universal values through a narrow prescription of how Negroness could be depicted. He wanted to prove that Negroes shared these values through the specificity of Negro experiences, saying "the more deeply representative [Negro art] is racially, the broader and more universal it is in appeal and scope, there being for truly great art no essential conflict between racial or national traits and universal human values."[42] To prove Negro value, Locke's Negro artists must communicate their racialized world in a language that Whites could understand, to produce a positive sociological effect through a standard of humanism in art. Paradoxically, Locke's standards for acceptable Negro representations limited the full spectrum of diversity of Negro experiences in order to recognize Negroes as universal. Although he concedes in the article that, as artists, Negroes have the right to artistic freedom, Locke quickly curbs that right by arguing for the importance of their bearing the burden of representation. He opined, "What should concern us primarily, then, is how to encourage and support our artists, assuring them that artistic freedom which is their right, but buttressing their creative effort with serious social and cultural appreciation and *use* so that their powerful

influence is widely felt" (my italics).[43] Although, as in the case of Moody's sculpture in *Contemporary Negro Art,* the work may be aesthetically pleasing, without use value, art by Negroes falls short of Locke's vision.

Contemporary Negro Art was regarded favorably in several newspaper and magazine reviews that highlighted individual artists and artworks as noteworthy. Some of these reviews expressed a pride in being the first Southern museum to display a large exhibition of art by Negroes, although the significance of hosting the exhibition is undefined.[44] It is not clear whether the exhibition was valued for being the first Negro event of its kind at the museum, or because it was interpreted as a progressive step toward American democracy in the city's museum. However, Locke's sentiment was that the art was not different enough from White art (or not Negro enough) to be remarkable or have any use value.[45] The desired use value for Negro art exhibitions to have a transformational sociological effect on race relations is a burden that Gary Reynolds, and more recently Mary Ann Calo, have argued was a prominent tension in the interwar period, particularly symptomatic of Harmon Foundation exhibitions.[46] Locke shared the foundation's preference for the usefulness of art by Negroes and understood visual evidence of Negro expression as an integral part of social change. This preference for and expectation of Negro artists demonstrating racial difference in their art has persisted as a marker of exhibitions of African American art.

The visual evidence of some legible Negro anthropologic feature has become an expected characteristic of art by Black artists as a basis for its value, not only to prove its merit through potential sociological change in the 1920s and 1930s, but beyond that era as a basis for legitimacy as art in the contemporary era. This adapted criterion has marginalized great nonfigurative works since the first half of the twentieth century by artists such as Wilfredo Lam and Norman Lewis and abstract and conceptual works by Black artists in the latter half of the twentieth century such as Ed Bereal and Howardena Pindell. Although landscapes, waterscapes, and still lifes were included in Negro group exhibitions since the 1920s, they were not collected by art institutions, nor were they noted as remarkable by Locke, because they did not contribute to a palpable Black difference that he regarded as so important for the recognition of Negro contribution to the arts and social change. This hierarchy of value for art made by Negroes continues to be a detriment to the recognition of the wide variety of what is considered valuable.

In retrospect, Locke's omission of a discussion of Palmer Hayden's controversial painting *The Janitor Who Paints* (c. 1937) from his review seems odd (figure 11). *Contemporary Negro Art* was the only exhibition in which the original painting was publicly displayed. Hayden's depictions of Negro figures rendered in the minstrel tradition were included in the original work and repainted sometime before the Harmon Foundation bought the painting in 1940. The revised painting shows Hayden's alterations made to the three figures and objects in the interior that offended some viewers, including art historian James A. Porter, who considered the work as evidence of Hayden's "talent gone far astray."[47] As art historian John Ott explains, Locke approved of the painting, although clues to Hayden's rejection of the Harmon Foundation's preference for Negro art depicting obvious African influence, life behind the veil, or "Lockean aesthetics" can be read in the work.[48] Such a reading interprets Hayden's use of primitivism as a criticism of the ways in which Negro painters, like himself and Cloyd Boykin, were treated by critics as amusing novelties instead of serious artists. Perhaps what is a remarkable painting for twenty-first century critics was a model display of a healthy dose of primitivism for Locke. Unlike Porter, Locke did not address the satire of Hayden's oeuvre or the potential for signification in "modern primitive" art. Locke either did not recognize or chose not to acknowledge the possibility of criticism in Hayden's painting, perhaps because it did not demonstrate a specific usefulness for successful Negro art. If, as Locke wrote in his exhibition review, art is the Negro's "best cultural line of defense," then there would be no room to acknowledge (let alone praise) the criticisms Negro artists held about their use value and construction in the White press, particularly under what Cornel West has termed the "white normative gaze," of which Locke was certainly aware.[49] Appeasing racist ideologies about "primitive" Negroes for White audiences in small healthy doses may have been Locke's strategy here. Maintaining some of the traditional racial hierarchy between Negroes and Whites in the work toward racial parity through the arts had been part of Locke's writings since *The New Negro* (1925). In the business of garnering White financial support for Negro artists, namely through the Harmon Foundation, a serving of primitivism would relieve the perceived threat of Negro accomplishment and reinscribe the roles of White superiority as benefactor and patron.[50]

Unlike most of the press about the Edmondson exhibition, *Contemporary Negro Art* reviews treat the exhibition critically rather than merely as a curious human-interest story deserving only of announcement. The *Baltimore Sun*

Figure 11.
Palmer C. Hayden, *The Janitor Who Paints* (c. 1937).
Courtesy of the Hayden Revocable Art Trust.

printed four reviews of the exhibition in which outstanding works were discussed and weaknesses of the exhibition were mentioned. These reviews addressed readers' expectation of what Negro art must look like, saying, "While members of their race are the artists' models, the subject matter is widely varied," and referred to the work as promising."[51] One author commended the BMA for a job well done and recommended that potential museum visitors

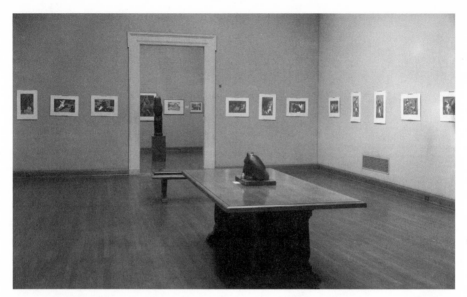

Figure 12.
Gallery with Jacob Lawrence's *General Toussaint L'Ouverture* series and Henry Wilmer Bannarn's *Colt* looking into gallery with Ronald Moody's *Lilith*. *Contemporary Negro Art* Exhibition, The Baltimore Museum of Art, 1939.
Archives and Manuscripts Collections: The Baltimore Museum of Art. AN6.45

read Locke's catalogue essay to understand the exhibition. Although several artists were mentioned by name for outstanding works, the bright star of the show was twenty-one-year-old Jacob Lawrence, whose forty-one-panel *General Toussaint L'Ouverture* (1937–38) was called "easily the most remarkable exhibit" of all (figure 12).[52] The museum received letters from the Dallas Museum of Fine Art and two universities requesting the show, indicating that other institutions perceived it as appropriate for a municipal museum or university art gallery. However, the museum did not tour the show, nor did it purchase any of the art from the exhibition, an act that would have confirmed its commitment to the democratic definition of American art it purported to support. Further, the majority of exhibition visitors were Negroes, indicating that Negroes did not convince the museum's regular audience, or the Baltimore community at large, of the importance of such art.[53]

About 12,000 visitors saw *Contemporary Negro Art* in its brief seventeen days on view. Despite its short run, Rogers described the exhibition as "one of our most successful shows of the season." Some Negro artists were gratified by the exhibition and expressed their appreciation to Rogers for his accomplishment.[54] Other Negro artists lamented the concept of the race-

based show. In a 1968 interview, painter and sculptor Charles Alston discusses the detrimental concept and effect of the all-Negro exhibition.

> One of the things that has concerned me throughout my painting life has been the business of the segregated show. I have always been pretty unalterably opposed to the segregated show. This all started in the very early days back in the '30s when the Harmon Foundation used to have an annual show of Negro painters. And you'd be in the show. That was that until the next year when you'd come out again and be paraded. The critics, sort of, at least I felt, pulled their punches, didn't apply the same standards. And I've always felt that the Negro artist cannot make it except in meeting the best of the competition from his contemporaries and that to artificially group him aside and apart was not giving him the chance for a full and total development. And at the same time, it was setting up what to me was a false premise—that there is such a thing distinctively in this country as a Negro art. I don't think so. I think you have a certain kind of American experience, be it an experience as a Negro in America, but it is an American experience. . . . I think to set up a little category like this, even in those days, to me said separation. I just didn't approve of it so I have refused consistently to show in segregated shows.[55]

Although Alston *did* participate in the Baltimore show, in retrospect he criticized the marginalization of Negro artists through exhibition. Calling it segregation, he further emphasized the privileged power position of Whites to create the all-Negro show for the goals of the art institution and defined the function and impact of the all-Negro show in the 1930s as another demonstration to mark Negroes as un-American. Later in the same interview, he identifies the difference between the all-Negro show in the 1930s and the all-Black show in the 1960s arguing that the 1930s exhibitions were "a completely different thing from a situation where a group of Negro artists out of their own motivation decide to do a segregated show for a specific purpose which they think has merit. Now maybe that's a subtle distinction but I think it is a distinction."[56] The difference between the two hinges on the display of power and validation by Black people self-selected for a primarily Black audience, in comparison to the beneficent, if well-intentioned, efforts for segregated inclusion by the Harmon Foundation, MoMA, and the BMA. What Alston politely identifies as a "subtle distinction" is a crucial one that traces the social movement of Black political power in the twentieth century.

The analysis of *Exhibition of Sculpture by William Edmondson* and *Contemporary Negro Art* demonstrates the challenge of criticism and interpretation of work by Negro artists. On one hand, Edmondson's un-academically trained, Southern, rural status defined the work of Negro artists as novel ancestors to modernity. On the other, *Contemporary Negro Artists* showed artists as a social project instead of through the distinct aesthetic and stylistic concerns of each artist. The all-Negro exhibition was an effort to give Negro artists exposure, even as they were shown as limited and separated from American artists by their racial identity. The artists were caught in a catch-22: for some critics, their Negroness was considered too different from the norm to be equally reviewed and collected; for other critics, their work was not considered Negro enough to make a difference.

The Rise of Jacob Lawrence

The inclusion of Jacob Lawrence's first epic narrative painting in *Contemporary Negro Art* launched his celebrated career in the mainstream art world. *General Toussaint L'Ouverture* was the first multi-paneled painting of several that helped Lawrence's distinctive style gain attention. Through the exhibition, the American art museum "discovered" a prolific, ambitious, and purposeful young talent in Lawrence, who consistently delivered focused explorations of Negro life throughout his sixty-year career. By the early 1940s, Jacob Lawrence was something of a sensation recognized in both Negro and White art circles. He benefited from academic training and training in FAP community centers. He won awards and fellowships from the best private foundations invested in the visual arts. He was mentored by Augusta Savage at the Savage School of Arts and Crafts, who helped him apply for government-funding.[57] He was part of the 306 Group and was the first Negro artist to be represented by a major commercial gallery in New York, Edith Halpert's prestigious Downtown Gallery. Curators, critics, and visitors were captivated by Lawrence's signature abstract, geometric, primary-colored, flat, tempura paintings, which narrativized sorrowful and heroic chapters of Negro history in captioned panels. The art world embraced Lawrence's stories as American stories simply abstracted by the young seaman in the Coast Guard. As Porter has commented, Lawrence produced the kind of Negro art that the public responded to with appreciation, "groping for possession of its long-neglected national heritage of art."[58]

Lawrence debuted his most recognizable work, the sixty-panel *The Migration of the Negro,* in November 1941 at the Downtown Gallery. Halpert was introduced to Lawrence's art through Locke, whom she allowed to curate the all-Negro exhibition *American Negro Art: Nineteenth and Twentieth Centuries* at her gallery later that year. Locke included *Migration* in his exhibition, which Lawrence recalls opened on December 7, 1941, a day that became a national day of remembrance for the Americans who died in the Japanese attack on Pearl Harbor. It also marked the event that instigated the internment of Japanese Americans in camps, under suspicion of being enemy aliens. The irony of these coinciding events highlights the ways in which the principles of American democracy and nationalism are simultaneously and hypocritically promoted alongside the protection of racial hierarchies in America. The connection between these contradictory ideals in the national and international public spheres played an integral role in the success and mobility of Jacob Lawrence's art. Lawrence was promoted at this moment as evidence of the democracy of the nation.

On the urging of Halpert, *Fortune* dedicated nine pages of its November 1941 issue to *The Migration of the Negro.* The first page features a photographic portrait of Lawrence as a serious modern artist, and includes a critical Negro history lesson about the Great Migration, Negro oppression, lynching, Marcus Garvey, and Negroes' desire to belong in America (figure 13).[59] The photograph is a closely cropped image of Lawrence's head emphasizing his intellectual ability and seriousness. He looks downward, away from the camera, and holds a narrow paintbrush in his right hand, which rests over his mouth. Showing a man engaged in his own thoughts as if calculating his next stroke, Lawrence's portrait is a far cry from the happy and carefree presentation of Edmondson.

Following this opening page is an impressive eight-page layout of full-color reproductions of twenty-six *Migration* panels with captions. This unprecedented feature on the art of a Negro in the popular press extended the reach of Lawrence's work through the art world. For a national audience, the *Fortune* portfolio unfolded the story of Negro Americans escaping poverty and punishment in the South and arriving in the North where economic and educational opportunities were better. The Downtown Gallery exhibition ran concurrently with the *Fortune* issue.

The Migration of the Negro (1940–1941) received an enthusiastic reception from the art museum world. The *New York Times* reviewed the work as

"... And the Migrants Kept Coming"

A Negro artist paints the story of the great American minority.

THE twenty-six pictures reproduced on the following pages were selected from a complete series of sixty panels executed by Jacob Lawrence (below), a young Negro artist whose work promises to earn for him the same high recognition accorded to Paul Robeson, Marian Anderson, W. C. Handy, and other talented members of his race. His use of harsh primary colors and his extreme simplicity of artistic statement have extraordinary force. In November, Artist Lawrence's full series will go on exhibition for the first time at the Downtown Gallery in New York. FORTUNE's choice was made partly on the basis of pictorial values, partly to preserve the continuity of the story of the American Negro that Lawrence tells through the medium of his sixty panels. The captions accompanying the pictures are his own.

Here is a strategic front in the Battle for America. Though they constitute a far larger minority group than any on the European continent, and though they represent a social and economic enigma of terrifying proportions, the 13 million U.S. Negroes are citizens of a shadowy subnation that is terra incognita to most whites. While carrying the "four freedoms" to the earth's ends American democracy might well bestow them on its Negroes, who are woefully in need of them. Except when one intrudes on the nation's consciousness as a great singer, musician, pugilist, or actor, the Negro is not an individual man but a great, dark, moiling mass with unknown aspirations, unknown potentialities. Today that concept is on the verge of imminent change. For the Negro is one-tenth of the U.S. population, and as the nation strives to develop the full measure of its strength it cannot for long ignore that one-tenth—or the problems it both faces and creates.

Theme of the story told by Lawrence's pictures is the great south-to-north migration of Negroes that commenced during the first world war and has continued in lesser degree ever since. In one of the biggest population shifts in U.S. history over a million Negroes quit the crumbling, semifeudal cotton economy of their forefathers and trekked to the industrial cities of the North. Behind them were poverty and the flaring prejudices that grew with poverty. An average of fifty-six Negroes were being lynched every year. Then the war-burdened factories of the North sent out a call for cheap labor. Labor agents roamed the South, promising the moon or better. The Negro press exhorted the Negroes to move, and earlier migrants, already settled in the North, wrote to their friends and relatives to tell of good jobs, good pay, and an amiable society wherein a colored man had a chance of living like a human being. Hundreds of thousands of southern Negroes responded. The first wave of migrants went north between 1916 and 1919 to relieve the acute labor shortage. The second great movement occurred between 1921 and 1923—after the immigration laws choked off the European labor supply. The Negro population of the North jumped almost 100 per cent, and much of the increase was concentrated in six cities—New York, Chicago, Philadelphia, Cleveland, Detroit, and St. Louis. Today nearly half of all U.S. Negroes are city Negroes.

While the war boom lasted the North seemed to fulfill some of its promises, though, from the start, Negroes were forced to live in overcrowded, segregated areas. Throughout the industrial North there was a series of race riots, often involving white and black laborers. Organized labor was no friend of the Negro, partly because he would work for low wages, partly because of his record as a strikebreaker, beginning in the 1850's when Negroes were brought up from the South to break a longshoremen's strike in New York. Symptomatic of the Negroes' confusion and despair was the rise of Marcus Aurelius Garvey, who promoted a fantastic scheme to take colonists back to Africa and found a Pan-African empire. Thousands contributed to Garvey's cause, and he purchased a steamship, first of his projected Black Star Line, to be used as a transport. But the ship was unseaworthy and sank in Newport News, and no colonist ever went to Garvey's Africa.

The North did give the Negro the right to vote, did send his children to school, and otherwise permitted him a modicum of dignity that he could not have in the South. It was this hope for the chance to live "like a human being" that inspired the continuing migration of the 1930's, for in the six cities of the North about a third of all the Negroes were on relief. Even in Harlem, where half a million Negroes are crammed into three square miles, white owners controlling 95 per cent of its business had always refused to hire Negroes. During this period, and before and since, Communist organizers were extraordinarily active among Negro communities in large cities. Aside from strengthening race solidarity, they have had surprisingly little effect, despite ideal conditions for agitation. Thus far, at least, the average Negro has been immune to direct ideological leadership.

The great majority of U.S. Negroes still live precariously, from meal to meal, and the Negro's long-range economic future looks no better. And still, in the concluding words of Artist Lawrence "... the migrants kept coming." They will come in ever-growing numbers, and they seem to be about to enact a tragic repetition of the events of the last war. Currently thousands are being drawn to Washington, D. C. by the lure of government jobs. It is common to hear whites predict "trouble" and talk of race riots if the influx continues. But Negroes by and large harbor no animosity against the whites. They plot no overthrow of the white man's domination, though as time goes on they become more articulate and begin to grasp the meaning of the power of masses—chiefly because circumstances force them to. The modern northern Negro has largely discarded the humble counsel of Booker T. Washington, who urged his followers "to know their place" and to crawl into the white man's kingdom through the back door. After many formal protests failed, a few months ago the Negro leader A. Philip Randolph, head of the Pullman porters union, announced plans for a "March on Washington" to protest against discrimination facing Negroes in the army, in industry, in every phase of the defense program. Fifty thousand Negroes pledged themselves ready to march July 1. Then on June 25 President Roosevelt issued an executive order to end discrimination and to implement it the OPM established its Committee on Fair Employment Practice with two Negro members. Randolph's 50,000 marchers primarily wanted jobs, of course, but they also wanted more—the chance to belong. The reasons for their hunger in both respects are elaborated in the captions accompanying the pictures.

Courtesy of The Harmon Foundation
JACOB LAWRENCE

102

46

"notable for directness, simplicity, imagination and an obvious conviction."[60] The work was received as so outstanding, and the art world so impressed, that MoMA and the Phillips Memorial Gallery shared the panels in an awkward split ownership: MoMA bought the even numbered panels and the Phillips bought the odd.[61] The *Migration* was exhibited at the Phillips Memorial Gallery in winter 1942. Later that year, MoMA sent the work on an extensive two-year national tour in museums and university galleries which concluded with MoMA's homecoming exhibition *Paintings by Jacob Lawrence: Migration of the Negro and Works Made in U.S. Coast Guard* in 1944.[62]

What was it about Lawrence's *Migration* that made it so desirable to the art world? Not only was it worthy of solo exhibition at several museums, it was acquired by two major art museums. For MoMA, purchasing Lawrence's work indicated a shift in the evaluation and status of Negro art from Edmondson's pre-modern carvings that were borrowed and quickly returned, to Lawrence's nationally toured paintings as part of the museum's permanent collection.

America's role in internationally pivotal events framed the warm response to Lawrence as a young Negro American artist and *Migration* as a quintessential American artwork. The bombing of Pearl Harbor in the month after *Migration* debuted at Downtown Gallery, and America's effective entry into World War II the following year, helped Lawrence to be received as a patriot in the art world sharing his story as an American story. An article in MoMA's bulletin about its own Lawrence installation states, "In spite of the stark simplification of forms and bold contrast of primary colors that give so much strength to his work, his pictorial statements are quiet, even-tempered, non-inflammatory. His pictures do not mount a soap box or preach a sermon. Yet almost imperceptibly his Coast Guard paintings suggest the gradual beginnings of a solution to the problem so movingly portrayed in the *Migration* series."[63]

The author makes it clear that the *Migration* panels are valued for the visual style and content they do contain as much as for what the panels do not. The description of the work speaks more to anxieties about the violent treatment of Negroes than about the content of the work, with a relief that Lawrence indicates that social change concerning injustice will begin gradually. The article ends with a discussion of Lawrence's life in the Coast Guard, noting his movement in rank from Steward's Mate to Specialist Third Class, and assuring readers that he will be able to devote his time to painting. The focus on his service record accompanied by a photograph on the same page of Lawrence in uniform not only makes a strong argument for the national and artistic

JACOB LAWRENCE

A Negro's contribution in terms of art to an understanding of this country's racial problem was presented by the Museum in October with the exhibition of *Paintings by Jacob Lawrence*. Eight new paintings made since the artist has been in service with the United States Coast Guard were shown with his *Migration of the Negro* series of 60 paintings depicting the movement of the Negro population Northward since World War I.

Coast Guardsman Lawrence paints facts, not propaganda. In spite of the stark simplification of forms and bold contrast of primary colors that give so much strength to his work, his pictorial statements are quiet, even-tempered, non-inflammatory. His pictures do not mount a soap box or preach a sermon. Yet almost imperceptibly his Coast Guard paintings suggest the gradual beginnings of a solution to the problem so movingly portrayed in the Migration series.

The earlier series, painted in 1940-41 on a grant from the Rosenwald Foundation, depict the poverty-stricken, fear-ridden existence of many Negroes in the South; their hopeful migration to the labor-starved markets of the North in World War I; and the conditions they met there—disillusionment because of segregated, overcrowded districts, fear because of occasional race riots, yet on the whole a step forward because they could exercise their right to the ballot and their children's right to an education.

Half of the sixty paintings in the Migration series are owned by the Phillips Memorial Gallery and half by the Museum of Modern Art (gift of Mrs. David M. Levy) which has been circulating the entire series to museums, art galleries and colleges throughout the country.

The Migration pictures were shown in May 1943 at the Portland (Oregon) Art Museum at a time when there were severe racial difficulties in the Kaiser shipyards. With the aid of a prominent

Jacob Lawrence with one of his Coast Guard paintings.

Negro organization, the Portland Museum arranged a forum for discussion of the immediate problems of World War II against the background of pictures which so understandingly portrayed the same problems during World War I. The forum produced good results.

Jacob Lawrence, born September 7, 1917 in Atlantic City, joined the United States Coast Guard in October 1943. He went in as a Steward's Mate but through the aid and encouragement of the Captain of the ship, Lt. Commander Carlton Skinner, found time to do some painting. While in the Service he has turned out seventeen paintings, all of Coast Guard activities and all in his favorite medium, gouache. Recently transferred to the Public Relations Branch of the Service, Lawrence has been given the rating of Specialist Third Class, and will be able to devote his time to painting.

11

Figure 14.
Jacob Lawrence. *The Bulletin of the Museum of Modern Art* 12, no. 2 (November 1944).
The Museum of Modern Art, New York, NY.
Digital Image © The Museum of Modern Art/Licensed by SCALA/Art Resource, NY.

belonging of Negroes in the art museum but also connects Lawrence to fellow Negro World War II soldier and hero Doris "Dorrie" Miller (figure 14). Two years younger than Lawrence, Miller served in the U.S. Navy as Third Class Mess attendant and Cook, the same rank as Lawrence.[64] Miller became a war hero, and an icon for Negro Americans in particular, for defending his ship with machine gun fire during the attack on Pearl Harbor. He was killed in the line of duty the month after Lawrence joined the U.S. Coast Guard in 1943. Literary scholar Saidiya Hartman has addressed the symbolic and psychological functions of Black people for the nation particularly during times of social instability, such as war, saying, "ultimately the metanarrative thrust is always towards an integration into the national project, and particularly when that project is in crisis, black people are called upon to affirm it."[65] Lawrence's position as a serviceman helped facilitate his reception in the art world as a young celebrated American soldier and spokesperson for the history of the Negro people: a story of triumph over adversity appropriated by the art world as an American story. His incorporation into MoMA during wartime supported the assertion of modern American art and validated the status of the nation as a unified world leader through the arts.

The *Migration* panels depicted the Negro struggle for a better life during the Great Migration. Eight new gouaches, painted while Lawrence was in the Coast Guard and exhibited with *Migration*, were depictions of that better life, achieved through government service in the Armed Forces. Lawrence's depiction of life in national service was interpreted as the documentary-like exploration of the realization of the American Dream. According to *Art News*, the paintings are testimonials to democratic and racial harmony in America: "In October, 1943, Lawrence enlisted in the Coast Guard, where he has found, in spite of racial rank, the greatest democracy he has known to date. Much of this is due to the understanding and encouragement of Lt. Comdr. Carlton Skinner, Captain of the U.S.S. *Sea Cloud*, where Lawrence served as Steward's Mate."[66]

The blatant disconnect between Negro suffering and the fight for equality presented in *Migration* and the "greatest democracy" that the reviewer claims Lawrence experienced is troubling. Instead of directly connecting the struggle of Negro migrants for greater incorporation into the nation with the opportunity for Lawrence to serve in the last American war with segregated troops, the reviewer attributes the victory for democracy to the ship's captain. Further, the reviewer does not address the subservient domestic service position that Lawrence filled, which enables her to call his experience exemplary of

"the greatest democracy." The reviewer goes on to discuss the "optimism and happiness" in the Coast Guard scenes in which Lawrence shows that "racial prejudices are forgotten." I am not arguing against the possibility that Lawrence experienced moments of optimism in his years in the Coast Guard; however, in the context of the exhibition, the Coast Guard paintings made a separate nationalist argument for the contemporary moment as the arrival of true democracy and racial equality. The exhibition served as a neat resolution to the social unrest of the Great Migration and Lawrence's accompanying depiction of it. The clarity of this argument is grounded in the reviewer's discussion of Lawrence's work as the essence of "purely visual truth" and as "forthright paintings, devoid of bitterness or overstatement." Lawrence is also characterized as sincere, honest, and "a painter with a purpose rather than a propagandist." The argument is made so cleverly that to argue against the racial democracy of the 1940s would be to discredit Lawrence and his paintings.

The author argues this point again through comparison of the success of the current *Migration* and Coast Guard paintings against Lawrence's previous multi-paneled painting *General Toussaint L'Ouverture* (1938), which is not discussed in the review, but represented by the reproduction of Panel #7 with the caption "Early less integrated style in the Harmon Foundation's 'Toussaint L'Ouverture' series" (plate 1). This panel does not show the racial harmony that the reviewer finds in the later work, but instead depicts a White planter holding a club raised over his head as he threatens to smite the half-clothed Black slaves begging for mercy at his feet. The caption for this panel states: "As a child, Toussaint heard the twang of the planter's whip and saw the blood stream from the bodies of slaves." It is no coincidence that the reviewer finds a painting that shows White brutality against Blacks to be less successful than the latter scenes in which "racial prejudices are forgotten." The interpretation of Lawrence's work as depictions of forgotten racial prejudices indicates the critic's desire not to deal with the reality of racial discrimination in order to work *through* it to a resolution of racial equality. This unproductive understanding of Lawrence's work ignores the history of violence and oppression of Negro bodies that he depicts in *Migration,* and jumps to a celebration of forgetfulness as the resolution of racial conflict.

During its installation at the Portland Art Museum in the spring of 1943, *Migration* literally became a site for racial and labor reconciliation. Portland was home to three of the seven West Coast shipyards devoted to the war effort and owned by industrialist Henry J. Kaiser. Negroes from mostly Southern

states migrated by the thousands for job opportunities at the Kaiser ship-
yards. As depicted in Lawrence's *Migration,* these workers and their families
faced strict housing segregation policies and inferior residences and were
met by a hostile environment of Whites who resented the influx of Negroes
into the area. In an effort to address these problems, which were common na-
tionwide, President Roosevelt signed Executive Order 9346, establishing that
employment discrimination concerning the war effort on the basis of race,
creed, color, or national origin would not be tolerated by the federal govern-
ment. This order was given during the installation of *Migration* in Portland,
reminding viewers that the problems depicted were not just historical, but
ongoing national and local issues. That same week, the Portland Art Museum
held an interracial discussion about problems of race relations at the Kaiser
shipyard in the gallery that displayed Lawrence's paintings.[67] Although there
are no records of what was discussed specifically, the museum was pleased
with the event stating, "The use of exhibitions to furnish the starting point for
a serious discussion of current problems has proved valuable."[68]

The reasons why Lawrence's paintings were deemed valuable in the early
1940s were not limited to the evidence of aesthetic value and quality within
Lawrence's artistic production, but extended into larger social issues concern-
ing the role of Negroes and their art in the mainstream art world, racial equal-
ity, integration, nationalism, patriotism, White liberal guilt, and life during
wartime in America. The exhibition and collection of *Migration* fulfilled the
competing desires for the role of Negro art in museums to be both perpetu-
ally primitive and contemporary. Lawrence's folk art aesthetic appealed to the
1930s and '40s interest in Negro Americans as "modern primitive" people, and
the folksy quality of his simplified forms and palette connected with American
Scene painting. His contemporary subject matter served as a corrective to
the invisibility of Negro American life and culture in museums. The blend of
his unique abstract style and racially grounded iconography in *Migration* an-
nounced a leading Negro artist on the art scene fulfilling Locke's prescription
for a unique non-imitative Negro art. Lawrence's patriotism, proved by his
service in the war and his Negro American subject matter, endeared him to
the art world. The unprecedented collection and tour of his work by art muse-
ums set the stage for American art museums to seriously consider the work of
Negro artists as modern and relevant. Simultaneously, its promotion demon-
strated the political use value of Negro art to support the nationalist ideals of
democracy, while maintaining segregation within the modern art museum.

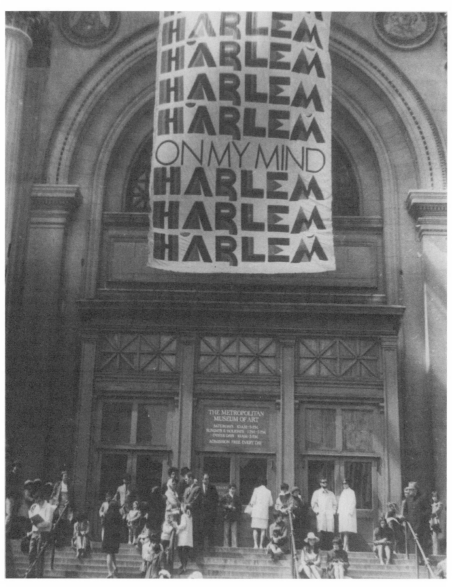

Figure 15.
Metropolitan Museum of Art Façade (1969).
Photograph by Lloyd Yearwood.

BLACK ARTISTS AND ACTIVISM

Harlem on My Mind, 1969

To me *Harlem on My Mind* is a discussion. It is a confrontation. It is education. It is a dialogue. And today we better have these things. Today there is a growing gap between people, and particularly between black people and white people. And this despite the efforts to do otherwise. There is little communication. *Harlem on My Mind* will change that.

—Thomas P. F. Hoving, Director
The Metropolitan Museum of Art, New York City, August 1968

In 1969, the Metropolitan Museum of Art mounted *Harlem on My Mind: Cultural Capital of Black America, 1900–1968,* an exhibition that sought to explore the cultural history of the predominantly Black community of Harlem, New York (figure 15).[1] At the center of one of the most controversial exhibitions in United States history were the Met's decisions to reject Harlem residents' participation in the exhibition planning and to exclude artwork by Harlem's thriving artist community from its galleries. Near the end of the Civil Rights Movement and the beginning of the Black Power Movement, Black culture emerged in the Met not as creative producer, but as ethnographic study.[2] The decisions to display African American people through oversized photo-murals and to dismiss their input and artwork as unworthy of being in the museum made *Harlem on My Mind* a site for racial politics and debates about artistic quality and art versus culture in the United States.

The conflicts between the Met and the Harlem art community engaged both political and aesthetic issues. For many Harlemites, the White mainstream art museum's refusal to engage Harlem's art community reeked of patronizing discriminatory racial politics and set off a fury of protests and charges of racism. Similarly, the museum's decision to exclude Harlem artists was met by disbelief and sincere efforts to correct the omission during

the planning stages of the exhibition. Harlem artists were further insulted by the inclusion only of photographs. At the time neither the art world at large nor Harlem's art and photography communities accepted photographs as a form of art. Even as a form of visual documentary, photography was an unacceptable representation of Harlem's rich artistic community in one of the world's greatest art museums.

In spite of the directors' intention to increase Black-White communication, what was most significant about *Harlem on My Mind* was not the exhibition itself, but the activism of the Black art communities in Harlem criticizing their omission. This community movement changed the discourse of Black art in mainstream American museum politics. In his succinct account of the significance of *Harlem on My Mind* for American museums, the arts and culture scholar Steven C. Dubin discusses some of the shortcomings and criticisms of the exhibition concerning Black exclusion, charges of anti-Semitism, and cultural conflict.[3] Missing from his critique, however, is the critical outcome: the increasingly powerful role of oppressed communities in organizing their voices against blatant omissions, disrespectful treatment, and cultural misrepresentation by art museums in the United States.

Harlem on My Mind commanded attention not only because of the Met's international status as an institution of fine art, but also because the exhibition was the museum's first attempt at representing Black Americans through exhibition.[4] The Met's position of privilege commanded attention, making the impact of *Harlem on My Mind* wide reaching and influential. This chapter explores the Met's impulse to become socially relevant, the issues at stake for the Harlem art community, and the significance of the exhibition for the discourse of Black art.

Miscommunications between *Harlem on My Mind* organizers and the Harlem art communities fueled Black activism to counter the exhibition's cultural assertion in two ways. First, Black artists and curators pressured mainstream art museums to make institutional change by including Black artists in their exhibitions, consulting members of Black arts communities regarding their representation, and hiring Black museum professionals. Second, Black artists and curators responded to the Metropolitan's disregard for Black artists by increasing their efforts to curate their own exhibitions. The significance of this activism moved beyond the geographic and temporal scope of the Met galleries and the 1960s New York art world.

Indeed, because of the museum's mistakes, the exhibition invigorated a movement of Black artists and museum professionals that changed the culture of the American art scene. Most immediately, their contribution became part of the Black Arts Movement, in which Black artists, poets, actors, and writers took hold of the creative history of Black Americans, connected with it, expanded it, and confronted mainstream America. The multifaceted response by Black visual arts communities to the failure of *Harlem on My Mind* represented a public criticism of art museums' larger failure to recognize living cultures.

The Appeal of Harlem

Because the Met is world renowned for its remarkable collection of fine art, it seems odd that the museum would produce a sociodocumentary exhibition about Harlem. The Met had established an identity as a cultural stronghold of artifacts and artistic knowledge. There were no practical, social, or professional expectations that the museum would take on an active role in the social politics of the day, particularly in 1969. Politically and racially the United States was reeling from the events of 1968, the watershed year that saw the North Vietnamese Tet Offensive which increased American opposition to the Vietnam War; the assassination of Martin Luther King, Jr., and subsequent riots in major American cities; the murder of seventeen-year-old Bobby Hutton of the Black Panther Party by Oakland City Police; the assassination of Robert F. Kennedy; the police riot against protestors at the Democratic National Convention in Chicago; and the fists raised for Black Power by American track and field athletes Tommie Smith and John Carlos during the medal awards ceremony of the Summer Olympic Games in Mexico City.

The struggle for power that developed between the Met directors and the Harlem art community over *Harlem on My Mind* had parallels in the struggle for public school decentralization and community control in the Ocean Hill–Brownsville area of Brooklyn. Between 1967 and 1971, the primarily Black and Puerto Rican Ocean Hill–Brownsville community battled with the United Federation of Teachers (UFT) and the New York City Board of Education to control the selection of public school faculty, administrators, and curriculum. In 1968, the local governing board of Ocean

Hill–Brownsville transferred nineteen white administrators and faculty, who were perceived as obstacles to community control of public schools, to the Board of Education headquarters to be reassigned.[5] Infuriated by the transfer, the nineteen returned to their jobs the next day and were met by parents blocking the school entrances.

Parents in New York suburbs already enjoyed community control over the public schools without engaging in a struggle for power. In her analysis of the Ocean Hill–Brownsville conflict, Jane Anna Gordon explains, "Because there was not such a sharp discrepancy in the racial demographics of the populations of students and staff in suburban schools, particular and episodic issues might have caused disagreement and dissension, but there was not a prevailing and omnipresent sense on the part of school employees that the children in the schools were fundamentally 'other people's children.' White normativity, in other words, unified those who controlled and those who inhabited the schools."[6]

In the case of Ocean Hill–Brownsville, racial and ethnic differences politicized the issue of community control. What had proven to be an unremarkable shift of power *within* both the predominantly White New York City Board of Education and the suburban public schools became a confrontation in which racial and ethnic discrimination and resentment forcefully exploded between the Board and the Ocean Hill–Brownsville community.[7]

Similarly, the conflict regarding how to represent the people of Harlem spurred a struggle between those who controlled the Met and the Harlem art community. Both the Board of Education/Ocean Hill–Brownsville and the Met/Harlem community struggles brought decades of class and ethnic resentment to the forefront. Both situations involved Black-Jewish conflicts. The Ocean Hill–Brownsville struggle contributed to the politicized context of the *Harlem on My Mind* exhibition. When plans for the exhibition were announced, the contention between Black and Jewish communities in the city was already at a peak.

Although it was peculiar for the Met to undertake an exhibition about the people of Harlem during this time, four factors contributed to the decision to create *Harlem on My Mind*. First, as mentioned in the epigraph of this chapter, the exhibition was conceived as an intervention into the growing cultural gap between Blacks and Whites. Through the exhibition, the Met attempted to be an ambassador of racial harmony. However, what was initially considered a politically savvy exhibition managed to offend

key political, racial, and ethnic factions. In itself, the goal of improving cross-cultural relationships through the arts was not uncommon in the middle of the twentieth century. In addition to the Harmon Foundation's efforts in this direction, documentary filmmakers had been using their medium to increase support for the education of Black Americans, especially for racial integration in the American South, and to promote White tolerance of Blacks.[8] In 1955, Edward Steichen, director of the Department of Photography at Museum of Modern Art, in curating the groundbreaking photography exhibition *The Family of Man,* intended to promote peace and present the commonalities among racial, ethnic, and religious groups internationally.[9] *Harlem on My Mind* followed in the path of these simplistic, if well-intentioned projects aimed at solving the "Negro problem."

Second, during the late 1960s, New York's social elite enjoyed the season of Radical Chic made famous by conservative cultural critic Tom Wolfe. Planned as an opportunity to bridge class, racial, and ethnic divisions, these high society parties hosted activists and leaders of organizations such as the Black Panther Party and La Causa that were treated unjustly by the United States government. The events raised money for the guest groups and served to relieve the guilt of the blue-blood New Yorkers that hosted them. In the private apartments of the wealthy, socialites would meet the exotic peoples they had only seen on television. Their meetings provided the opportunity for hosts to show their peers that they were "hip" to the struggle of the politically disenfranchised if not the FBI's most wanted.[10]

The crucial irony of this arrangement was the hosts' superficial understanding of the objectified group's oppression on one hand and the sincere desire to maintain an ostentatious lifestyle with their names in the press on the other. In order to sustain this delicate balance, Radical Chic had to avoid the direct connection between the two hands that would show how the wealth of the few is directly connected to the poverty of the many. The phenomenon of Radical Chic created a highly orchestrated arrangement for the wealthy to protect their social status while being moved by (but not enough to actually change) the struggles of the underclass. Civil rights leader Bayard Rustin was one of many Black Americans critical of Radical Chic, saying, "These people [the party hosts] are really saying 'You sic 'em, nigger Panthers. *You* bring about a revolution for us while we go on living our nice little jolly lives. You niggers do it. We'll be right behind you—at a considerable distance.'"[11] Dozens of these fundraising parties, which offered

the wealthy an opportunity to live vicariously through the *other,* took place in New York just minutes away from the Met. The museum's plan to mount *Harlem on My Mind* followed this social trend by extending the tantalizingly transgressive interracial event from Park Avenue to its own galleries at the top of the art world. Although the Met is situated on Manhattan's Upper East Side at Fifth Avenue and 82nd Street, less than two miles from Harlem's southern perimeter, it is light-years away from the socioeconomic reality of Harlem.

Third, under the command of Allon Schoener, director of the Visual Arts Program of the New York State Council on the Arts and director of the Met Museum's Exhibition Committee, and Thomas P. F. Hoving, recently hired director of the Met, the museum's new leadership hoped to mix current cultural issues with the traditions of the prestigious institution. Before Hoving joined the Met, he served as the Parks Commissioner and Administrator of Recreation and Cultural Affairs for New York City in the liberal administration of Republican Mayor John V. Lindsay. In that capacity he earned a reputation for nontraditional programs by, as a *Life* reporter put it, organizing "be-ins, love-ins, traffic-free bike ridings, Puerto Rican folk festivals, and happenings."[12] Hoving had become known as someone who could combine elements of tradition with contemporary topics.

To underscore the importance of curating *Harlem on My Mind* and to reinforce his decision to take a risk by presenting it, Hoving referred to the Met's Charter: "one of the stated missions of the museum is to relate art to practical life, and practical living to art We have this remarkable show because the city and the country need it. We put it on because this great cultural institution is indeed a crusading force attempting to enhance the quality of our life, and to support and buttress and confirm the deep and abiding importance of humanism."[13]

Though unrecognized by Hoving and Schoener, the need to go beyond the limits of humanism to understand the specific attributes of cultural struggle, values, and politics was most important for the cross-cultural success of *Harlem on My Mind*. Schoener organized a popular humanistic project instead of engaging in a reflective examination and understanding of the diversity of the community that he chose to represent.

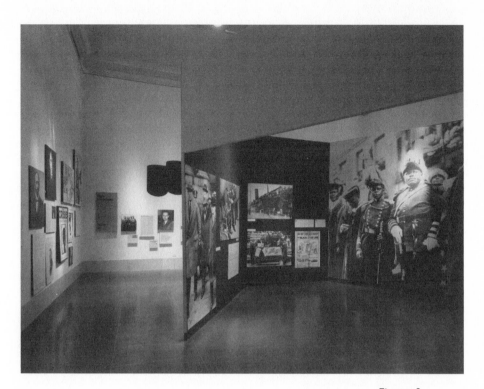

Figure 16.
"1920–1929: An Urban Black Culture,"
Harlem on My Mind: Cultural Capital of Black America, 1900–1968.
Gallery Installation: Photographed March 25, 1969; The Metropolitan Museum of Art.
Image © The Metropolitan Museum of Art.

Seeing Harlem through the Met

The exhibition consisted of thirteen galleries organized chronologically into thematic decade-long sections: "1900–1919: From White to Black Harlem"; "1920–1929: An Urban Black Culture"; "1930–1939: Depression and Hard Times"; "1940–1949: War, Hope, and Opportunity"; "1950–1959: Frustration and Ambivalence"; and "1960–1968: Militancy and Identity."[14]

Text panels marking the decades and thematic titles within each section hung from the gallery ceilings. Various wall layout designs were used throughout the galleries to display more than 2,000 photographs.[15] Some walls held large-scale black and white photomurals eighteen feet in height and of varying widths. Unframed mounted photographs and reproductions of ephemera such as covers of the NAACP's magazine *The Crisis,* and advertisements

59

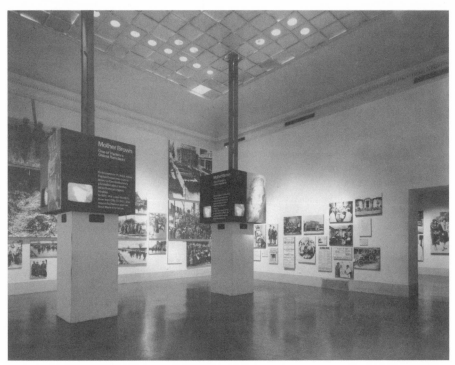

Figure 17.
"1900–1919: From White to Black Harlem," *Harlem on My Mind: Cultural Capital of Black America, 1900–1968.*
Gallery Installation: Photographed March 25, 1969; The Metropolitan Museum of Art.
Image © The Metropolitan Museum of Art.

for musical and dance performances, were arranged in horizontal lines and regular and irregular grid patterns from approximately six feet in height down to the floor molding (figure 16).

Some walls were used dramatically as dark screens for projected images of Harlemites and street scenes from slide projectors suspended from ceiling tracks. Four-sided columns displayed photographs of Harlem buildings, streets, and residents in both formal portraits and informal community scenes. Some columns, topped with large photo-text cubes, stood over ten feet high in selected galleries as if they were free-standing sculpture (figures 17 and 18). Several of these towers highlighted notable Harlem figures such as elder resident Alice Payton "Mother" Brown and Billie Holiday in their respective decade galleries.

Speakers, camouflaged in large cylinders, hung throughout the galleries, delivered Harlem street sounds and music to visitors (figures 16 and 19).

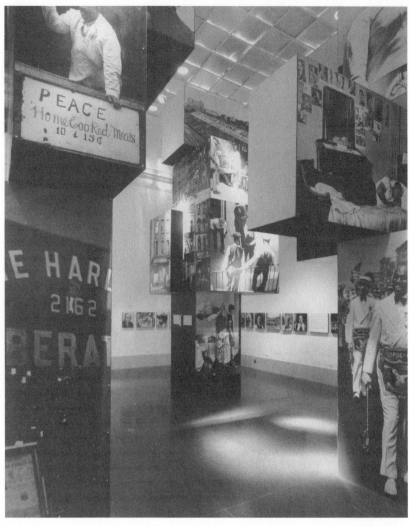

Figure 18.
"1930–1939: Depression and Hard Times,"
Harlem on My Mind: Cultural Capital of Black America, 1900–1968.
Gallery Installation: Photographed March 25, 1969; The Metropolitan Museum of Art.
Image © The Metropolitan Museum of Art.

Films and videos were interspersed through the galleries to provide further information, and a closed-circuit television showed the real-time activity at the intersection of Seventh Avenue and 125th Street in Harlem.[16] Photographs punctuated with text were suspended from the ceiling to create billboard-like visual timelines that marked important national events such as the 1954

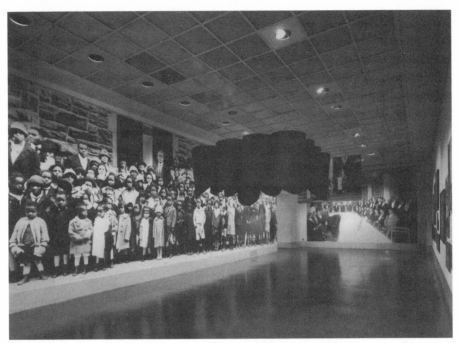

Figure 19.
"1900–1919: From White to Black Harlem,"
Harlem on My Mind: Cultural Capital of Black America, 1900–1968.
Gallery Installation: Photographed March 25, 1969; The Metropolitan Museum of Art.
Image © The Metropolitan Museum of Art.

Supreme Court ruling *Brown v. Board of Education* (figure 20). The exhibition was designed to provide a one-hour experience for each visitor.[17]

The *Harlem on My Mind* catalogue contains only a small percentage of the photographs and facsimiles of ephemera displayed in the exhibition. The catalogue does not provide a sense of the physical presence or spatial dimensions of the exhibition.[18] The pictures and texts printed in their respective decade-long sections were represented on the gallery walls and photo-text cubes in *Harlem on My Mind,* but their reproduction on the catalogue pages does not even hint at the production level of the exhibition. Instead of reprinting all of the photographs, ephemera, object labels, and interpretive texts peppered throughout the galleries, the catalogue contains newspaper articles about Harlem from mainstream and Harlem community newspapers and some photographs.

Hoving fulfilled his promise to offer a multimedia extravaganza in *Harlem on My Mind,* but critics from the Black and White presses agreed that this triumph of form was delivered at the expense of content. Art critics were disappointed,

Figure 20."1950–1959: Frustration and Ambivalence," *Harlem on My Mind:*
Cultural Capital of Black America, 1900–1968.
Gallery Installation: Photographed March 25, 1969; The Metropolitan Museum of Art.

calling *Harlem on My Mind* a sociology exhibit rather than the art exhibition that they had expected from the Met. Some wrote that the exhibition did not belong in an art museum, and therefore they were unqualified to review it. In his review of the exhibition, *New York Times* art critic John Canaday explained that the exhibition "presents a subject vastly complicated, easily subject to distortion, and just now so highly charged emotionally that to evaluate the show objectively is going to be impossible for most people." He went on:

> In its breadth and complexity the phenomenon of Harlem may be impossible of [*sic*] exposition in popular terms except as a picturesque surface or from an arbitrarily adopted point of view that will include this, exclude that, in order to develop a predetermined thesis. . . . I cannot see that an art critic has any business reviewing either [the book] or the exhibition unless he is also sure of himself as a sociologist, which lets me out.[19]

Exhibition reviewer Cathy Aldridge summarized her experience as a visitor for the *New York Amsterdam News:*

The subtle staging of the show created this boxed-in feeling—its stark white walls, its crisp black and white photographs most of which are life-sized. The few illustrious figures who were created as famous men and women in entertainment, jazz, and a few other fields do little to soften the effect. Without softness to alleviate the stark black and whiteness of the show the exhibit remains a stark semblance of a white man's view of a black section of the city which was created out of color prejudice. . . . It is a shame that such an opportunity did not create something of which all of New York can be proud. True, the photographs portray truth, but there are other truths which are missing from this exhibit.[20]

Another *New York Times* art critic, Grace Glueck, observed,

To this viewer, there is something terribly American about "Harlem." It panders to our penchant for instant history, packaged culture, the kind of photojournalistic "experience" that puts us at a distance from the experience itself. Instead of the full, rich, Harlem brew, it presents a freeze-dried Harlem that does not even hint at flavor.[21]

The exhibition's lack of artworks, combined with the simplistic presentation of Harlem, provided a disservice to Harlemites, the art world, and exhibition visitors. Contemporary voices from the Black press agreed that the exhibit did not reflect enough of Harlem life. In her *New York Amsterdam News* article "Exhibit on Everybody's Mind," Cathy Aldridge wrote, "A white man's view of Harlem can be objective, but when that objectivity is narrow in scope and shallow in depth what else could result but an unintelligent display of his so-called objectivity."[22]

The last and perhaps most influential factor leading to *Harlem on My Mind* was Schoener's previous exhibition curated for the Jewish Museum in New York in 1967. The goal of *Portal to America: The Lower East Side, 1870–1925* was to design an exhibition dedicated to the first American neighborhood for millions of immigrants. Schoener was a trained art historian specializing in twentieth-century environmental criticism. He had not had the opportunity to study the history of Jewish Americans and found the chance to explore his own heritage appealing.[23] *Portal to America* was a successful exhibition in terms of its critical reception, its local cultural relevance, and its appeal to New Yorkers. It was essentially the model for *Harlem on My Mind*. Both exhibitions addressed geographic spaces in New York City and primarily used photomurals of documentary images for the gallery walls. The catalogues for the two exhibitions share the same art director and designer, Harris Lewine

and Herb Lubalin, and appear to be nearly identical in format and concept.[24] The differences between the two exhibitions, however, caused the fundamental tensions that created contention. *Harlem on My Mind* explored sixty-eight years of history, bringing the discussion up to the year of the exhibition. *Portal to America* covered fifty-five years on the Lower East Side, ending in 1925. This difference in time periods posed a challenge, not only because *Harlem on My Mind* was larger and chronologically longer than *Portal to America,* but also because *Portal to America* relegated the discussion of the Jewish community safely to the past while *Harlem on My Mind* included an exploration of the contemporary community. The Met's first exhibition about the racial *other* presented an additional challenge, particularly during a volatile period of racial conflict between Black and Jewish communities.

The exclusion of art was a critical difference between *Portal to America* and *Harlem on My Mind.* Both exhibitions were multimedia presentations of photographs, sounds, and slide projections, but *Portal to America* included forty-eight lithographs, paintings, drawings, and one sculpture by artists either from the Lower East Side or depicting notable neighborhood figures and scenes. Although initial plans conceived *Harlem on My Mind* as "a multimedia exhibition on the history of Harlem, since 1900, using photographs, paintings, prints, drawings, films, television recordings of sounds and voices, music and memorabilia," later press coverage of the upcoming exhibition reflected the curatorial decision to omit paintings and prints.[25] These texts described the exhibition as a "multi-media exhibit," and a "sociohistorical communications environment" "not to be confused with an art show."[26]

To supplement the *Portal to America* exhibition catalogue, the Jewish Museum published a separate anthology of fifteen essays about the Lower East Side by writers who lived there or who testified to the profound effect that the neighborhood had had on their lives and on the larger culture beyond the neighborhood's geographic boundaries.[27] Included in this anthology were biographies of each artist whose work was in *Portal to America* and selected reproductions of artworks in the exhibition. There was no additional publication for *Harlem on My Mind* that could offer supplemental testimony about life in Harlem or commentary about its artwork or artists. Through the inclusion of artwork and the companion publication that gave writers the opportunity to pay tribute to and express the relevance of the Lower East Side, the *Portal to America* exhibition and catalogue pro-

vided a respectful and inclusive examination. Likewise, the Harlem artists believed that their artwork should have been privileged in an art museum exhibition about their community.

Getting Harlem Involved

Artist and author Romare Bearden made an "urgent request" to Hoving to meet about the accuracy of the exhibition regarding "serious questions relating both to the organization and the plans for presenting the artistic material in this important exhibit" by "a number of artists, photographers, and other interested persons."[28] In a letter to Schoener dated June 6, 1968, Bearden expressed concern about the lack of art in the exhibition saying, "importantly, I know the artists are not going to tolerate color transparencies of their work in an Art Museum. As I see it, the sort of show you are putting together should be in the Museum of the City of New York, The New York Historical Society, or some similar place."[29] In a symposium sponsored by the Met titled "The Black Artist in America," artist William T. Williams stated his thoughts about the exclusion of artwork from *Harlem on My Mind:* "One of the things that's happening is that every show that concerns Black artists is really a sociological show. The *Harlem on My Mind* show is a pointing example of total rejection on the part of the establishment, of saying 'Well, you're really not doing art,' or of not dealing with the artists that may exist or do exist in Harlem. These shows deal with the sociological aspects of a community, a historical thing."[30] The exclusion of artwork and an anthologized critical commentary sent a message from the Met that Harlem was a less serious subject for examination than the Lower East Side.

Although Schoener had included art in the Lower East Side exhibition, he stated that paintings would have "detracted from the kind of experience I wanted to create, and [I] decided to use only photographs in the Harlem exhibition."[31] Paintings would have testified to the artistic abilities of Black people and included their point of view. Uninterested in this kind of sophisticated contribution, Schoener chose instead to construct an exhibition that would re-create the way that he experienced Harlem on his mind from his position of privilege. In fact, the difference between Schoener's concept of Harlem and the way the people of Harlem wanted to be represented formed the great tension over *Harlem on My Mind.* This war over

cultural representation illuminated what was at stake for the Harlem community and for a larger community of Black Americans who were invested in how their story would be represented, packaged, and sold.

In an effort to appear inclusive, Schoener spent the summer of 1967 selecting members of a special staff to research exhibition content and plan the overall design of the galleries using the latest audiovisual technology. With the help of Jean Blackwell Hutson, curator of the Schomburg Center for Research in Black Culture at the New York Public Library in Harlem, Schoener assembled a three-person research-advisory committee consisting of Hutson, Regina Andrews, a board member of the National Urban League, and John Henrik Clarke, a political and cultural activist in Harlem. These three were residents of Harlem and their jobs involved the history and politics of their community.

In addition, Schoener organized a five-member research staff for the exhibition through the New York State Council on the Arts, including Robert Malone, exhibition designer, Reginald McGhee, director of photographic research, Donald Harper, associate researcher and media director, A'lelia Nelson, community research coordinator, and Martin S. Moskof, exhibition graphic designer. This staff worked in a satellite office housed in the Schomburg Center. Although McGhee, Harper, and Nelson were Black, none of the members of the research staff were from Harlem.[32] Because they were not residents, their selection drew criticism from the research-advisory committee and Harlem artists, who were increasingly interested in the exhibition planning.

Schoener also made a connection with the Harlem Cultural Council, comprised of several hundred members. Established in 1964 and led by executive director Edward K. Taylor, Jr., the Harlem Cultural Council was a prominent Black advocacy group that had sponsored a major survey of African American art in 1966.[33] Schoener made Taylor a member of the executive board of the Community Advisory Committee.[34]

Although the members of Schoener's Harlem committees took their positions seriously, they were not allowed to have a say in the planning of the exhibition. Frustrated by their lack of influence, the research-advisory committee and the Harlem Cultural Council withdrew their support on November 22, 1968. The Harlem Cultural Council stated that there was a "breakdown in communication" between the council and the museum. Taylor openly complained, "The Met came to us with elaborate promises of community involvement in the show. But they haven't really begun to consult us. We're expected

simply to be rubber stamps and window dressing."[35] In an August 28, 1968, letter to Romare Bearden, John Henrik Clarke reported the poor treatment he was receiving from the exhibition organizers: "Right now I don't know where the project, 'Harlem on My Mind' is going and I am not encouraged by some of the late developments relative to it. The basis of the trouble with this project is that it never belonged to us and while alot of people listened to our suggestions about the project. [sic] Very few of these suggestions were ever put into effect."[36] Upset by the exhibition planning, Clarke said that the research-advisory committee's suggestions that *Harlem on My Mind* "be more culturally oriented" had been bypassed for a stress on "entertainment." He stated, "It could be a magnificent show, but the emphasis is more on show biz techniques than on content. It's what I call cutesie-pie-ism."[37] Hoving protested the withdrawal of Harlem support, saying, "Our staff of black and white specialists has worked closely with various organizations in Harlem. This show has incomparable potential. Too much is at stake for any particular group, no matter how dedicated it is, not to be involved."[38] Despite his immediate defensiveness, Schoener later admitted that his approach to winning the approval of Harlem through his administrative committees was superficial and that he never intended to seriously consider what contributions they could make.[39]

Further controversy around the exhibition stemmed from anti-Semitic remarks published in the exhibition catalogue. Hoving sought to include comment on the cultural content of *Harlem on My Mind* and the current Black and Jewish tensions in New York by printing in the catalogue a term paper written by Candice Van Ellison, a Harlem resident and a recent graduate of Theodore Roosevelt High School in the Bronx who had served as an intern at the New York Council on the Arts through its "Ghetto Arts Corps" program. She came to the attention of McGhee, who gave her term paper to Schoener. Inspired by her insight, Schoener asked Van Ellison to omit the footnotes and quotations so that the essay would be less academic and be written in her own words.[40] Schoener wanted the introduction to serve as commentary from "an ordinary citizen, a true representative of the people."[41]

In the essay, Van Ellison discussed the relationship between Black, Irish, Jewish, and Puerto Rican communities in New York. She states in one of her now infamous passages:

It is true that only a small portion of Harlem's population is Irish, yet a strong Irish influence is exerted on Harlem through the city's police force. As early as 1900, when the city's main poverty concentration was in the Tenderloin,

a bloody three-day riot was sparked when an Afro-American named Arthur Harris knifed and killed an Irish policeman who was manhandling his girl. This incident was just the spark needed to set off the already strained Irish–Afro-American relations. The numerous tales of police brutality in the riot ranged from policemen merely looking the other way while mobs attacked Blacks, to the arresting of Negroes and beating them senseless inside the precinct. . . . Anti-Jewish feeling is a natural result of the black Northern migration. Afro-Americans in Northeastern industrial cities are constantly coming in contact with Jews. Pouring into lower-income areas in the city, the Afro-American pushes out the Jew. Behind every hurdle that the Afro-American has yet to jump stands the Jew who has already cleared it. Jewish shopkeepers are the only remaining "survivors" in the expanding Black ghettoes. This is especially true in Harlem, where almost all of the high-priced delicatessens or other small food stores are run by Jews. The lack of competition in this area allows the already badly exploited Black to be further exploited by Jews. . . . One other important factor worth noting is that, psychologically, Blacks may find anti-Jewish sentiments place them for once, within a majority. Thus, our contempt for the Jew makes us feel more completely American in sharing a national prejudice.[42]

In the week before the exhibition opened, word spread quickly about the content of Van Ellison's essay, and there was an immediate uproar. On January 17, 1969, Mayor Lindsay called the catalogue racist and requested that it no longer be sold.[43] On January 18, Dore Schary, the president of the Anti-Defamation League, said the catalogue was "something akin to the worst hatred ever spewed out by the Nazis."[44] The Jewish Defense League and the American Jewish Congress followed in the condemnation of the book. Schoener defended the catalogue and denied that the introduction was racist. Though the essay embarrassed him, Hoving also stood by Van Ellison, saying, "It is her personal observation on life in her block. It is not inflammatory. It is the truth. If the truth hurts, so be it."[45]

Responding to public criticism, Hoving also ordered that an insert be placed in the introduction of all the copies of the exhibition catalogue disclaiming the racist content of Van Ellison's essay. The disclaimer was to be written by Van Ellison to deny any racist intent, but in a 1993 interview, Schoener disclosed that the disclaimer was written through a series of telephone conversations between Van Ellison and Bernard Botein, chairman of the Special Committee on Revival and Religious Prejudice of New York.[46] Hoving maintained that Van Ellison wrote the insert, which read:

In regards to the controversy concerning the section in my introduction dealing with intergroup relations, I would like to state that the facts were organized

according to the socio-economic realities of Harlem at the time, and that any racist overtones which were inferred from the passages quoted out of context are regrettable.[47]

Unconvinced that she had done anything wrong, Van Ellison had hardly written an apology. Random House inserted its own apology for the essay in copies of the hardcover edition of the catalogue.

The New York City Council threatened to withhold city funds from the Met unless it stopped selling the catalogue. On February 7, the museum stopped catalogue sales, but the catalogue was still available in retail bookstores.[48] The same day, plans were made to discuss the controversies over the catalogue and the exclusion of the Harlem community in the planning of the exhibition. Students at Columbia University announced a roundtable discussion about *Harlem on My Mind* with a group of speakers that included Jean Hutson from the Research-Advisory Committee; Henri Ghent, Harlem artist and Community Division Director of the Brooklyn Museum; photographer Roy DeCarava; Edwin Henry, Director of the Tutorial Program at the Academy for Black and Latin Education; and Richard E. Whittemore, chairman of the Social Studies Department at Teachers College.[49]

Van Ellison was the only Harlem resident who was asked to contribute to the catalogue. There was no other perspective from a historian, art historian, sociologist, or other scholar from Harlem who might have made a relevant contribution. The other texts in the catalogue were the preface, by Hoving, and the editor's foreword, by Schoener.[50] The uproar over the catalogue comments was discussed in the mainstream media through letters to the editor of the *New York Times* and WBAI New York City radio programs.[51] Certainly a more thoughtfully considered choice of catalogue texts, perhaps following the *Portal to America* model, would have provided more support for the goal of bridging the racial gap through *Harlem on My Mind*.

Harlem artists maintained that the inclusion of artwork could have provided museum visitors a richer and more accurate experience of Harlem.[52] Instead of stating that he intentionally excluded artwork from the exhibition, Schoener considered his own vision of Harlem as a work of art. He explained, "For me, people create art; therefore, it was legitimate to create an exhibition in an art museum which dealt with people."[53] Affirming his earlier statement that the inclusion of artwork would have detracted from the experience he wanted to create, Schoener takes his place as the author who speaks the exhibition's title. It is Harlem on Schoener's mind that was

displayed in the galleries. Though cultural context is an important element in representing art in an art museum, in this equation the art is excluded and the exhibition of people becomes the work of art. The ethnographic turn toward African American culture in the art museum comes into focus through this exhibition. Similarly, in the exhibition press release Hoving called the neighborhood of Harlem a work of art by making an analogy between *Harlem on My Mind* and other exhibitions that the museum would mount: "There is no difference between this show and one of Rembrandt or Degas. Through their works, these artists reveal their individual worlds to us. The Harlem community becomes the artist in this case, the canvas the total environment in which Harlem's history was formed."[54]

As if they were unable to represent themselves, Harlem residents were interpreted through the Met and packaged as a cultural object. By considering all people of Harlem as artists, and the geographic space of Harlem as an artwork, the exhibition prohibited any sense of diversity within the Harlem community. In this way, the question of artistic production from Harlem was precluded, overdetermined by the Met as place.

In his book *The Predicament of Culture,* James Clifford addresses the divide between art and culture in the American art museum. Clifford discusses the art–culture relationship as a system in which art is defined as original and singular, and culture is defined as traditional and collective.[55] Schoener perceived Harlem as a cultural collective. This definition conflicted with the possibility of an art world as defined by Eurocentric standards. To recognize art made by Black people would have interfered with Schoener's collective view by acknowledging living people and individual artists with original visions and expressions. In short, the Harlem individual as artist would have disturbed the symbolic value of Blackness needed to reinscribe the Met's Whiteness. This investment in Whiteness defined the museum's identity as privileged, racially pure, and therefore entitled to define what art could and could not be along aesthetic and cultural lines. Eliminating art from the Harlem community confirmed a hierarchy of cultural production in the art world.

By omitting the art of Black Americans the Met defined their production as non-art. Racial difference was constructed in the galleries as ethnography and the people of Harlem as a collective cultural specimen. The chosen representations of Harlem presented the community as cultural capital, an objectified place, but not a living culture in itself.

The Black Emergency Cultural Coalition

In 1968, two well-established and respected Black artists, Romare Bearden and Norman Lewis, met with Schoener to express their dissatisfaction with the multimedia format of the exhibition, particularly with the concept of using photographs as the primary means of representation. Bearden and Lewis were founding members of the artist group Spiral, formed in 1963 to discuss the potential of Black artists to engage with issues of racial equality and struggle in the 1960s through their work.[56] The exclusion of art from *Harlem on My Mind* was a concern for members of Spiral as an issue of racial inequality and lack of self-representation in the art world. Bearden and Lewis argued that if the Met wanted to open its doors to Harlem, Black artists should be included.[57] Dismissing their position, Schoener replied that he was creating a documentary exhibition without original works of art.[58] That same year, Bearden wrote a letter to Schoener that definitively stated his position on the state of the exhibition planning: "As I have told you there are several things that the community is just not going to accept, and rather than completely antagonize people, it might actually be best to phase the show out, or else start immediately to work in the interests of the kind of show the community as a whole would want."[59] To no avail, the artists, Schoener, and his staff met several times to find a common ground for Black representation in *Harlem on My Mind*. At the end of November 1968, Bearden, Hutson, and Harlem-based artist Benny Andrews organized a demonstration against the exhibition. Unfazed by their protests, Schoener continued his project of cultural definition through display. Equally determined, the Harlem artist community continued their struggle for representation at the Met. After months of discussions with the museum's administrators, Andrews formed the Black Emergency Cultural Coalition (B.E.C.C.) in his studio on January 9, 1969, specifically for the purpose of protesting *Harlem on My Mind*.[60] Three days later he described in his journal the first B.E.C.C. demonstration against the exhibition.

> At 1:00 p.m. we started our demonstration at the Metropolitan against the "Harlem on My Mind" show. The police were waiting for us with barricades and very stern looks. A line of the Museum's staff were right inside the Museum with their noses pressed against the glass doors peering out at us. We formed a long oval line and started to walk slowly around and around the police barricades with our placards denouncing the exhibition. The passing pedestrians and street traffic practically came to a halt when they spotted this small slow

line of Black people in front of this massive, angry, forbidding, endless façade of the Metropolitan Museum of Art.[61]

Some of the interracial group had attended the meeting at Andrews's studio, some joined after hearing about the meeting, and others joined spontaneously off the street.[62] Members of the B.E.C.C. wore sandwich boards and carried picket signs that read, "Tricky Tom at it Again?", "That's White of Hoving!", "Harlem on whose mind?", "Whose image of whom?", "On the Auction Block Again—Sold Out by Massa Hoving," and "Visit the Metropolitan Museum of Photography."[63] The B.E.C.C. distributed leaflets in front of the museum, some with the headings "Soul's Been Sold Again!!!" and "Harlem on Whose Mind?"

The B.E.C.C.'s questions displayed in protest demanded answers. The B.E.C.C. agreed with Schoener, that it was his vision of Harlem that was on view in the Met's galleries. However, as one of the museum's directors and spokespersons for the exhibition, Hoving was the target of criticism as well. The exhibition displayed Harlem on the museum directors' minds, not on the mind of the Harlem art community. The B.E.C.C. wanted to articulate the significant difference they saw between the museum's representations of Harlem and their own rejected efforts to include their perspectives through self-representation.

The problems that aroused the protest of the Harlem art community were both political and aesthetic. The B.E.C.C. called Hoving out as "White" and "Massa," emphasizing that contemporary unequal power relationships between Blacks and Whites echo those of slavery. Similarly the reference to selling soul hearkens back to the auction block where White planters bought Black labor for White economic gain. The references are clear and direct: the B.E.C.C. criticized their treatment by the museum as a continuation of a racist patriarchal hegemonic system of White control. The organization's protest material addressed its issue of the aesthetic conflict within the exhibition by highlighting the difference between photography and art. The B.E.C.C. condemned the museum for working outside of the realm of its own self-defined formal boundaries by referring to the Met as a museum of photography rather than a museum of art.

The flyers also included a critique:

> One would certainly imagine that an art museum would be interested in the world of Harlem's painters and sculptors. Instead, we are offered an audio-visual display comparable to those installed in hotel lobbies during conventions.

> If art represents the very soul of a people, then this rejection of the Black
> painter and sculptor is the most insidious segregation of all.[64]

The B.E.C.C. charged the Met with presenting a "more squalid, seamy side of life in Harlem" and accused the museum of giving up art for social science. B.E.C.C. members demanded a change in the structure of the museum. They wanted Black people to be a part of the daily business of the Met as staff members in hopes that integration within the museum would solve the problem of exclusion of Black artists.[65] The coalition presented a list of demands including the "appointment of Black people on a curatorial level and in all other policy-making areas of the museum." They also challenged the museum to "seek a more viable relationship with the Total Black Community." The leaflets called for a boycott of the exhibition and extended an open invitation for anyone to join the demonstration.[66]

On January 18, Hoving announced that the museum was developing plans for an exhibition of contemporary Black art in February. He expected that a second exhibition of contemporary Black painting and art would follow shortly after the first.[67] This statement was powerful enough to stop the B.E.C.C. from demonstrating. Schoener began plans for an exhibition of works by Black artists soon after meeting with Bearden and Lewis in 1968. The initial plan was for it to serve as a supplement to *Harlem on My Mind* and run concurrently with it. The Met selected James Sneed, director of the Harlem Art Gallery, to organize the exhibition, but planning ended because the Harlem artists and the Met could not agree on Sneed's exhibition proposal. Schoener explained, "The show never took place. This failure demonstrated the Met's lack of commitment to that request. The exhibition's cancellation left in its wake a sense of distrust on the part of the artists in Harlem who should have been our logical allies."[68] Expectation of collaboration was at the heart of Harlem artists' protest. The painter Richard Mayhew, a member of Spiral and one of the artists who protested *Harlem on My Mind,* continues today to express his dissatisfaction with the way the exhibition organizers handled the artists:

> The B.E.C.C. was more active than Spiral in terms of actually picketing and
> challenging the museum at the time. Spiral, Bearden and Charles Alston,
> wanted to do it more in a letter form, and in some other ways, making contact
> with the museum directly and having meetings with them. Many of the meet-
> ings never happened. The picketing came about as more of a radical group.
> Benny Andrews and myself and other people, art historians were involved in

that group. So we picketed and we challenged to have meetings with them and they refused to have that. The people at the museum never encouraged meetings or encouraged us to do this. It was always a sense of denial and omission. No direct contact.[69]

Photography, Art, and Hoving's Harlem

Despite protests against the Met, thousands of people went to see *Harlem on My Mind*. Ten thousand visited the exhibition on opening day, double the number of visitors on past opening days. An estimated 1,500 of those visitors were Black, six to seven times the average daily number of Black visitors to the museum, attesting to the desire of Blacks to see themselves in American institutions and to support institutions that recognize them even if *Harlem on My Mind* dealt superficially with Harlem and Black America.[70] For example, the gallery space dedicated to 1950–1959 displayed representations of Malcolm X on one side and Martin Luther King, Jr. on the other in a dichotomous relationship.[71] Historian Eugene D. Genovese pointedly addressed this issue in his exhibition review: "The exhibit immediately involved political decisions: Should you emphasize the early or the late Malcolm? Malcolm the uncompromising Black Nationalist or Malcolm the man who ended his life edging toward a new position? The exhibit settles these questions in a manner that will not be to everyone's taste, but the real problem lies elsewhere: Who is making the decision to interpret Malcolm?"[72] Just four years after his death, the question of how to represent Malcolm X as a part of Harlem needed careful consideration, especially by Schoener and Hoving, who had no previous experience with those kinds of cultural politics in museums.[73]

Most of the selected photographs of Malcolm X and Black Muslims were taken by Harlem photographer Lloyd Yearwood, who has made his name as a photographer of Black spiritual communities with a specific focus on the activities of Black Muslims.[74] In 1968 Yearwood responded to a newspaper ad placed by the Met that called for work by Harlem photographers.[75] He recalls his visit to the museum to show his photographs: "They had the show laid out on boards. There was nothing on the 1960s. Nothing on Malcolm X. They rearranged the whole board to make room for my photographs. I brought 277 prints and forty-six contact sheets. The Met kept fifty-seven prints and all contact sheets."[76]

The Met selected several of Yearwood's photographs of Black Muslim

Figure 21.
"1960–1968: Militancy and Identity" exhibition gallery in *Harlem on My Mind* (1969).
Lloyd Yearwood, photographer. Yearwood photographs on display (c. 1959–1960).
Clockwise from left to right: *Malcolm X in Harlem, Muslim Women I,*
Muslim Women II, and *Muslim Brothers.*

activities including images of Malcolm X for the 1950s and 1960s sections of the exhibition (figures 20–21). The contrast between King and Malcolm X in the galleries was not inherent in Yearwood's photographs but contrived by Schoener. Representing Malcolm X and King as binary ideologies was an easy way for the museum to avoid examining the complexities of the lives of both men and their contributions to politics, philosophy, and strategies for survival on an international and local level. A closer look at Yearwood's photographs should have suggested ways of representing the Civil Rights Movement in Harlem beyond the misperception of an oppositional relationship between the two leaders.

It is probable that Schoener and his staff chose documentary photographs as the primary medium because they believed that it would make the exhibition appear to be objective. In the 1960s, the status of photography as art was acceptable in some art circles, but not in an established receptacle of great "masterpieces" of European painting, sculpture, and decorative arts.

Ironically, some of the Black photographers whose work was included in the exhibition are now considered exceptional artists. Most notable are two giants in American photography, Gordon Parks and James VanDerZee. Although in 1969 their images were not considered art by the standards of the Met or the Black artists who protested the exhibition, they were highly esteemed by their peers as outstanding photographers.[77] In the cultural moment, the use of photographs in the exhibition and the combination of photography and newspaper articles in the catalogue were thought to support the museum's position as an apolitical institution. Regardless of its rejection of photography as art, the Met was implicated in the "objective" perspectives it chose for the exhibition. Yearwood is proud of his inclusion in *Harlem on My Mind* and regards the experience of seeing his work and name on the walls of the Met galleries as a highlight of his professional career.

Similarly, for James VanDerZee *Harlem on My Mind* was the pivotal event of his career. While looking for photographs of Harlem life in December 1967, McGhee happened upon VanDerZee's photography studio window. When he entered, he found the wealth of photographs that VanDerZee had created since the 1910s. In an interview, VanDerZee revealed that had he known that *Harlem on My Mind* was not "just another advertising stunt," he would have given "a much better selection" of photographs to the exhibition.[78] The exposure that VanDerZee received from the exhibition led to a number of awards, honorary doctorates, one-man exhibitions, and publications. As a result of his "discovery" of VanDerZee's work and the subsequent display of that work in *Harlem on My Mind*, McGhee co-founded the James VanDerZee Institute in 1969 and in 1970 the Met acquired sixty-six of VanDerZee's photographs as a gift from the Institute.[79] The Institute was housed in the Met for a brief time before merging with the Studio Museum of Harlem in 1978.

The opportunity to see Black faces on the gallery walls of the Met made an incredible impression on many Black visitors. A young generation of Black visitors, initially unaware of the controversy surrounding the exhibition, was greatly influenced by the *Harlem on My Mind* experience. Deborah Willis, who went on to become the nation's premiere photo-historian of African American images in the United States, was one of these young visitors who has mentioned the exhibition as an influential moment in her life.[80]

Unlike Yearwood and VanDerZee, photographer Roy DeCarava, who was included in *The Family of Man* exhibition and had published his own photographs about Harlem with Langston Hughes in *The Sweet Flypaper of Life*

(1955), refused the Met's invitation to be included in *Harlem on My Mind.* DeCarava opposed the presumption of Schoener and Hoving in staking a claim to Harlem. He declined participation in the exhibition, explaining, "It is evident from the physical makeup of the show that Schoener and company have no respect for or understanding of photography, or, for that matter, any of the other media that they employed. I would say also that they have no great love or understanding for Harlem, black people, or history."[81]

In *The Family of Man,* DeCarava was exhibited as the equal of established photographers such as Ansel Adams, Henri Cartier-Bresson, and Robert Frank. (He was also treated with respect at MoMA, having been eagerly befriended by Steichen in 1947 and quickly added to MoMA's permanent collection in 1950.)[82] In *The Family of Man,* the work of Black artists such as DeCarava and Gordon Parks comprised part of an international collection of images that sought, though problematically, to find the commonality between peoples. The artists were conscripted into a nationalistic project as representatives of America.[83] DeCarava found this role more respectful than allowing his work to be used as illustrations for Schoener's vision of Harlem. Schoener's dismissive manner of working with the Harlem community further influenced DeCarava's decision to decline participation in the exhibition.

The presentation of images by photographers who were mostly outsiders to the Harlem community raised old issues of scholarly representation through patronizing anthropological study. This was substantiated by Hoving's preface to the exhibition catalogue, which established the idea of Harlem as a dangerous place where Whites would go seeking adventure. "My mother went to Harlem from time to time. To the clubs, carrying the delightful sense of slumming and far-off danger, a titillation of the perilous possibility that never came to pass. . . . Negroes, as human beings, did not exist in any real sense when I was eight, nine, ten, eleven. And they didn't really exist as far as my parents were concerned."[84]

Although Hoving wrote about the differences between Black and White people in the past tense, his preface clearly enunciated an attitude about Harlem and Black Americans that still existed. His mother's slumming served as Hoving's introduction to Harlem and certainly influenced his understanding of the community. The Met's approach to Harlem's cultural offerings, like thrill-seekers slumming during the Harlem Renaissance, allowed White people to keep a privileged distance as outsiders looking in.

Plate 1.
Jacob Lawrence, *The Life of Toussaint L'Ouverture* (1938).
Panel #7: As a child, Toussaint heard the twang of the
planter's whip and saw blood stream from the bodies of slaves.

Amistad Research Center at Tulane University, New Orleans.

Plate 2.
Charles White, *Seed of Love* (1969).
© Copyright. Black ink. Sheet: 51 x 36 in. (129.54 x 91.44 cm).
Museum Acquisitions Fund (M.71.9).
Los Angeles County Museum of Art, Los Angeles.
Digital Image © 2009 Museum Associates/LACMA Art Resource, NY.

Plate 3.
Timothy E. Washington, *One Nation Under God* (1970).

Plate 4.
John James Audubon, *Virginian Partridge* (1830).

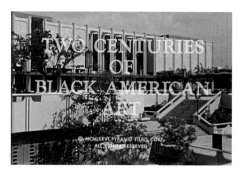

Plate 5.
Title still from the film *Two Centuries of Black American Art* (Director: Carlton Moss, 1976).

Plate 6.
Still of David Driskell and Rex Stead in LACMA office from the film *Two Centuries of Black American Art* (Director: Carlton Moss, 1976).

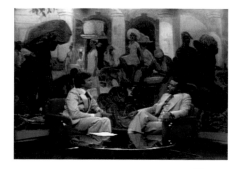

Plate 7.
David Driskell and Tom Brokaw in conversation about *Two Centuries of Black American Art* on *The Today Show*.

Plate 8.
Tom Brokaw on *The Today Show* discussing *Two Centuries of Black American Art* in front of an enlarged reproduction of *Haitian Market* (1950) by William E. Scott.

Plate 9.
Fred Wilson, *Guarded View* (1991),
wood, paint, steel, and fabric, dimensions variable.

© Fred Wilson, courtesy The Pace Gallery.

Plate 10.
Lyle Ashton Harris, *Constructs,* 1989.
Installation view, *Black Male: Representations of Masculinity in
Contemporary Art*, November 10, 2004—March 5, 2005.
Whitney Museum of American Art, New York.

Courtesy of Lyle Ashton Harris and CRG Gallery.

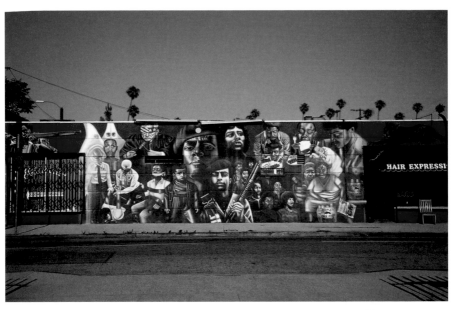

Plate 11.
Noni Olabisi, *To Protect and Serve* (1994).
© SPARC Neighborhood Pride Mural Program.

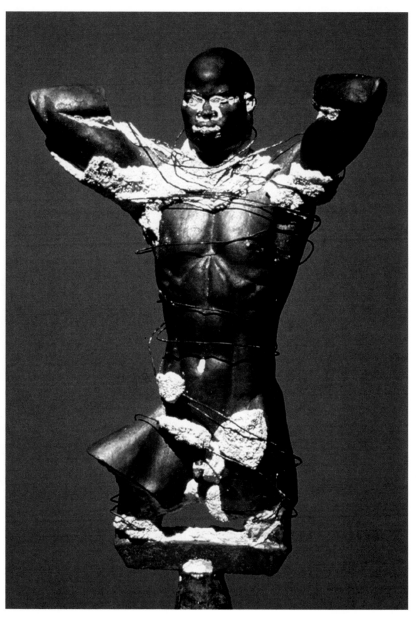

Plate 12.
Artis Lane, *Emerging New Man Fragment* (1993),
bronze, ceramic shell, resin, 22.5 x 13 x 6".

Courtesy of Artis Lane. www.artislane.com.

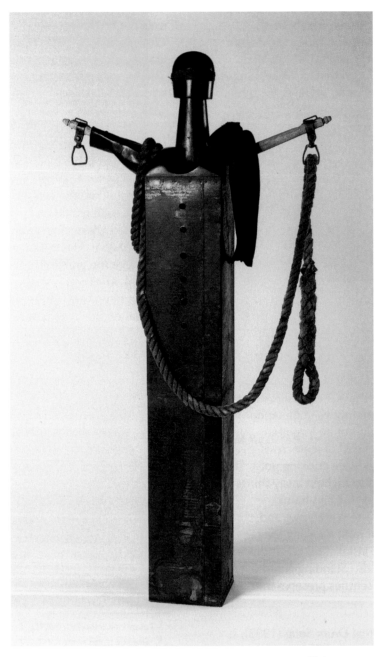

Plate 13.
John Outterbridge, *In Search of the Missing Mule* (in progress) (1993).

Courtesy of John Outterbridge.

In his preface to the catalogue, Hoving elaborates on his personal relationship to Harlem by writing about what Harlem meant to him as a child.

> Times change, bodies change, minds change. When I grew up in New York and when I was a boy of eight, nine, ten, eleven, twelve, there was a Harlem. And Harlem was with me and my family—a wonderful maid of sunny disposition and a thin, sour chauffeur who drove me to school in moody silence.
>
> To me and my family, living on 84th and Park Avenue, Harlem was a light-year away, uptown. And that was good. For behind the vague misty thoughts concerning *other people* that came through members of my family down to me, Negroes—colored people—constituted an unspoken menace, the tribe that must not be allowed to come down the Avenue.

Later in the preface, Hoving again refers to the maid as he wondered why his chauffer was "sour," asking, "Why can't he be like Bessie the maid?" To make matters worse, it turns out that Hoving created Bessie for the preface. He states in his memoir that he thought about omitting the fiction, but Schoener encouraged him to leave the essay the way it was, "saying that he liked the confessional tone and especially the part about the maid and the family chauffeur."[85] The fictional Bessie served to complete the picture of Hoving's privileged upbringing by having a mammy at his service. His racial and class-based fantasy expressed Hoving's ideal relationship to Harlem, which may have influenced his decision not to participate in meaningful communication with real Black Harlemites.[86]

The New Black Show

Still, in the face of an enormous challenge, Harlem's visual arts community refused to be ignored. Members of Spiral, the B.E.C.C., the Harlem Cultural Council, and the artists' group Weusi contested the omission of Black artists in different and sometimes overlapping ways.[87] Although protesting en masse, the B.E.C.C., Spiral, and Weusi picketed the exhibition as separate groups representing multi-generational attacks from different factions of the Harlem art community.[88] The Harlem Cultural Council protested by withdrawing their support of the exhibition. Members from all three artists' groups worked with the Research Committee of African American Art to plan a supplementary exhibit to *Harlem on My Mind* at the Met, which was not realized.[89] As an

established artist and co-founder of Spiral, Bearden sought to talk with Hoving and offered members of Spiral as consultants for *Harlem on My Mind*.[90] Members of Spiral and the B.E.C.C. protested by developing strategic plans for formal meetings with museum administrators, along with public demonstrations to ensure that they would be heard and seen. Benny Andrews recalls an incident at the preview reception for the exhibition during which he sought to discuss with Hoving "how this whole idea of an exhibition pertaining to the black mean [*sic*] seems to have already gotten off on the wrong foot."[91] He was told by a staff member that he would be contacted to set up an opportunity to speak, but he never was. After the demonstrations against *Harlem on My Mind*, the B.E.C.C. formed an executive board of artists and a three-person committee headed by Andrews, Henri Ghent, and John Sadler. Their goals included serving as "a watchdog group of the black community in the graphic arts" and continuing to "carry on the fight against racism in the cultural area of American society."[92] Already established as an activist group in response to the Met, the B.E.C.C. turned to another mainstream institution, the Whitney Museum of American Art, to address the exclusion of Black artists in their exhibitions. This attack on multiple fronts made the B.E.C.C. highly visible and brought attention to the exclusion of Black artists from mainstream museums and the determination for Black representation in its place.

On April 24, 1969, the coalition met with Whitney director John I. H. Baur and other administrators of the museum to discuss its professed commitment to representing artists of all races. The meeting was prompted by the Whitney exhibition *The 1930's: Painting and Sculpture in America* (October 15–December 1, 1968) just before the opening of *Harlem on My Mind*. The exclusion of Black artists at the Whitney inspired as a response the exhibition at the Studio Museum in Harlem, *Invisible Americans: Black Artists of the 30's,* curated by Henri Ghent, and the B.E.C.C. followed up with the Whitney about their exclusionary exhibition practices. In an article about the B.E.C.C. meeting with the Whitney administration Andrews reported that the Whitney staff agreed to the following five demands:

1. Stage a major exhibition of "Black Art Works,"
2. Establish a fund to buy more works by black artists.
3. Show at least five annual one man exhibitions, in the small gallery off the lobby, of black artists.
4. Have more black artists represented in the "Whitney Annual."
5. Consult with black art experts.[93]

Though not satisfied with the progress toward inclusion at the Whitney at the time the article was published, Andrews was quite pleased with the performance of the coalition at the meeting: "The B.E.C.C. set out in the talks with the Whitney Museum to show that we could sit down with 'them' and deal in measured tones with the inequities accorded the black man in this society—and dammit we did. . . . We left no promises, and made no requests, but we know we'll be back to the Whitney Museum of Art some-day—as painters and sculptors, we hope; not as stand-in curators and vocal spokesmen for the black man."[94]

In claiming this as a victory for Black men, Andrews ignored the exclusion of Black women from the mainstream art museum. The sexism of Andrews's statement was typical of the Black Arts Movement, which was often split along gender lines.[95]

After meeting with staff at the Whitney, the B.E.C.C. met with representatives from MoMA to discuss the exclusion of Black artists in a memorial exhibition for Dr. Martin Luther King, Jr., and they approached the Met again. During the rest of 1969, the coalition met with the Whitney staff to try to negotiate an agreement to their demands, but the two groups did not reach a compromise. In April 1971, Whitney curator Robert Doty organized the exhibition *Contemporary Black Art in America* (April 6–May 16, 1971), which included 58 Black men and women artists. Ten works from the exhibition were bought during and shortly after the exhibition. Because their demands were not met, however, the B.E.C.C. led protests against the Whitney during the exhibition.[96]

Owing in part to the efforts of the B.E.C.C, the Boston Museum of Fine Arts opened the exhibition *Afro-American Artists: New York and Boston* (May 19–June 23, 1970). Edmund B. Gaither, curator of the exhibition and director of the Elmer Lewis Art School, also attributed the exhibition to the phenomenon of *Harlem on My Mind*.[97] Gaither aligned *Afro-American Artists* with a group of exhibitions focused on Black artists that he called examples of the "new black show." According to Gaither, the new black show differed from previous exhibitions of work by Black artists because it served as "a valuable educational and cultural experience for both black and white viewers and artists." New black shows were exhibited in major museums and universities instead of community meeting places such as churches, YWCAs, and schools. New black shows were a result of the pressures from Black arts organizations on mainstream art institutions to exhibit work by Black artists. Gaither stated

that because Black artists, curators, and scholars worked together, they were able to produce exhibitions that presented remarkable expressions of Black culture. The emergence of the "new black show" helped establish the significance of what Black artists and curators were trying to do. Gaither's exhibition proved the significance of Black creativity outside the geographic borders of New York. *Afro-American Artists: New York and Boston* responded to *Harlem on My Mind* not only to confirm that the Met had ignored the relevance of the visual arts in its own city, but also to demonstrate that Harlem artists were just a part of a larger nation of visual artists on the scene.

Gaither defined the function of the new black show for the 1970s: "It begins to meet the need for real involvement between the black community and the professional art world. It begins to attack the ignorance which still clouds the culture of black people. It provokes people, black and white, to look, and it precipitates benefits for the artists."[98]

What made the "new black show" new was its break from the past struggles and misrepresentation with White mainstream museums. The conceptualization of what Black shows could be was based on the kind of mistakes made with *Harlem on My Mind* and the response to cultural misrepresentation by the B.E.C.C., the first organization of its kind. The coalition's protest, criticism, and determination to infiltrate mainstream art museums contributed powerfully to the Black Arts Movement, making it effective from multiple positions. Instead of positing a specific Black aesthetic, the B.E.C.C. pushed for the acknowledgment of Black artists, their visibility within White mainstream museums, and the accessibility of artwork by Black artists within Black communities. They contributed along with Black writers and poets of the Black Arts Movement who articulated their connection with Africa and their unique vision in the United States. Black curators and artists forged a space for art by Black artists to be seen. The influence of their actions went beyond the context of the Met and the example of *Harlem on My Mind,* providing a model for institutional critique and activism in the American art world.

The Legacy of *Harlem on My Mind*

In his discussion of the exhibition, Steven C. Dubin ultimately gives credit to the Met for making a great contribution to American museums through

Harlem on My Mind when he writes, "Even minus the direct experience of the 'electronic museum theatre,' it is difficult to deny the importance of the achievement of *Harlem on My Mind*. In the final analysis, for all the exhibition's flaws or naïve miscalculations, the catalog's dedication, 'To the people of Harlem—past, present and future—as a record of their achievements,' is a sincere reflection of what's contained inside."[99]

I agree with Dubin that the exhibition was important. However, in my final analysis, the credit for the significance of *Harlem on My Mind* is due to the community activism leading to African American self-representation, visibility, and recognition in the mainstream art world. Instead of applause for Hoving and Schoener for discriminatory treatment of Black Americans through their exhibit, praise should be given to the artists and protestors in Spiral, the B.E.C.C., Weusi, and the Harlem Cultural Council for creating an uproar and putting pressure on museum administrators to be more responsible in representing communities of racial and ethnic others. Although there were informative displays about Harlem in the exhibition, the greater record of African American achievement was not found within the catalogue or the exhibition; rather, it was struggling outside the doors of the Met. These excluded communities deserve the recognition for speaking out and forming a critical discourse about the exhibition and their ill treatment by the museum administration.

Lowery Stokes Sims, who worked as a curator of twentieth-century art at the Met (1972–1999), clarifies the impact of the protest against the exhibition:

> As a result of the demonstrations against Harlem on My Mind, the MMA (Metropolitan Museum of Art) instituted the Community Programs Department under the directorship of Susan Coppello (later Badden), who hired me in 1972. After she left, Cathy Chance took over and became perhaps the first black administrator in the MMA's history. I eventually had access to the files on Harlem on My Mind and could see that the miscommunication about the content of the exhibition existed from the beginning.[100]

In a 1997 interview with Dubin, Thelma Golden, then curator at the Whitney Museum of American Art, stated:

> The reason I have my job is because of *Harlem on My Mind*. Lowery Sims often says she got her job at the Met specifically in 1973 because of the controversy. Had the protests not happened, I'm not sure the Whitney or other institutions in this city would have changed. It galvanized most museums to

get to the place where in 1990 I could work here and do the things I do. But it took twenty years.[101]

The advancement of African American curators like Golden and Sims are traced back to the protests against *Harlem on My Mind,* not to the exhibition as a self-contained project or to its curators, who ignored the artwork by Harlem artists. Although Dubin states that *Harlem on My Mind* "forced museums to represent minority communities," it was the organized artists' resistance to the Met's representations that forced change.[102] Schoener, Hoving, and other museum administrators do not deserve credit for creating the problem that forced Harlem to respond. By privileging the view of the museum, Dubin underplays the role of African American artists and disregards their contributions just as they were ignored in 1968. Without the critical engagement of the African American communities, the exhibition would not have achieved the attention it received.

In the late 1960s museums and galleries committed to African American culture were founded. In New York alone four institutions dedicated to exhibiting art by Black artists opened: the Studio Museum in Harlem (1967), Cinque Gallery (1969), Acts of Art (1969), and American Contemporary Artists ACA Gallery (1969).[103] On a national map several museums for African American art and cultural history were founded from the mid 1960s to the late 1970s, including the International Afro-American Museum, Detroit (1965), Anacostia Museum of Culture and History, Washington, DC (1967), Museum of the National Center for Afro-American Art, Boston (1968), Museum of African American Art, Los Angeles (1976), Afro-American Historical and Cultural Museum, Philadelphia (1976), and California Afro-American Museum, Los Angeles (1979).[104] The response to *Harlem on My Mind* by the Black visual arts community was a fundamental element in a movement toward the autonomy of Black artists.

Harlem on My Mind forced the Black visual arts community to organize against unfair representations of Black culture, the exclusion of Black artists from exhibitions, and discrimination in hiring of Black museum professionals. As the historian Deborah Willis explains, the organizers of *Harlem on My Mind* incited many in the Harlem community "to protest that a museum ostensibly dedicated to art suddenly adopted a documentary stance when confronted with the visual presence of the *other* within its walls."[105] Although gains were made because of the activism that followed *Harlem on My Mind,* the struggle for Black representation in art museums continues against new challenges.

Since *Harlem on My Mind,* over two hundred African American museums have been founded around the country. The increase of Blacks as museum professionals and the number of racially specific museums illustrates different strategies for achieving Black visibility in American art. There is an exchange of ideas and artists in both the mainstream art institution and the African American museum, but the African American museum exists specifically to collect, exhibit, and educate visitors about art made by Black artists. The African American museum has come about because the need for cultural expression and understanding could not wait for or depend upon mainstream art institutions to open their gates.[106] The struggle for Black representation in mainstream art institutions reflects the larger national need for cultural recognition, understanding, and respect. The diverse Black visual arts community struggles within itself and with mainstream art museums not only to answer the recurring questions "What is Black art?" and "Who are Black artists?" but "How can we ensure that Black artists are recognized as equal contributors to the American scene?"

Figure 22.
Installation view of *Two Centuries of Black American Art* at LACMA. Gallery with
Bulbous Jar with Two Ear Lug Handles (1859) by Dave Drake (formerly known as Dave
the Potter); *Portrait of Mrs. Barbara Baker Murphy* and *Portrait of Captain John Murphy*
(both c. 1801); and other nineteenth-century works.

Digital Image © 2009 Museum Associates/LACMA Art Resource, NY.
Los Angeles County Museum of Art, Los Angeles.

CHAPTER 3

FILLING THE VOID

Two Centuries of Black American Art, 1976

Two Centuries of Black American Art was the only historically comprehensive exhibition of art by Black Americans ever to be presented by a major American art museum (figure 22). Organized by the Los Angeles County Museum of Art (LACMA) in 1976, the exhibition traveled in 1977 to the High Museum of Art in Atlanta, the Dallas Museum of Fine Arts, and the Brooklyn Museum. *Two Centuries* received greater visibility and validation from the mainstream art world than any other group exhibition of work by Black artists. It also gave the general public the opportunity to become aware of and enjoy the depth and breadth of art created by Black people. Guest curated by Professor David C. Driskell while he was chairman of the Department of Art at Fisk University, *Two Centuries* announced the presence of Black contemporary artists and shocked record-breaking numbers of visitors and critics in attendance with its display of objects from several visual traditions that had largely been omitted from most accounts of American art.

This chapter analyzes what was at stake concerning the curatorial objectives, critical reception, and museological impact of *Two Centuries* and focuses on three of the greatest challenges it posed to the art world. First, mounted in the commemorative year of the nation's bicentennial, *Two Centuries* was positioned to fulfill a nationalist desire to demonstrate

America's progress regarding race relations on its 200th anniversary.[1] Like the celebration and acquisition of Jacob Lawrence's *Migration of the Negro* during World War II, *Two Centuries* took to the national stage during a patriotic moment in which Black Americans were temporarily incorporated into the discriminatory exhibition practices of art museums to prove the ideals of American democracy. Along with the LACMA exhibition *Women Artists: 1550–1950,* curated by Ann Sutherland Harris and Linda Nochlin earlier in the year, *Two Centuries* was poised to serve as evidence of the unity of the American people through the arts and the inclusive policies of the art museum along gender and racial lines. In reality, Driskell's objective was not to confirm that racial equality had arrived in the art world. Instead, his charge was to break through the racial barriers of ignorance and willful exclusion that still existed in America's most respected art museums even two centuries after it was founded. Through his curatorial vision, Driskell brought the art world up to date on the history of Black American art production beginning in 1750 (twenty-six years before the nation's birth) in a bold presentation of over 200 works of art by sixty-three artists virtually ignored by American museums.

Two Centuries served as a corrective to the brazen devaluing of Black American struggle and creativity. Driskell argued for the inclusion of artwork by Black Americans in American art museums and art history. Known as "The Black Show" in Los Angeles during its planning stages, *Two Centuries* was a Black affirmation and a political insertion into art history, art museums, and immediately into race relations in Los Angeles, which was still grappling with the devastation from the Watts Riots.

Second, *Two Centuries* befuddled art critics, some of whom were faced with reviewing an exhibition of art by Black American artists for the first time. Although *Two Centuries* was an exhibition of American art, critics shifted from their regular approaches to it because their understanding of racial Blackness disqualified the show as an art exhibition. The reviews reveal several troubling reactions that demonstrate the critics' discomfort with the presence of Black artists in the museum and express their critical limitations concerning definitions of Black ability. One critic complained about reviewing the show because he believed it contained too much social history and therefore did not belong in a museum.[2] Critics also stated their annoyance at the exhibition for not showing enough of a Black difference from art by White Americans.[3] Through these critical responses, *Two*

Centuries forced a discussion of what was at stake in protecting America's art museums from acknowledging national diversity and racial conflict as an American reality, and maintaining the hierarchy of White privilege on the gallery walls.

Third, Driskell challenged the racial category of Black itself. The exhibition included the work of the renowned painter and naturalist John James Audubon. Although considered a White man, Audubon was actually biracial, born to a Black Haitian mother and French planter father in 1785. The inclusion of Audubon as a Black artist was considered by some critics and members of the public as a case of mistaken identity. Others understood Driskell's claim of Audubon as a desperate attempt to boost Black American self-esteem. By showing that some White artists are Black, or at least as Black as they are White, Driskell forced an important interruption in the mainstream art world, highlighting the history of racial interdependence and oppression in our national body—a body that is in fact, interracial. The significance of this reclamation of Audubon into the Black body in 1976 challenged the myth of White superiority and exclusivity in the art world and the tense racial politics in the cities in which the exhibition traveled.

Until 1976, evidence of Black American creativity and artistic production in mainstream museums had been sparse. Beginning with their exhibitions of art in the nineteenth century through private galleries and world's exhibitions, Black Americans struggled to be recognized as relevant to the art world. Black artists took advantage of every exhibition opportunity to prove themselves equal contributors to the history of American art. Mainstream art museums did not begin organizing exhibitions of art by Black Americans until the late 1920s. Inconsistent in their acknowledgment of the quality and value of art by Black Americans and sporadically offered to the public, these exhibitions did not indicate the rich history of diverse artistic production by Black artists. *Two Centuries* filled the void of this omission of Black American artists in art history and museum history and pointed to the absence of artworks that had been discarded, devalued, and lost because of poor judgment and unequal standards of recognition.

Just in the ten years prior to *Two Centuries*, Black artists experienced many significant gains in the mainstream American museum world.[4] In 1968, the Minneapolis Institute of Art held an exhibition titled *Thirty Contemporary Black Artists* that traveled to several museums from the East to the West Coasts. In the following year, *Contemporary American Black*

Artists was presented by the Smithsonian in its Arts and Industries building. *Afro-American Artists: New York and Boston* was organized at the Museum of the National Center for Afro-American Art, Boston, in the spring of 1970. The Whitney Museum of American Art began its series of twelve exhibitions featuring the work of Black artists from 1969 to 1975. Eleven of the exhibitions were solo exhibitions, including the first solo exhibitions of work at the Whitney for a Black man and a Black woman.[5] The exhibitions were an institutional response to demands by the Black Emergency Cultural Coalition that included the call for more exhibitions of work by Black artists. In 1971, the Museum of Modern Art opened solo exhibitions of sculptor Richard Hunt and painter and collagist Romare Bearden. Later that year the National Collection of Fine Arts at the Smithsonian Institution held two concurrent exhibitions of Black artists: *Art of Black Americans of the 1930's and 1940's* and *William H. Johnson*. In the late 1960s through the early 1970s, the work of contemporary Black artists was slowly being recognized by mainstream museums; however, these aesthetic and educational institutions had yet to discover the cultural and art historical foundation for this handful of exceptional Black American artists allowed to pass through their gates. The organization of *Two Centuries* at LACMA emerged as an opportunity to exhibit this ignored art history and respond to local protest and demand for the exhibition of art by Black Americans at the museum.

Pressure from Inside and Outside

It all started in 1968 when LACMA, known then as the County Museum of Art, organized *The Sculpture of Black Africa: The Paul Tishman Collection*, an exhibition of the Tishman collection of African Art. At the time, most of the security guards at the museum were Black, but there had been no exhibition of art by a Black American artist since the 1935 exhibition of sculpture by Beulah Ecton Woodard in the institution's previous incarnation as the Los Angeles County Museum.[6] Led by Sergeant William Knight, the guards organized to make the African art exhibition an event that would involve the Black communities of Los Angeles. Knight and twelve other guards formed the idea for a Black Culture Festival to take place at the museum during the run of the exhibition. With approval from the museum administration, this group became the organizing committee for the festival to

"commemorate the awakening of Black Culture and to encourage the Black Community to participate in more Museum activities."[7] A diverse group of Black Angelenos—students, artists, television and film entertainers, dancers, musicians, and others—got involved in the public programs and cultural festivities as a result of the guards' efforts to seize upon the museum's interest in Black Africans. In a strategy reminiscent of the Harlem Renaissance, in which Black Americans capitalized on the art world's fascination with African art to create a space for Black American artists to be recognized, the exhibition of the Tishman collection at the County Museum of Art provided an opportunity for Blacks to pressure the museum to recognize Black American creativity and achievement in the city.

On December 28, 1968, more than 4,000 mostly Black visitors made the Black Culture Festival at the County Museum a celebration of African heritage and current achievements of Black Los Angeles. The exhibition and its programs opened the door for Black Americans to take a role in the County Museum of Art's programming as the art of their ancestral homeland was featured at the museum.[8] The exhibition's public programs validated Africa's cultural heritage and articulated connections between African nations and contemporary Black American culture in music, the visual arts, and literature. The name tags at the event read *Habari Gani,* "hello" in Swahili. The program included performances of West African and American music by Big Black and His Quintet, Letta Mbulu, the Afro-American Zulu Dancers, the Albert McNeil Singers, Louise Whitney, the Latin Jazz Prophets, and others. A special focus of the musical contributions was to show the evolution of African music into jazz, supporting the connection between the Tishman show and Black America. The festival included storytellers sharing African American folklore; Black queens crowned by the Watts community, the University of Southern California, UCLA, and California State University, Los Angeles, were guest hostesses for the festival (figure 23); Black women modeled fashions by Mr. Jefferson's Minimention Fashions and the L'Tony Afro-American Fashions shows; and dance collectives trained in Ghana and the United States performed.

It was truly a remarkable event. *L.A. Times* writer Sharon E. Fay summarized its significance, writing, "The Black Community scored a number of firsts at the Black Culture Festival at the County Museum of Art. It was the first time so many had come to the museum in a group. It was the first such event ever held at the museum. And it could have been the first time a group

Figure 23.
Portrait of UCLA Homecoming Queen Carolyn Webb (right), in *The Sculpture of Black Africa: The Paul Tishman Collection*, December 31, 1969.
Los Angeles Times Photographic Archive, Department of Special Collections, Charles E. Young Research Library, UCLA.

of museum employees such as the mostly black security guards, ever organized and put on such a museum event."[9] The museum's director Kenneth Donahue expressed his surprise to the festival when he said, "I've seen faces tonight that I've never seen before in Los Angeles."[10] Certainly the temporary change in the museum's audience showed the museum how it could use its exhibition programs to expand its reach to communities that had only been acknowledged as a labor force on campus, and not as a cultural resource of potential visitors and contributors to the visual arts.[11] According to actor and director Ivan Dixon who served as emcee for the festival, "frankly, not too many of us have been showing up. And so the security officers decided to do something to get more of our people down here."[12] The owner of the African collection, Paul Tishman, gave a lecture about the exhibition and led a tour

of it especially for the guards. The museum also provided an unprecedented and unconventional service by allowing museum guards Stanley Swinger and Wiley Williams to give tours of the exhibition, and the other guards on the committee to give behind-the-scene tours of the museum's library, members' lounge, children's workshop, preparators' work space, paint and carpentry shops, and shipping dock.[13]

The energy from the festival made a lasting impact on the museum and its critics. Head of Security Sidney Slade and Sergeant Knight received a commendation from the Los Angeles County Board of Supervisors for their "unique contribution toward broadening community participation in the Museum." One year later, *L.A. Times* writer Henry Seldis addressed the success of the festival and foreshadowed *Two Centuries* in his critical review of the Met's *Harlem on My Mind:*

> Los Angeles has been more thoughtful in its approach to its black community by the County Museum of Art. The extraordinary selection of black African art from the Tishman Collection and the Afro-American happening created around it by an imaginative and dedicated security staff was surely more construc-tive and suitable to an art museum in every way than the Hoving-Schoener hodgepodge. It would be well to consider exhibiting the works of 19th-century American Negro painters with whose best work we are not familiar here.[14]

This critical support of the festival and interest in future explorations into Black art helped create a welcoming environment for *Two Centuries*.

The guards were not the only ones involved in making a change in the ex-hibition programs at the museum. In 1969 two Black members of the museum staff, art preparators Cecil Fergerson and Claude Booker, began agitating for the presence of Black American artists in the museum's exhibitions. Fergerson began working for the museum at age seventeen when what became LACMA was still a part of the Museum of Natural History and Art in Exposition Park. In an amazing feat of determination and dedication, and with the help of a suc-cessful discrimination law suit, he worked his way up the museum ranks from his initial janitorial position in 1948, to art preparator in 1964, and in 1972 to curatorial assistant to Maurice Tuchman, senior curator of twentieth-century art. Claude Booker worked as one of the museum's art preparators and was also an artist in Los Angeles' thriving Black art scene.

Fergerson and Booker formed the Black Arts Council in 1968, an organi-zation of Black staff, artists, and citizens concerned about the advancement of art by Blacks in Los Angeles.[15] Booker was the president and Fergerson

the secretary. At the time, the museum's Board of Directors was all White, and the Black Arts Council served to represent the interests of the Black art and cultural community within the museum. The Black Arts Council was the activist component of a small but stimulating art scene for Blacks in Los Angeles. Annual arts exhibitions and cultural festivities became available in 1966 through the Watts Summer Festival and the Festival in Black. In 1967 brothers Dale and Alonzo Davis opened the Brockman Gallery in the predominantly Black neighborhood Leimert Park, which was the most active gallery for Black artists in the city. In 1968, Suzanne Jackson opened Gallery 32, which presented art made by a racially diverse roster of artists. In its brief two-year history, the gallery was an artist hangout and a safe space for socially conscious conversation and political art. Heritage Gallery, which held exhibitions by Black and Latino artists, Ankrum Gallery, and the Watts Towers Art Center also provided exhibition spaces. Other exhibition venues for Black artists were informal and temporary spaces in churches, playgrounds, community centers, tennis courts, and banks.

Booker and Fergerson presented a proposal to the museum on behalf of the Black Arts Council for some of the city's Black art activity to take place at the museum. The museum's Board of Directors committed to a three-evening lecture series focusing on Black artists, and a Black art exhibition; however, the exhibition would not be allowed in the museum's galleries. The three lectures were delivered in 1969. On the first evening, the author and artist Samella Lewis, the museum's first Black education coordinator, presented "The Contributions of the Black Artist to Our Society," and artist, athlete, and actor Bernie Casey followed with "The Relationship of the Black Artist to the Community."[16] On the second evening graphic artist, teacher, and mentor Charles White spoke on "Soul in Art," and sculptor John Riddle presented "Art and Social Protest."[17] For the third evening, Black jazz musicians readied the crowd before the panel of Black artists Gloria Bohanon, Dan Concholar, John Outterbridge, and Arenzo Smith discussed the relationship between Black music and art with moderator Truman Jacques, a local television host.[18] These evenings served to educate the public about Black artists and to prove to the museum that there would be a Black audience for an exhibition of Black art. To help attract hundreds of Black Angelenos to the event, Fergerson piped Paul Robeson's recording of "I Am America" through the speakers on the outdoor plaza, and wired the auditorium microphones to the speakers to attract people who were not

at the museum.[19] To the curators' surprise, the lectures more than filled the Bing Auditorium's 600 seats.

The First Black Shows

In its history, LACMA has organized three exhibitions of work by Black artists. All three took place in the 1970s; *Two Centuries* was the last of them. The first was *Three Graphic Artists: Charles White, David Hammons, Timothy Washington* in the Prints and Drawings Galleries in January 1971. The exhibition was not organized by the Black Arts Council but by Ebria Feinblatt, County Museum Curator of Prints and Drawings, and Joseph E. Young, Curatorial Assistant. It included forty-one works. Hammons was represented by twelve works from his body print series, some of which were overtly political in the inclusion of modified American flags in dialogue with the printed black ink figure of Hammons's own body. Now iconic and perpetually fresh, the images from Hammons's inventive self-involved prints are provocative and ghostly. Playing with the visual perception of negative and positive space, the form of the images is a seamless part of their functions. In *Injustice Case* (1970), inspired by Black Panther Bobby Seale's gagged and bound body in the 1969 trial of the Chicago Seven, the surrender of Hammons's body as the physical medium for the print gives a raw and immediate quality to the image. The doubleness in the immediacy of Hammons's image as self-representation and as surrogate for Seale's demonstrates the interconnectedness of the personal and political.

Charles White celebrated the relationship between mother and child in *Seed of Love* (1969) (plate 2). A peaceful expression graces the face of the woman whose naturalistic head crowns an impossibly monumental body. Though heavy with child, she seems to float across the dense surface of the print. The abstract geometric forms of the background fade into the shadows of the cool light above. White gives the image such dreamlike complexity that the viewer may become more intrigued by what exactly has been dismissed under the contested trope Black art.

Timothy E. Washington's engravings on aluminum pushed the envelope of graphic art by presenting printing plates as the medium. *One Nation Under God* (1970) shows a male figure pledging allegiance to the American flag protectively pressing against his otherwise nude body (plate 3). He

stands in front of a mule in an ambiguous red, white, blue, and black space. The signature binocular-like eyes of the figure emphasize its alien quality and the strangeness of this patriotic scene. The colors of the image, flag, and mule, as a symbol of labor and unfulfilled promises to Black Americans (40 acres and a mule), make the cold metal work a critical social commentary.

A few of the members of the Black Arts Council, including Fergerson, picketed the exhibition on opening night. They were upset that Charles White was not given a more legitimate space in the museum because he was senior to and more accomplished than the young Hammons and Washington. The protest was small and short-lived and ignored by the Black and White presses.[20] The protesters did not expect the museum to take White out of the exhibition and give him a solo show. The point of picketing was to tell the curators that they needed to differentiate between Black artists at different stages of their careers as they would with White artists. The demonstration aimed to highlight the significance of White's name in the art world, since he had had his first solo exhibition in New York's American Contemporary Artists gallery in 1941, before Hammons and Washington were born.

The *Los Angeles Times* review of the exhibition found some merit in each of the artists' works but particularly praised the experimental quality of Hammons's influential body prints. The review ends prescriptively, "Whatever objections are being raised to this exhibition ought to be judged with reference to the excellence of the images these artists have created rather than to the degree of fury that can be found in their pictorial protests."[21] This statement calls for a division between aesthetic quality and social politics in order for viewers to appreciate the art, indicating a requisite for Black art in the art museum. It is not that other works exhibited at the museum excluded political content, but the expression of Black politics offended the critics. The review provides evidence of a racial and class tension between the concerns of Black Americans and those of the critics. The Black American presence at the museum was welcomed for a festival in 1968, but troubling when it was expressed on the gallery walls. As a show of appreciation to the artists and support for Los Angeles' Black art community, the museum purchased one work by each artist for its permanent collection through Alonzo Davis of the Brockman Gallery.

In 1972, the Black Arts Council organized *Los Angeles 1972: A Panorama of Black Artists,* the second exhibition of work by Black American artists, this time located in the museum's basement Art Rental Gallery. The seventy-

six-object *Panorama* was curated by Carroll Greene, Jr., a notable Black curator and advocate for art by Black Americans, and supported by the Kress Foundation, a private organization dedicated to the preservation and study of European art in American museums. For the Black Arts Council, the exhibition was an opportunity to promote art by the fifty-two Black artists on view, including Hammons and White from *Three Graphic Artists,* and funk and assemblage artists John Outterbridge, Noah Purifoy, and Betye Saar, among others. In the exhibition, organized as a survey of contemporary work by Black artists in Los Angeles, each object was available to be rented or sold. The curators and administration of the museum considered the exhibition an experiment to gauge the public's level of interest in Black American art for the possibility of a higher-profile show to be held in the museum galleries.

In the *Los Angeles Times,* William Wilson reviewed *Panorama* as "lukewarm" and found high contrast between the art and its environment. He described the exhibition as looking "like any ordinary, attractive community art exhibition, except it is shown to advantage, professionally installed in the museum's galleries."[22] He argued that the quality of the exhibition was compromised by Greene's desire for artworks of aesthetic excellence and artworks that express Black social consciousness which, for him, were two mutually exclusive categories. Wilson located the failure of the exhibition in the absence of the form he considered apropos to present socially conscious art. He asks unapologetically and without self-awareness, "why doesn't this art take the form of slogans, posters, comix [*sic*] or graffiti? Why is it not in a form, language and place accessible to ghetto people without the carfare to get uptown? What is it doing in the museum at all?" Wilson's invocation of "ghetto people" demonstrates a familiar class prejudice since he assumes "ghetto people" are somehow incapable of understanding art unless it consists of pop cultural forms. Through an argument reminiscent of Alain Locke's nearly half a century earlier, he surmises, "Ideally, 'Panorama' ought to show the emergence of some artistic style or attitude we could characterize as 'Black Art,' something visually as resonant and original as the forms and spirit that characterize Afro-American music." He makes his point by revealing that the artists he finds most impressive "are the most individualistic and simultaneously the 'blackest' in the show."[23]

Booker responded to the racial and aesthetic judgments in Wilson's review in the newspaper two weeks later: "To castigate the majority of the artists because they do not conform to his [Wilson's] view of what constitutes

revolutionary art, or what can be categorized for his convenience as black art, immediately negates any values his criticism might have held. . . . For those who cannot afford the carfare 'uptown,' the Black Arts Council and other nonofficial museum organizations will continue to stage exhibitions in outside community art shows as they have done in the past."[24] The critical reception of *Three Graphic Artists* and *Panorama* clarified the obstacles ahead for the even larger group exhibition of work by Black artists in the museum's main exhibition galleries. Critics were looking for an essential Black difference in the work of Black artists. Art that did not depict this difference was perceived as unsuccessful. However, inclusion of figurative race-related social commentary or the visual assertion of pro-Black politics was to be ignored so that the work could be evaluated on its aesthetic merit.

The 1970s rules for Black artists' inclusion in the museum nearly restricted Black expression to abstraction, a style in which many successful contemporary Black artists worked and were recognized for through the Whitney's series of solo exhibitions. The work of those artists is often, though not always, loaded with sociopolitical commentary, but not directly enough to make viewers and critics who are resistant to Black liberation politics feel uncomfortable. In addition to abstraction, Black artists were working in a variety of styles and forms for expression. Their acceptance into the mainstream art world required some kind of distancing effect between form, style, and whatever political expression the work may include. Restriction at such an important historical moment for Black self-definition in the art world was a significant limitation. The Black Arts Council wanted the rules for Black artists' inclusion to allow for the wide range of expression reflected by the work that was being made, and they wanted to define those rules on their own terms.

Organizing *Two Centuries*

After *Panorama*, the Black Arts Council pressured the museum's curatorial staff for nearly three years to organize a major Black art exhibition in the museum's main galleries. On behalf of the curatorial staff, Kenneth Donahue reported to the Council that the curators had considered the idea of a Black art show and rejected it. Finally, in April 1974, Deputy Director

Rexford Stead sent a letter to Professor David Driskell on the recommendation of Charles White, telling him about the museum's preliminary plans for a bicentennial "survey presentation of Black American Art from the Colonial Period to mid-20th Century" and requesting a formal proposal from him if he would be interested in serving as the guest curator.[25] When Driskell flew to Los Angeles to give his presentation to the Board in June, he was met with enthusiasm and resistance from the Board and staff. Maurice Tuchman, chief curator of Modern and Contemporary Art refused to attend Driskell's presentation.[26] Cecil Fergerson, by then Tuchman's curatorial assistant, was unaware of the plans for the exhibition, and believes that he was kept out of the planning because he was considered too radical and "too Black."[27] However, two of the LACMA Board of Trustees' most culturally influential members, Franklin Murphy, Chancellor of UCLA and chairman of the Board of Trustees of the *Times Mirror,* and Sidney F. Brody, president of the museum board, supported the idea of a Black show. Murphy recruited the first Black member of the Board, Charles Z. Wilson, Jr., Vice Chancellor for Academic Programs at UCLA, in 1971, and Brody recruited the second Black member, Robert Wilson, a prominent stockbroker and Los Angeles' first Black stock broker in 1974.[28] Both Wilsons supported the Black show project. In January 1975, within a month of the sudden death of Black Arts Council president Claude Booker, the Board support of the new exhibition came at a cost. Donelson Hoopes, curator of American art, and Ruth Bowman, director of education, resigned from their posts, citing the Board's decision to mount *Two Centuries.*[29]

Driskell was new to Los Angeles but not new to the art scene. An accomplished artist who began exhibiting in mainstream galleries in the 1950s, he was a student of James A. Porter at Howard University, and had curated several exhibitions as a faculty member at Talladega College in Alabama and Fisk University in Tennessee, namely *Modern Masters from the Guggenheim Museum* (1956) and *Amistad II: Afro American Art* (1975). Driskell was also well traveled. Recent trips to West Africa in 1969 and 1972 influenced his own art practice and art historical knowledge. He instituted a curatorial program for his students at Fisk, who worked at the Smithsonian Museum of American History and Detroit Institute of the Arts.

His plan for *Two Centuries* was simply to curate an exhibition that could represent the long history of Black American artists through various forms

Figure 24.
Three installation views of *Two Centuries of Black American Art.*
Brooklyn Museum Archives.

Records of the Department of Photography: Exhibition. *Two Centuries of Black
American Art.* [06/25/1977–09/05/1977]. [Negatives] Installation PHO_E1977i017;
Installation PHO_E1977i018; and Installation PHO_E1977i019.

(figure 24).[30] As Stead stated in his introduction to the catalogue, Driskell's charge was "to locate a broad-ranged group of works reflecting the efforts of the more significant black American artists from slave times into the mid-twentieth century."[31] Assisting him most with this project from LACMA was Stead, who Driskell recalls worked with a spirited dedication to make the exhibition a success. Driskell selected the art historian, civil rights activist, and accomplished actor Leonard Simon as his research assistant because of his comprehensive grasp of art history. Simon wrote the biographic entries for each artist and the object descriptions in the catalogue.[32] Driskell traveled all over the country to select the objects for the exhibition. The dates of several of the artworks exceeded the 200-year limit of the exhibition because some of the artists wanted to be recognized for some of their more recent work. Driskell conceded to their requests as long as they had proven themselves

as artists by 1950.[33] *Two Centuries* set a new exhibition attendance record at LACMA, broken only by the blockbuster cultural phenomenon *Treasures of King Tutankhamen* in 1977.

To reference and counter *Harlem on My Mind,* which had unapologetically presented photo-murals in an art museum, Driskell explicitly presented a large photo-mural at the entrance to *Two Centuries* (figure 25). Upon entry into the exhibition, the viewer faced the enlarged photograph *Henry Ossawa Tanner at Work in his Studio* (attributed to an unknown photographer, c. 1900) which appears on page 51 of the exhibition catalogue. The photo-mural foregrounded the Black artist at work to clarify the focus of the show. Just to the left of this photograph was John Rhoden's *Population Explosion* (1962). Together, the mural and the sculpture offered a snapshot of the chronological breadth and diversity of the work enclosed. Other photo reproductions were of architectural structures built by slaves. In one of his two canonical essays in the exhibition catalogue, "Black Artists and Craftsmen in the Formative Years, 1750–1950," Driskell accounts for these structures as part of the artistic history of Black Americans: "Not surprisingly, the slaves received little or no credit; in fact, there are very few written accounts in which slavemasters permitted them to be identified by name, although the refinement of slave work was frequently stressed."[34] To show the museum's commitment to contemporary Black American artists, the Graphic Arts Council commissioned Charles White to design a print for the exhibition for sale to museum members.[35] Several artworks for the exhibition were donated to LACMA and placed on view months before the *Two Centuries* opened.[36]

When Driskell was an undergraduate student at Howard University, artist and art historian James Herring had told him that John James Audubon was Black. Driskell decided to pursue the claim to test its truth and potential for inclusion in *Two Centuries.* After seeing the Jesuit birth record for Audubon, he decided to include Audubon in the show through his work *Virginian Partridge* (plate 4). The fact of Audubon's heritage and inclusion in *Two Centuries* was mentioned in announcements and reviews of the exhibition. However, Driskell and the Brooklyn Museum received threats of a lawsuit from Walter Audubon, John James's great-great-great grandson. Though at first he denied the ancestry, he later admitted that he knew the Audubons had Black ancestry, but was afraid his pregnant wife would leave him for fear that their child might look black.[37] As well as this private

protest, a letter to the editor of the *New York Times* argued that Driskell had made a mistake and that the great naturalist was not part Black and was a racist, "We blacks can't claim him, don't need to and don't want him."[38] Fergerson agreed with Audubon's inclusion in the exhibition and disagreed with his identification as being anything but Black.[39]

Driskell looks back on some of the show's strengths to evidence "the lineage of the oppressiveness of slavery and yet the quality of work that was done. If it wasn't shown [by physical object], there was reference to it just so anyone could find it." Similarly he remembers the significance of the exhibition and its programs working in collaboration to illustrate the points in the exhibition.[40] *Two Centuries* was supported by a number of community events, educational programs, artist and studio visits, symposia, poetry readings, and film and dance programs that involved many Black Americans in each of the cities it traveled to.[41] Overwhelmingly, the businesses, schools, artists, musicians, and actors throughout the Black communities of the hosting cities showed support of the exhibition.

Driskell planned for a film to be created about *Two Centuries* and screened in the exhibition. The film *Two Centuries of Black American Art,* written and directed by pioneering Black filmmaker and cultural critic Carleton Moss, depicts the process of Driskell organizing the exhibition, meeting with artists in their studios and homes, and includes interview segments with several artists.[42] It begins by showing Driskell reading and photographing facsimiles of slave owners' diaries and related slave documents in a library, walking into the Smithsonian's National Collection of Fine Arts, and being presented by a White male worker with paintings by Joshua Johnston, Edward Mitchell Bannister, and Robert Duncanson in museum storage. Driskell proceeds to measure Bannister's *Newspaper Boy* (1869) with a tape measure and take notes. The film serves as proof of the serious, detail-oriented, professional research Driskell conducted to create a top-notch exhibition worthy of a major mainstream art museum. It is important, however, to note that the documentation of Driskell's labor was a performance to make the point of the professional process for the film. It is true that Driskell did all of the work depicted; however, the act of curating is re-created for the camera and set to music, giving the viewer the impression that the process was smooth and effortless. Although the actual project of curating the exhibition was exciting for Driskell, a documentation of the process would likely translate into something quite boring on film. Driskell's work was mostly intellectual.

Although Driskell is admired, inarguably so, for his cool demeanor, his curatorial process was not as performative and cool as it appears in the film. It was full of challenges as well as cooperative moments.

As the film shows Driskell walking onto the LACMA campus and being greeted by a gardener who excitedly jogs over to him for conversation, Driskell testifies to his curatorial work in a voiceover: "I've been collecting materials for the past eighteen months. Some of the pieces were thought to have been lost. Other works have rarely been seen in public. This is the first time that so much of this has been brought under one roof." The violin music crescendos as the film's title is shown over a wide shot of LACMA's campus (plate 5). This aural and visual shift, led up to by the enthusiastic gardener and Driskell's statement, relays a feeling of excitement about the exhibition. The film continues by showing Driskell in the Ahmanson Building with a crate being moved by a Black art preparator. He quickly signs off on a document presented by a White woman, steps into the office of Rex Stead, and hands him exhibition wall labels which Stead, who is busy taking a phone call, accepts as he nods to Driskell with approval. Not dismissed, Driskell looks at photographs of objects in the exhibition, and arranges a maquette of the exhibition galleries on Stead's desk. The two men, Black and White, are shown working together in the same office (plate 6). The quick sequence demonstrates Driskell's respectability, power, and importance at the museum. The scenes showing him interacting with White museum workers legitimize his work for a skeptical viewer. The scene of Driskell with Black preparators at LACMA shows his acceptance among Black workers as well. Narrator Stanley Waxman introduces one of the earliest known Black American painters, Joshua Johnston, by reading the text on one of the labels in Stead's hand. Paintings by Johnston are shown along with documents that prove the life history that appears on the label. The narrator assures viewers that this talented painter was Black by clearly enunciating, "That he was a Black man seems certain, for to have incorrectly listed a White man as Black would have been a libelous matter." This guarantee is heard as Black art preparator Edwin Thornhill takes notes in front of a selection of Johnston's paintings and traces the edge of one of the painting's frames with a look of pride on his face.

Similar treatment is given to nineteenth-century artists Robert S. Duncanson, Edward Mitchell Bannister, Edmonia Lewis, and Henry Ossawa Tanner before presenting rare footage of Aaron Douglas, Selma Burke, Romare Bearden, Alma Thomas, John Rhoden, Lois M. Jones, Jacob Lawrence,

Richmond Barthé, and Charles White, making artwork and talking about their artistic careers. Cut between each artist's segments are scenes of the museum's Black art preparators and security guards handling the artwork.

The exhibition catalogue was printed in an unusually large quantity of 5,000 instead of the standard 1,000 copies. The book became a standard text for students and teachers of American art beyond the typical coffee table function of many art exhibition catalogues.[43] Driskell explains the extraordinary role of the catalogue, "The catalogue became a textbook or resource . . . like an encyclopedia or some sort of reference book . . . proof that we could have this enormous exhibition and here is the record of it."[44]

In her *Art in America* review Amy Goldin called the *Two Centuries* "a mediocre show, but valuable all the same."[45] This sentiment and similar ones by other reviewers indicate liberal sympathies to champion diversity for the sake of democracy. They think that discrimination in the art world is wrong, but they don't like exhibitions of the excluded. Goldin also shared her frustration with the lack of reactions to the exhibition by her colleagues: "Critical response to it was depressing evidence of the still-unraised consciousness of the New York establishment."[46] In some moments reviewers were able to make valid criticisms of *Two Centuries* as an art exhibition and were not hindered by the fact that the artists were all Black. Goldin, Hilton Kramer of the *New York Times,* and Lawrence Alloway of *The Nation* expressed their wish that Driskell had showed less of an even-handed presentation of major and minor artists. Alloway argues, "By reducing the major artists in this style and emphasizing a lesser, Driskell has blunted the case for the vigor of black art in general."[47] The validity of this critique speaks to the infrequency of major exhibitions of work by Black artists that continues today. The problem of one exhibition taking on the pressure to account for an incredible number of artists with their own styles, histories, concerns, etc. was even more pronounced for exhibitions of earlier decades with even fewer predecessors. For viewers who are learning about these artists for the first time, the historical significance of one artist in relationship to another is a reasonable preference. However, their comments may also reflect their feelings of being overwhelmed by the number of new artists and an anxiety of having too many Black artists in the museum too soon.

Two Centuries broadened the categories of art in mainstream American art museums and art history by including textiles, dolls, musical instruments, slave architecture, and other forms of material culture not previ-

ously validated by art museums. The inclusion of this work argued for the necessary understanding of social history within art history. The curatorial challenge Driskell faced may have been too much considering: 1) the dismissive criticism of the show from the reviewers in mainstream press and 2) that *Two Centuries* was the first and last major exhibition of Black American art that LACMA has organized to date. The specter of racial determinism precluded some critics from reviewing the exhibition as an art show. *Two Centuries* was interpreted as being sociology, exempting some from seriously reviewing it. These critics were limited by a conception of Blackness that separated Black art from the art world even as it was exhibited within it.

New York Times critic Grace Glueck concluded that the art was not Black enough to be remarkable and was disappointed that Driskell did not define the Blackness of the show: "Though Professor Driskell feels obliged to flirt, in his catalogue essay, with the idea of a 'black aesthetic,' he never defines it, nor does he come to grips with it in terms of the work shown."[48] Hilton Kramer impatiently echoed Glueck in his review: "If there is something that can legitimately be described as 'a black esthetic' in the visual arts in this country, Professor Driskell has yet to tell us or show us what it is."[49] For these critics who looked for a visual marker of Black difference to show its significance, art historian Julie L. McGee eloquently explains, "Those who failed to see universality in black subject matter were likewise unable to respect formal qualities and contributions of black artistry."[50] The critics missed the point of their observations of the similarities between art by Blacks and Whites. If, indeed, there is no Black difference, why is there the need for all-Black exhibitions? The evidence of sameness argues against racial exclusion.

Critic Harold Rosenberg's review was mostly a complaint about the ridiculous concept of the "minority" show based on his perception that all artists are minorities. He stated that the exhibition "has an ulterior purpose; that is to say, it is presented primarily to help bring about changes in the situation of black people in America. To thus put aesthetic standards in second place is for some critics a sufficient ground for dismissing the 'Two Centuries' show as a whole."[51] Despite his feeling that the show was beneath a true art critic, he reviewed the exhibition, and revealed that he learned something from it. He appreciated the talent of Joshua Johnston and Robert S. Duncanson, stating, "It will be more difficult in the future to

omit these artists from the history of American paintings." He also understood one of the goals of the show: "Except in certain picturesque aspects, black art is not distinct from majority art; the complaint is that it has been insufficiently incorporated in the national tradition."[52]

On June 26, 1977, Hilton Kramer reviewed *Two Centuries* in a *Times* article titled "Black Art or Merely Social History?" Although he found merit in the exhibition, noting paintings by Joshua Johnston, Robert S. Duncanson, Edward Mitchell Bannister, Palmer Hayden, James A. Porter and a few others, he complained, "There is simply too much here that does not belong in a serious museum exhibition."[53] He further expressed his resentment toward the exhibition, saying: "it is a difficult show to review. The result is a show that is often more interesting as social history than for its aesthetic revelations. We do not feel the presence in this exhibition of any stringent esthetic criteria.... It remains, by and large, a social documentary *about* the black American artist in America rather than an anthology of his highest achievements."

Distracted by the social history of Black Americans, Kramer found it difficult to focus on the visual images. Ironically, art was interpreted as social history at LACMA, but in *Harlem on My Mind*, social history precluded the presence of art at the Met.

In an article titled "Black Art Label Disputed by Curator" that appeared three days later in the *New York Times*, Driskell is quoted as defining the term "black art" used in the title of Kramer's article by saying that black art "is a sociological concept. I don't think it's anything stylistic. We don't go around saying white art, but I think it's very important for us to keep saying black art until it becomes recognized as American art."[54] It seems that Kramer's inability to recognize that the social history of Black artists does not mirror that of Whites made it difficult for him to understand that Black artists had been making quality work for hundreds of years. Driskell's recognition of social history as an integral part of Black Americans' stories and artistic expressions was a challenge that Kramer could not accept. Perhaps the critic's previous knowledge about the social history of mainstream American art made that history seem invisible in the work of White artists. Being faced with the new information about Black history distracted him from the art that it is a part of. Driskell had forcefully addressed this issue of art and racial separation in the catalogue, saying, "It is the aim of this exhibition to make available a more accurate compendium of quality of a body

of work that should never have been set apart as a separate entity."[55] One of the constructive criticisms in Kramer's review concerns his dissatisfaction with the absence of sculptor Richard Hunt and painters Sam Gilliam and Barkley L. Hendricks. Kramer's list of omitted artists pointed out that there are even more remarkable artists than the ones selected for the exhibition. By championing the merits of three of those omitted, Kramer showed support for Driskell's project to recognize the significance of the work of Black artists and include them in the art world.

Despite Kramer's uneven review, *Two Centuries* was discussed favorably by other critics and proved to be a popular exhibition with visitors. The exhibition reached the mainstream institutionally and also through the mainstream presses. The exhibition was even discussed in a rare segment on *The Today Show* as a significant cultural event. The segment conveys the popular level of interest in the show and the high-profile coverage of it in the mainstream press. In the episode of July 5, 1977, Tom Brokaw hosts Driskell as a guest on his show (plate 7). However, it is Brokaw, not Driskell, who discusses the artists and examples of the artwork from the exhibition, providing recognition of Black artists that was unprecedented in the mainstream media. The image of Brokaw introducing Black American art to America with the larger-than-life projection of *Haitian Market* (1950) by William E. Scott behind him is a remarkable moment in Black visual culture (plate 8). When Brokaw asks Driskell if Hilton Kramer's review of *Two Centuries* disappoints him, Driskell responds:

> No, not at all. I expect that from what one refers to as a mainstream critic because in many cases these persons are not familiar with what we might refer to as a black experience. They've never had the experience of knowing what it was like to suffer injustices, knowing what it is like to live in the poverty that many of these artists have experienced, and consequently they have no real sensitivity, no real feel for what it has taken for these artists to achieve what they've achieved at this time. So, one expects one who has not had that kind of experience to be more concerned only with what one might refer to as the aesthetic appearance of the form and not necessarily whether or not it is message-oriented or functionally oriented.[56]

Driskell defines the importance of social history in art history and expands the criteria that define art in the museum world. In this brief television moment, Driskell could share his criticism with more people than were reached by the *New York Times* and all the host museums combined.

The Legacy of *Two Centuries*

The exhibition was an important step toward improving the national recognition of Black artists inside and outside of the art museum. *Two Centuries* provided an effective alternative model to the one offered through *Harlem on My Mind* for ways museums and Black communities could work together to incorporate Black artists. It is important to recognize the role of Black activism in making the exhibition a reality. *Two Centuries* demonstrated the concerted effort of community advocates for Black artists that has been a feature in the exhibitions of their work since the 1920s. Without the agitation of the security officers at the County Museum, the Black Arts Council, *Three Graphic Artists, Panorama,* and the series of public lectures about Black artists, Driskell would not have received the invitation to propose *Two Centuries*. It is only because of the combination of local activism and Driskell's expertise that LACMA offered "The Black Show." Although the exhibition did not make lasting institutional change at LACMA, the life of the catalogue has made an impact in American art history. Driskell's discussions of the history of Black artists and the explanation of the Black aesthetic as a universal aesthetic, illustrated with color reproductions of art works, made art by Black Americans more accessible than before to art and art history students and teachers.

The exhibition challenged art critics, some of whom admitted to having learned more about American art through the show and others who resented the artists' work in the art museum. These reviews demonstrated that the next step in understanding and valuing the work of Black artists was to have more exhibition models in art museums to feature work by Black artists and explore the diversity of their art in smaller focused shows rather than the survey format. *Two Centuries* presented an abridged version of the history of Black artists and laid out a selection of artists for curators to see and bring into their exhibition programs. However, until art museums collect work by Black artists in their permanent collections and exhibit the work regularly in their exhibitions, there will be a need for Black activism in the art world.

CHAPTER 4
NEW YORK TO L.A.

*Black Male: Representations
of Masculinity in Contemporary
American Art*, 1994–1995

In 1976, Driskell and LACMA got it right with *Two Centuries* by showing that communities of people who do not regularly constitute the art museum audience could be made to feel welcome if their artistic contributions were recognized and people of their racial group were involved in the production of the exhibition. This collaborative approach benefited the art museum by increasing its audience and financial revenue. This was an important revelation in the relationship between art museums and Black artists, especially after the public relations fiasco of *Harlem on My Mind*. What followed *Two Centuries* was an increase in the visibility of Black American art in the 1980s through three major exhibitions: *Hidden Heritage: Afro-American Art, 1800–1950* (Bellevue Arts Museum, 1985); *Sharing Traditions: Five Black Artists in Nineteenth-Century America* (National Museum of American Art, Smithsonian Institution, 1985); and *Black Art—Ancestral Legacy: The African Impulse in African-American Art* (Dallas Museum of Art, 1989). Each show included artists featured in *Two Centuries* and elaborated on its themes.

At the same time that these exhibitions celebrated Black American art from the nineteenth and twentieth centuries, contemporary Black American artists were impacted in a struggle for representation in the art world. It became clear during the 1980s that exhibitions of Black American art were engaged in an effort toward mainstream recognition on two sepa-

rate but related fronts. First, the corrective exhibition of Black American art continued to provide an in-depth historical examination chronologically and thematically. Second, contemporary artists and curators were concerned with breaking the historic cycle of omission by exhibiting the work of Black artists in their moment of production.

The culture wars of the 1980s brought frustration with the traditionally conservative exclusionary practices of art museums to a head. In response, three New York museums—the Museum of Contemporary Hispanic Art (now defunct), the Studio Museum in Harlem, and the New Museum of Contemporary Art—mounted *The Decade Show: Frameworks of Identity in the 1980s* (1990), the exhibition that defined the art world and art exhibitions of the 1980s. By centering on the work of artists marginalized by the art world because of their cultural identities, curators, artists, and art activists challenged the canon of American art through exhibition. *The Decade Show* served as a corrective intervention by claiming the art world for these cultural "others" and provided an institutional critique of the 1980s art world through the unique strategy of solidarity in difference that was successfully broached by these three institutions. The tripartite show was part of a surge of challenging artists, activism, and exhibitions that contested the institutional racism and conservatism of American art museums. Whether or not racial identity was a subject of their works, the presence of the proud racial difference of the artists was in conflict with the assumed standard of the elevated White "norm" in American race relations and in the art museum.

Guided by the right-wing administrations of Presidents Ronald Reagan (1981–1989) and George H. W. Bush (1989–1993), the National Endowment for the Arts functioned conservatively as a watchdog group to decide what should and should not be validated as American art. Art that asserted criticisms of America's colonial history, the increasing economic gap between "the haves and the have-nots," conservative religious and family values, and the unapologetic persistence of police brutality against Black and Latino men was simply not welcomed or tolerated by the NEA. In the late 1980s and early 1990s, the culture wars were happening in the streets, universities, congressional meetings, and museums.

This chapter investigates the controversial art exhibition *Black Male: Representations of Masculinity in Contemporary American Art* exhibited at the Whitney Museum of American Art in 1994 during this volatile period. Exhibition viewers and critics were uncertain whether images that depicted

the Black male nude such as photographs from Robert Mapplethorpe's *Black Males* (1980) and *Black Book* (1986), representations of Black men as criminals in Gary Simmons's *The Lineup* (1993), or Black male violence in Robert Arneson's *Special Assistant to the President* (1989) served to criticize popular conceptions of Black masculinity and contribute to an interrogation of them, or to reinforce those popular conceptions. The ambiguity of the meanings of the artworks was complicated by two factors. First, *Black Male* was a new kind of all-Black show in which the artists were unified not by their racial identities, but by the subject matter of Black masculinity addressed in their works. Because many of the artists were not Black, their perspective was not assumed to be critical of racism. Second, in consideration of the Whitney Museum and its troubled past concerning the inclusion of Black perspectives in American art, a critical context for understanding the works on view could not be taken for granted.

My analysis of the exhibition examines the ambiguity of meaning in the works on view and argues that in the context of the Whitney Museum, the critique of racism and sexism within the images was at risk of being missed. To be clear, ambiguity and the possibility of multiple interpretations are desirable elements in contemporary art. However, during the culturally and politically critical moment of the early 1990s, the potential for open-ended presentations of images of Black masculinity was overshadowed by the suspicion of institutional complicity in the perpetuation of stereotypes of Black men as dangerous, debased, violent, and hypersexual. Art critics and cultural critics expressed their concern with the exhibition in the majority of the exhibition's reviews. For example, Okwui Enwezor criticized the sardonic approach of the exhibition's curator, Thelma Golden: "In Golden's incessant reliance on post modern strategies of production, the complex reality of the subject is not only diluted but also compromised."[1] Likewise many Black viewers were concerned about the potential effect of the images, particularly on White viewers' perceptions of Black men.

When the show traveled to Los Angeles, community activist Cecil Fergerson established an organization to express his concern about *Black Male.* He coordinated a series of counter-exhibitions to present supplemental images of Black masculinity. Fergerson believed that there was no room for ambiguous images of Black men that ran the risk of reinscribing stereotypes in such difficult social times. Because there was no good-faith

relationship or trust between Black America and the art museum, the Whitney's position as author of the exhibition influenced a reading of the artworks as uncritical representations of stereotypes. Further, the perception of the museum, as an ambivalent producer of images of Black men, was as troubling as one that promoted stereotypes.

This chapter explores the continued division between the mainstream art world and the Black art world and addresses the representational concerns regarding Black masculinity in both. It shows why having a Black curator isn't a guaranteed resolution for tensions between the two communities regarding Black representation. Was the museum so distanced from the real-life issues of racism and violence that it was not concerned with the message that would be received from some of the postmodern approaches of the artworks? Could Golden, the first and only Black curator at the Whitney, successfully mediate the relationships between the artworks, art museum, exhibition, and the public's beliefs about Black masculinity in a single exhibition?

Approaching *Black Male*

While preparing for the 1993 Whitney Biennial, then newly hired curator Thelma Golden began thinking about a thematic exhibition that would address representations of race and sexuality. Co-organizing the 1993 Whitney Biennial, Golden's first exhibition at the Whitney (and the museum's most diverse biennial in terms of the race and sexuality of the artists), no doubt had some influence on her exhibition idea. Most of the reviews of the Biennial were unfavorable, opposing the exhibition's inclusiveness and reducing the meaning of the works to "identity politics" without exploring further. Yet despite the mixed reception of the Biennial, or perhaps fueled by it, Golden curated an exhibition that explored how discussions of race, gender, and sexuality informed representations of Black masculinity in the art world. Her exhibition included perspectives from artists who were Black and male and others who were not. What was going on in the world concerning Black masculinity in the early 1990s was being played out through a series of media events—not only through the culture wars' struggles for affirmative action, the visibility of racial and sexual differences, and cultural equality—but through incidents like the Rodney King beating and

the subsequent 1992 Los Angeles Uprising, and the O. J. Simpson double murder trial in 1995.[2]

In the art world, the 1993 Whitney Biennial highlighted the problem of the lack of diversity of artists in the mainstream art world by exhibiting the work of many who had been excluded. Partly because of this exhibition, along with the previously mentioned *Decade Show,* issues of difference and power were brought to the cultural forefront. Golden approached artists Leon Golub and Nayland Blake with the idea of having race and sexuality as the themes for a future exhibition.[3] The artists were receptive to the idea, and thus Golden had found the first two of twenty-nine artists who would exhibit work in *Black Male.*

Beginning with art created in 1968—a crucial year in history for Black Americans and the Civil Rights Movement—this multimedia exhibition sought to explore Black masculinity in art, film, video, and television through seventy works. The exhibition received a great deal of attention because of its ambition and the complexity of its subject matter. Although the title is an intriguing double entendre referring to Black men and the manipulation of power through blackmailing, *Black Male* also introduced the exhibition through an anthropological framework as if the show would enact the examination of specimens on display. The words suggest description for the identification of a type, promoting the visual act of racial profiling in scientific terms and perhaps criminal suspicion. The independent curator Jorge Daniel Veneciano has discussed the font chosen for the graphic design of the title, Memphis Medium, as a slight modification of the nineteenth-century typeface used in "WANTED" posters. He suggests that this typological kinship "returns us to its deliberate association with transgression."[4] The title also tapped into popular American Negrophilia and Negrophobic beliefs about Black men that reflect both the erotically charged admiration of the Black male body and fear of Black sexuality, ability, strength, and violence.

Statistics about Black men in the early 1990s were devastating. Data on the high percentage of Black men in the American prison system, the number suffering from mental illness, and their lower life expectancy in comparison to White men were often repeated with such regularity that they were removed from any contextual discussion of the history of the roles that socioeconomics, psychosocial dynamics, and sociopolitical events play in understanding, but not justifying, the history and the current condition of racism and its effects on Black men in the United States.[5] Golden raised the

following questions through the exhibition: How does one negotiate the image of Black men in the media, the list of statistics, personal experiences, artists' intentions, and Black men's experiences? How can Black masculinity be represented through exhibition in the American art museum? In her catalogue essay "My Brother," Golden states the problem in the perception of the exhibition subject matter: "Black masculinity suffers not just from overrepresentation, but oversimplification, demonization, and (at times) utter incomprehension." Her project was to "examine the black male as body and political icon."[6] That a mainstream art institution was willing to organize and exhibit the ambitious exhibition was unprecedented.

Golden chose 1968 as the date to begin looking at representations of Black masculinity for two reasons. First, she was interested in examining the transitional period between the Civil Rights Movement and the Black Power Movement.[7] Second, she was influenced by Guy C. McElroy's compelling exhibition *Facing History: The Black Image in American Art, 1710–1940*, displayed at the Corcoran Museum of Art and the Brooklyn Museum of Art in 1990. Because Golden thought that *Facing History* was so thorough in its examination of representations of Black men and women in American art through nearly half of the twentieth century, she was inspired to continue this type of thematic investigation through her own exhibition.

Black Male continued the project of exploring Black representation, but omitted Black women from the equation. This decision was upsetting to some viewers and cultural activists who were invested in preserving a specific idea of the Black family—a nuclear heterosexual one in which the husband/father has a Black wife/mother who nurtures their children. Because Black contributions to American culture have been either ignored or misrepresented in American history and art history, privileging Black men's experiences over Black women's was a divisive exclusion through gender that some believed we could not afford. In his essay "Introduction: Where and When Black Men Enter," Devon W. Carbado explains that, although the focus on Black men in anti-racist discourse is important in light of the statistics on violent deaths, crime, and incarceration, "without a similar focus on Black women, Black men are perceived to be *significantly* more vulnerable and *significantly* more 'endangered' than Black women. They become the quintessential example of the effects of racial subordination."[8]

Carbado argues that the focus on Black men as a separate group to be given special attention isolates Black women and disregards the larger Black cultural

body. By default, Black women are considered unimportant and invisible. The exclusion of Black women from representations of Black men creates a homosocial environment that includes Black gay male culture. Because of this, homophobic Black communities that promote the nuclear heterosexual family and reject homosexuality as immoral and racially divisive are threatened by the absence of Black women in the representation of Black masculinity.[9]

The Exhibition

The exhibition was organized into five sections according to historical moments or signposts that Golden selected. The first signpost marked the transition from the Civil Rights Movement to the Black Power era, the pivotal moment in which Golden wanted to begin the exhibition because it "signified a change in the American consciousness, both black and white."[10] The second signpost recognized blaxploitation film as a Black-produced movement that rejected previous clean-cut images of Blacks in White-produced films and created larger-than-life, violent, misogynist films about Black characters. These films became popular with some Black audiences because the characters were so powerful and fearless. The third signpost regarded the lists of fatalistic statistics used in arguments that Black men are an endangered species. The fourth marked the rise of rap music and hip-hop culture as an international phenomenon. The fifth recognized the trauma of events current to the exhibition, namely the police beating of Rodney King and its effect on the lives of Black men in this nation.

Further organizing *Black Male* was a color schematic of red, black, and green that layered the presentation of artwork with context and historical meaning. The three colors have significant historical meanings in Afrocentric culture: red for blood, black for Black people, and green for the earth and growth. In the exhibition, the red section included images that Golden had chosen to present a challenge to negative stereotypes. She defines these stereotypes of Black masculinity as both "real and imagined."[11] The black section presented images of the Black male body and "symbolic depictions of the black male psyche." The green section presented work that offered possibilities for diverse ways to represent masculinity.

Entering the first gallery, visitors were greeted by an artwork that criticized the often overlooked presence of Black men in the museum context.

Fred Wilson's *Guarded View* (1991), which consists of four headless male brown-skinned mannequins wearing gallery guard uniforms, stood appropriately in front of the exhibition title wall (plate 9). The uniforms of these headless protectors represent four major New York museums: the Whitney, the Jewish Museum, the Metropolitan Museum of Art, and the Museum of Modern Art. The work appears to ask whether, within these museums, the Black men working as guards outnumber the Black artists who have works in the collection or Black men depicted in artworks in the collection. In the case of most exhibitions at these museums, the Black male guards are protectors of objects that often discount their visibility. Museum guards are often treated by visitors, and some museum professionals, as fixtures that are extensions of the museum apparatus instead of as actual people.

Originally, Fred Wilson (who has worked as a guard in several museums in New York) conceived of *Guarded View* as a performance piece called *My Life As a Dog* in 1992. After the idea was approved by Constance Wolf, head of education, museum director David Ross, and the Whitney guards, who were mostly Black men, Wilson appeared dressed as a guard on a Sunday afternoon in the Whitney's permanent collection galleries. As Golden relayed the story,

> He had some props that were hidden in the little maintenance closet, magic markers, sheets of vellum to put on the wall, and basically he just started talking. He would just move out of his post, go up to a work, talk about it, talk to people, say, "What do you think of this work?" It was amazing because half the people ran down to the front desk and said, "There's a guard going crazy." And he was only talking about work and any of you who know, Fred is very smart, so it was not like he was babbling. He was saying intelligent things, but they said, "There is a guard going crazy on the floor." Other people walked up to him and said, "Oh my God, you are so smart. You know you should not be a guard." Equally as problematic. And this went on all afternoon.[12]

Out of this performance came the work *Guarded View*, an institutional criticism of the museum and commentary on museum visitors' viewing practices. In his *Black Male* review, Jorge Daniel Veneciano relates his experience watching visitor interactions with the work. He recounts an incident in which a woman jumped in fear after mistaking a real living gallery guard standing beside *Guarded View* as an object on display. The woman apologetically told the guard that she thought he was part of the exhibit because

he was standing so still.[13] Veneciano's experience illustrates the irony and strength of Wilson's piece to make the invisibility of guards visible.

Lyle Ashton Harris contributed to the exhibition through his nude self-portrait photographs from the series *Constructs* (1989) (plate 10). In this work, Harris references two other series of Black male nudes, *Black Males* and *Black Book* by Robert Mapplethorpe, also included in the exhibition. Harris creates a dialogue with Mapplethorpe's work in three ways. First, he responds as an artist by using himself as the subject of his images. This assertion as the creator and model stands in contrast to Mapplethorpe's work, in which Mapplethorpe is the White creator of the images of the Black body. Second, Harris's nudes expose the artificiality of the studio environment for the photographs, a strategy that interrupts the viewing of conventional portrait photography. By revealing the visual context of the photography studio, Harris disrupts the depiction of an idealistic fantasy around the Black male body. Traditionally, studio backdrops or outdoor, jungle-like, natural environments devoid of a recognizable location have often perpetuated fantasies of the Black male body.[14] By rupturing the seamless background of the portrait, Harris challenges Mapplethorpe's depiction of the Black male body as an object of fantasy and exposes the practical apparatus of photography as the means to document the reality of the subject and object positions in portrait photography. In his own words, Harris says, "I see myself involved in a project of resuscitation—giving life back to the black male body."[15] Third, Harris uses props such as a white tulle tutu-like skirt, a wedding veil, and wigs that feminize the image. These accoutrements play with the idea of Black masculinity and gay identity and confront the hypermasculine portraits of the Black body in Mapplethorpe's work. By taking control over his objectification, Harris makes his identity as a Black gay man and as an artist (who is engaged with the history of the representation of Black masculinity) visible on his own terms.

bell hooks has written about the dangerous dominance of Mapplethorpe's images of Black male nudes, saying that they have been privileged as the quintessential images of this genre not only in the art world but in popular culture. Because of the popularity of Mapplethorpe's Black male nudes, all other artists who work with the same subject matter are pressured to reference Mapplethorpe's work in their own. hooks explains that this privileging of Mapplethorpe's work "subordinates all other image-making of the black male body both by insisting that it reference or mirror this work and

by continually foregrounding these images in ways that erase and exclude more compelling oppositional representations."[16] Harris's work accepts this challenge of the authority of Mapplethorpe's images and is able not only to respond to them, but to critique them in a way that gives Harris's work its own place and dimension on which to build other images of the Black male body.

The critical interpretation of Mapplethorpe's *Black Males* and *Black Book* has a complex history. In his 1986 essay "Imaging the Black Man's Sex," Kobena Mercer criticizes Mapplethorpe's Black male nudes, saying,

> Certainly this particular work must be set in the context of Mapplethorpe's oeuvre as a whole: through his cool and deadly gaze each found object— "flowers, S/M, blacks"—is brought under the clinical precision of his master vision, his complete control of photo-technique, and thus aestheticized to the abject status of thinghood.[17]

This response to Mapplethorpe's work echoed the reaction of many viewers, especially Black viewers, who were particularly sensitive to the history of the objectification of Black bodies. Although Mapplethorpe's technical ability as a photographer was undeniable, the content of the *Black Book* images called for a critique of his racial politics. Mercer continues to interrogate Mapplethorpe's politics and the relationship between *Black Book* and the larger context of racism and objectification.

> Mass-media stereotypes of black men—as criminals, athletes, entertainers— bear witness to the contemporary repetition of such colonial fantasy, in that the rigid and limited grid of representations through which black male subjects become publicly visible continues to reproduce certain idées fixes, ideological fictions and psychic fixations, about the nature of black sexuality and the "otherness" it is constructed to embody. As an artist, Mapplethorpe engineers a fantasy of absolute authority over the image of the black nude body by appropriating the function of the stereotype to stabilize the erotic objectification of racial otherness and thereby affirm his own identity as the sovereign I/eye empowered with mastery over the abject thinghood of the Other; as if the pictures implied, Eye have the power to turn you, base and worthless creature, into a work of art.[18]

Mercer makes a powerful critique of Mapplethorpe's project, marked with a heated passion about the work's connection to colonialism, erotic objectification, White power, and Black subordination. Mercer's emotional response to the work is in part due to his identity as a Black gay man and his alliance with Mapplethorpe's models.

In his 1989 essay "Skin Head Sex Thing: Racial Difference and the Homo-erotic Imaginary," Mercer reconsiders his critiques of Mapplethorpe's work and speaks of his ambivalence about the images. He articulates his views about the nudes, which both support and deny the potential of *Black Book* to present racist stereotypes. In *Black Male,* Mapplethorpe's work maintained this ambiguity in a double context. The parameters of *Black Male,* with Harris's work nearby, suggested an interpretation of Mapplethorpe's images as a celebration of Black gay identity. However, considering the institutional context of the museum as author of the exhibition and taking into account the popular racist attitudes highlighted by current events in the early 1990s, the work was likely to have been interpreted as denying Black male subjectivity. Recognition of the double context of the artworks considers the complexities and multiple responses to the work presented in the exhibition. Despite Golden's identity as a Black curator, the historical politics of the institution loomed over her position as organizer of the exhibition. Because of these contexts of double authorship, ambivalence in the interpretation of Mapplethorpe's work was highlighted.

Other works in *Black Male* were seemingly so in tune with the stereotypes of Black masculinity and heavily dependent on irony that they seemed to reinforce the image that the exhibition sought to investigate. Robert Colescott was represented by two paintings: *George Washington Carver Crossing the Delaware: Page from American History* (1975) and *Temptation of St. Anthony* (1983). Colescott is best known for his reinterpretations of famous Western paintings in which he often paints the White figures Black. He combines the realms of high and low art by presenting the characters in a highly expressionistic and parodist manner. The viewer's attention is drawn to the outrageous visual depictions and, for those who are familiar with his artistic references, to the paintings that he references. Ideally, viewers would go beyond the parody to a thoughtful consideration of the absence of Black figures in Western masterpieces and to the many representations of Blacks in the racist cartoon style from which he adopts his own. Not every viewer, however, gets beyond consternation to this point of reflection on his work, and Colescott has been accused of being racist and irresponsible because of this. One visitor to *Black Male* reports, "I read the museum description: '. . . white characters of Western art historical masterpieces are recast as blacks, who are rendered in typical racist cartoon style.' But I wonder if anyone else is reading the fine print. I wonder if many who see this

piece—who *need* to understand the ironies—are just seeing it as comedy. 'Hilarious,' I can hear some observers say."[19]

Two works by Leon Golub were included from a group of large-scale paintings. Known for his depictions of physical and psychological violence inspired by war and human conflict, in the 1980s Golub became interested in the racial tension and psychological effects of racism, sexism, and the abuse of power, particularly in the United States. In the exhibition, *Four Black Men* (1985) and *Three Seated Black Men* (1986) depicted Black men sitting in a linear fashion facing the viewer. These men appear to be casually hanging out together engaged in conversation. Although the scene suggests the conventions of a snapshot photograph, Golub's painting technique and composition render it in a more intriguing way. The textured sketchlike brushstrokes give an incomplete and otherworldly quality to the work. The figures appear oddly two-dimensional, awkwardly caught mid-action in their gestures—their weight unsettled in slightly twisted positions, and their arms raised at odd angles. Golub's paintings of Black men comment on the divide between public and private space that the exhibition freely transgressed. In *Black Male,* these paintings recreated the voyeurism that some visitors felt while viewing of images of Black men in the galleries. Golub's iconographic turn from war and combat in Southeast Asia to racial tensions and violence between Black and White people in the United States is indicative of the volatile social temper of the time.[20]

Mel Chin, a Chinese American conceptual artist, presented three customized ready-made sculptures in the exhibition, all of which illustrated the fear of the Black male body. For *Night Rap* (1994), the end of a black billy-club was covered with metal mesh to look like a microphone. The short side handle was shaped into the form of a penis. The work connotes police use of the weapon for rape, and more broadly, a symbol of abuse by authority. The microphone end could be commentary about the media's involvement with police abuse and misconduct in situations dealing with Black men like Rodney King and O. J. Simpson. In these interpretations, *Night Rap* enunciates connections between power, sex, and violence. *HOMEySEW "9"* (1994) consisted of a Glock 9mm handgun with items from a first aid kit placed inside. The self-contained object has the power to wound a victim and then facilitate healing, underscoring the absurdity and frequency of gun violence. *Impotent Victory* (1994) is a high-top basketball shoe modified to assume the shape of a penis and testicles. The piece alludes to male

athletes, the lure of sports fame, and the inability to reach one's goal. Chin's work was clever, but in the context of *Black Male,* his in-your-face works seemed especially confrontational. Although some viewers assumed that Chin was sympathetic to or critical of the stereotypes of Black men as criminals, drug addicts, and athletes, his works agitated other viewers.[21]

In addition to the artwork, *Black Male* offered extensive public programs in conjunction with the exhibition. These included seminars with artists Pat Ward Williams, Gary Simmons, and Carl Pope, filmmakers Melvin Van Peebles and St. Clair Bourne, and cultural critics Clyde Taylor, bell hooks, Michele Wallace, and Phillip Brian Harper; a five-part film and video series composed by five guest curators; and a course taught by Judith Wilson, then assistant professor of art history and African–African American Studies at Yale. Van Peebles, a leading blaxploitation filmmaker in the 1970s most noted for his influential cult classic *Sweet Sweetback's Baadasss Song* (1972), and Bourne, a contemporary documentary filmmaker, discussed their films and the issues of Black representation in film and the filmmaking industry. Their conversation allowed participants to learn more about their projects and to ask questions about the larger issues explored in their work.

Judith Wilson's three-part art history course addressed the ways that visual art reflects racial and cultural politics in the United States, specifically in terms of nationalism, American identity, and ethnicity in the current age of consumer culture. Her course did not address *Black Male* directly, but provided a larger global and economic context for understanding why an exhibition on Black masculinity had relevance for a mainstream American art museum at the end of the twentieth century. The programs for *Black Male* facilitated conversation and the exchange of ideas between the museum and its communities.

Golden wanted to go beyond traditional public programs to have dialogues with artists and the public about the exhibition. She would meet with artists outside the museum or have them attend programs not organized by the museum where *Black Male* was being discussed. For example, Danny Tisdale, an artist in *Black Male* who is also a political activist, went to meetings that Golden was "afraid to go to" where *Black Male* was discussed in public forums. Tisdale defended the exhibition in these forums from the perspective of an artist.[22]

Not Black Male to Me

Although there was some variation in the reviews of *Black Male,* the most common criticism was that the exhibition focused on degrading images of Black masculinity and therefore appeared to support these images rather than open productive discussions about them.

In his *New York Times* review, Michael Kimmelman explains,

> The problem is the show is small in scope. Too much of it consists of the sort of uncharismatic objects ubiquitous in the art world today with meanings nearly impossible to decipher. Some of the works are so obscurantist they're prone to be misconstrued. Thelma Golden, the show's curator, writes in the cata-logue that "media fascination around black masculinity is always concentrated in three areas: sex, crime and sport." But you can come away from the exhibi-tion dispirited by the preponderance of art that seems to define the black man in just those terms while purporting to expose and debunk the stereotypes.[23]

The cultural critic and art historian Okwui Enwezor revealed his initial attraction to and later hurt and disappointment with *Black Male:*

> The transformation of the subject (the "black male") was what drew me initially to Golden's project. As one of the specimens being studied, I felt excited, yet nervous. I felt troubled by the idea, but nevertheless hopeful that the exhibit would present meaningful insight and articulation of real black men's relation to what we represent in the contemporary imagination. But here, the body in question looks unrecognizable even to itself. Insistently sited within a kind of temporal abyss, one comes upon it as perpetual fragments; one sees it as diminished, disembodied, and homeless. And in this abject homelessness, it lies wasted, consumed and ravished; its psyche ransacked.[24]

Journalist Wyatt Closs discusses his response to Gary Simmons's *The Lineup* (1993), which consists of eight pairs of gold-plated basketball shoes side by side in front of a police lineup wall for suspected criminals. Closs received a message that:

> Young brothers are accused in droves every day; any black man is suspect. . . . Still, although I can't see myself in Simmons' piece, I know other people see me there. And that is exactly what I hear this exhibit saying: These images are not about me, but about how others see me. I'm cool with the artistic intent; my cynicism runs deep, and the images are cynical representations of hard reali-ties. I "get it"—the ironies, the stereotypes, the gestures. But does the white guy with the suede elbow patches next to me understand? Are these bold statements enlightening him—or are they simply reinforcing stereotypes?

... The artists and the Whitney staff are assuming a certain level of wit and sensitivity on the part of the public, which is not generally known for hip openmindedness.[25]

Jen Budney of *Flash Art* appreciated the diversity of the works, calling the show "expansive and inclusive." She writes that though there are moments of "blandness" in the exhibition, "'Black Male' is a most important, radical art event. If only all exhibitions felt this way. 'Black Male' has power and something is actually happening at the museum."[26]

In his *New York Magazine* review, Mark Stevens appreciated the absence of the museum's critical views. Not expecting much of the show because of his distaste for the wall texts in the 1993 Whitney Biennial, Stevens was pleased that in *Black Male* the "writing is less intrusive and jargon-choked than usual.... The exhibition does not have that haranguing, oppressively educational voice-over that often overwhelms art. The work can breathe; one can think for oneself." He found the work "melancholy" and was pleased that the exhibition did not contain "much visual counterpart to rap music, not much in-your-face anger."[27] He argued that the uncritical context of the exhibition did not lead viewers to believe in stereotypes. In his analysis of Carrie Mae Weems's photographic work *The Kitchen Table Series* (1990), which depicts a romantic relationship between a Black man and woman around her kitchen table, Stevens writes:

> The relationship, not surprisingly, does not work out. Does the viewer ever think about black stereotypes? I doubt it. To be sure, the couple is subject to the kinds of interpersonal tensions that reportedly afflict the black community (she has a job, for example, whereas he doesn't). But it is the counterpoint between the lush romantic writing and the harsh kitchen light that creates the power of the piece.[28]

However, his expectation that the relationship would fail and his belief that most Black men are unemployed make his claim about not thinking about black stereotypes suspect.

It is helpful to consider the burden of representation in understanding the criticism of the exhibition from both the mainstream and Black art worlds. Kobena Mercer expresses frustration with the burden of representation:

> If, after many years of struggle, you arrive at the threshold of enunciation and are "given" the right to speak, is it not the case that there will be an overwhelming pressure to try and tell the whole story all at once? If there is likely to be only the one opportunity to make your voice heard is it not the case that

there will be an intolerable imperative to try and say everything there is to be said, all in one mouthful?[29]

Mercer articulates the predicament that the Whitney, Golden, the exhibition's Black artists, critics, and viewers faced. For decades, the Whitney had been pressured to exhibit the works of Black artists, and *Black Male* presented the museum with another opportunity to ease Black frustration with under-representation and misrepresentation.[30] Golden faced the burden of representation as a Black woman who wanted to curate an exhibition focused along racial and gender lines within this exclusive institution. Black artists who were invited to contribute work faced the burden of representing a quintessential perspective about Black masculinity. Critics and viewers anticipated an exhibition that reflected their beliefs about Black masculinity and would speak to the current anxieties about Black men. Many hoped to find work that would engage them in the discourse of Black masculinity in thoughtful and inspiring ways.

The "intolerable imperative" of which Mercer writes describes the anxiety and importance of the opportunity presented. Because there is no way to say everything there is to be said, the burden of representation pressured the Whitney, Golden, and the exhibition's Black artists to create a project that could not meet the many expectations for Black representation. For both the Whitney and Golden, the rarity of contemporary exhibitions by Black artists organized by mainstream institutions increased the burden. *Black Male* was doomed to bear the impossible pressure of representing the individual experiences of its audience, or at least to represent every artistic interpretation of Black masculinity produced since 1968.

For curator and artist Willie Middlebrook, participation in the exhibitions about Black masculinity in Los Angeles was about making more image choices of Black masculinity available to the public: "This show [*Black Male*] would mean nothing if I could regularly go and see other images of African-Americans. I don't have a problem with the show if there were shows on a regular basis. But the last major show was 'Two Centuries of Black Art,' and that was 18 years ago at LACMA."[31]

Moving West

After a four-month run at the Whitney, *Black Male* traveled to the Armand Hammer Museum of Art and Cultural Center in Los Angeles.[32] Upon its arriv-

al there, a group of Black artists, community activists, and museum workers, led by Cecil Fergerson, created three exhibitions collectively called *African American Representations of Masculinity (AARM)*. These were *Paul Robeson & the Black Panthers*, at the William Grant Still Art Center (April 29–May 29, 1995) curated by Alden and Mary Kimbrough with Fergerson; *African American Representations of Masculinity*, at the Museum of African American Art (May 3–June 3, 1995); and *Contemporary African American Photography* at Watts Towers Art Center (May 13–June 15, 1995), curated by Donald Bernard, Roland Charles, and Willie Robert Middlebrook. *AARM* also included a lecture series at the California Afro-American Museum (now the California African American Museum) in Exposition Park. Fergerson responded to *Black Male* from a strong local base of artists and private and public arts organizations, including the Norton Family Foundation.[33] He chose not to confine the *AARM* exhibitions to representations of Black masculinity in art for fear that the images would not defy stereotypes. The exhibitions included art, but also other forms of visual documentation to educate viewers about Black masculinity.[34] Twelve of the sixty-nine artists in the *AARM* exhibitions were women. All the artists were Black. Many people involved with the *AARM* exhibitions agreed that *Black Male* was degrading, stereotypical, and pornographic; however, Fergerson wanted the series of *AARM* exhibitions to be a complement to *Black Male* and not a challenge.[35] *AARM*'s dissatisfaction with *Black Male* demonstrates the diverse opinions concerning how to represent Black masculinity in art. It also addresses the challenge of representation and the desire for self-representation within Black communities.

The Los Angeles community had the opportunity to know about *Black Male* and to prepare its various positions on the exhibition before it arrived. Fergerson, who did not see the show in New York or in Los Angeles, began to organize *AARM* and the subsequent exhibitions after a meeting at the home of Peter and Eileen Norton, contemporary art collectors and exhibition sponsors. Known for his involvement in Los Angeles' Black arts communities and his outspoken political views on Black power, Fergerson was invited to the meeting so that he could preview the exhibition project, presumably voice his opinions, and ask any questions before the exhibition was placed on view.[36] It was a smart political move and a respectful gesture to include a leader of the Black community of Los Angeles before the exhibition opened, although it did not result in his acceptance or approval.

At this meeting, Thelma Golden presented information about the exhi-

bition and showed slides of works from *Black Male* to representatives of the press, artists in the exhibition, and staff from the Hammer. After viewing a slide of Colescott's *George Washington Carver Crossing the Delaware: Page from American History*, the group began to laugh. Fergerson raised his hand in objection and voiced his discomfort with the piece and his offense at the group's laughter. His objection to Colescott's work is long-standing. Although Fergerson understands Colescott's intended critique, he does not approve of his strategy of intervention.[37] Ideologically, he disapproves of using racist imagery in artwork to make critical commentary. Fergerson did not receive a satisfactory response to his objection, and he left the meeting. Upset by both the meeting and the upcoming exhibition, he began to organize his own exhibitions the next day.

Fergerson was demonstrative about his dissatisfaction with the discrimination he saw at LACMA, both through exhibitions and through the overwhelmingly White museum staff.[38] For the *AARM* exhibitions he created an accompanying booklet. On its cover is the pencil drawing *Lion, Lioness, and Cub* by Cedric Adams, which embodies the image of Black masculinity that Fergerson wanted to promote (1994) (figure 26). The drawing's title implies that the trio depicted is a family unit, like the African animal family that they are named after. As the signature image for the *AARM* exhibitions, Adams's drawing defined Black men as heterosexual, fathers, family leaders, and powerful like the king of the jungle. The booklet consists of five essays, illustrations, two poems, and an opening statement by Fergerson. This declaration explained why the *AARM* exhibitions were organized.

> One reason for mounting the AFRICAN AMERICAN REPRESENTATIONS OF MASCULINITY exhibition is because we believe it is about time the African American male spoke for himself about his relationship in today's society. We are bombarded daily in all media . . . Black Males face extinction due to black-on-black crime, unemployment, gang and/or delinquent behavior, absentee "fatherism," police brutality, undereducation, spousal abuse/neglect and drug abuse. Is it any wonder many younger African American males feel a sense of defeat even before they have learned how to live?
>
> The African American Community feels so strongly about the issues facing African American males that it is responding in conjunction with the COALITION FOR CULTURAL SURVIVAL OF COMMUNITY ARTS, FRIENDS OF WILLIAM GRANT STILL ARTS CENTER, AND WATTS ACTION COUNCIL to celebrate the life and legacy of the strong, prolific, productive, creative, genius of the African American Male.[39]

The *AARM* Exhibitions

The first *AARM* exhibition, *Paul Robeson & the Black Panthers,* presented information through photographs and documents about Paul Robeson along with the political graphics of Emory Douglas, former minister of culture and production manager for the Black Panther newsletter from 1967 to 1980. The exhibition also presented study drawings for the local mural of the Black Panthers, *To Protect and Serve,* by Noni Olabisi. This insertion of Robeson as one part of the *AARM* shows provided a moment of acknowledgment and reverence that some critics of *Black Male* believed was lacking. Although the exhibition about Robeson was not an exhibition of contemporary art, it was a reminder of the reality of Black masculinity in one man's life and the struggle for visibility, power, and respect on the national stage. Works by Emory Douglas presented some of his political posters created for the Black Panthers, along with his work used on front covers of the party's newsletter. In the exhibition, Douglas's Black masculinity was celebrated as part of the leadership of a Black Nationalist organization and as that of an artist who used his talents to educate others and promote a Black Nationalist agenda.

Drawings of Noni Olabisi's controversial mural *To Protect and Serve* (1994) testified to the relevance and longevity of the Black Panthers (plate 11). The mural was commissioned by the Social and Public Art Resource Center (SPARC) as part of its Neighborhood Pride mural program. However, Olabisi had difficulty securing funding from the Cultural Affairs Commission of Los Angeles because the Commission thought the mural would incite violence.[40] The forty-foot mural depicts a range of images of the Black Panthers' activity such as the free breakfast program, Huey P. Newton holding a rifle, a gagged and bound Bobby Seale, police brutality against Black men, and the Ku Klux Klan preparing for a lynching. The mural's execution in the Crenshaw district, a predominately Black middle-class area of Los Angeles, was delayed for nearly a year because of struggles between the city and some local residents who argued that the mural did not present the image that they wanted their neighborhood to project. Eventually the project went forward, and the mural was completed by the time the *AARM* exhibitions opened. The disagreement over Olabisi's mural reveals the various conflicting ideas about how to represent Black masculinity within a single Black neighborhood, underscoring how embattled *Black Male* was destined to be. It is likely that in the context of *Black Male,* the mural itself would have been interpreted as promoting stereotypes.

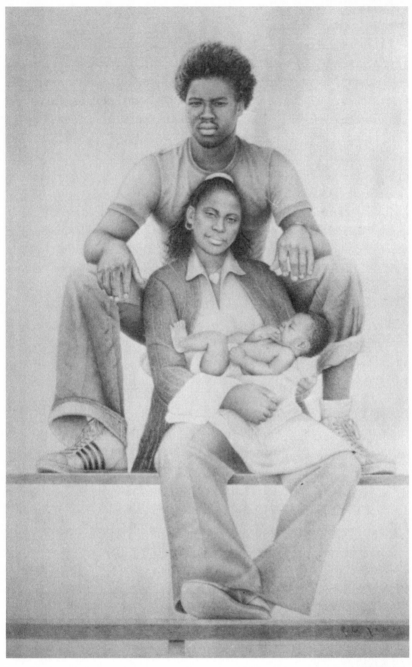

Figure 26.
Cedric Adams, *Lion, Lioness, and Cub* (1994).
Master drawing, graphite on paper, 64" x 44."
Courtesy of Cedric Adams.

In the *AARM* exhibitions, recurring themes of family and freedom from physical and social boundaries were explored. Sculptor Artis Lane presented *Emerging New Man Fragment* from her *Emerging into Spirit* bronze series (1993) (plate 12). This sculpture depicts the head and the tall muscular torso of a Black man whose legs and arms have been partially cut off. Circles of wire wrapped around the torso confine and restrict the figure. On his face, neck, arms, and groin area are lumps of white clay. In the state of movement depicted in the sculpture, the debris seems to be falling away as the man stretches to be free.

John Outterbridge included his large-scale assemblage sculpture *In Search of the Missing Mule* (1993) (plate 13). The mule is a symbol that appears in much of Outterbridge's work. Composed of a tall metal box, struts of a chair, leather from a World War I army uniform, a mule collar, and a rope tied in a noose, *In Search of the Missing Mule* is a metaphor for African American labor and a symbol of a strong work ethic. Outterbridge believes that the mule and African Americans are "old friends" who labored together to build America.[41] Around the head where the eyes would be is a blindfold made from a torn and bleached American flag. Outterbridge blinded the figure in this way to give the figure courage. As he describes it, the figure is "blind but still in search."[42] What the figure is in search of is not only the missing mule, but also the freedom that was promised.

These two examples depict popular themes found in art from Black communities, but rarely in the mainstream art world. The ideological arguments of these two worlds became clear in the case of *Black Male* and the *AARM* exhibitions. Works in *Black Male,* such as *George Washington Carver Crossing the Delaware: Page from American History,* represented Black men through parody in order to deconstruct the role of Black men in American history. *Black Male* asked that viewers look ironically at overtly offensive images like Colescott's to find the meanings behind them. The *AARM* exhibitions argued that showing racist images was damaging and degrading. I agree with Susan Kandel's assessment that the overwhelmingly "positive" images of Black men as heads of heterosexual families, creative musicians, and teachers "risks oversimplifying the tangled realities the African American male must confront."[43] What we see in the *AARM* exhibitions counters Fergerson's perception of *Black Male* by focusing directly, and not ironically, on narratives of African American male survival and struggle. Most of the works in the *AARM* exhibitions did not take an in-your-face

approach or use the sort of shocking visual imagery that made *Black Male* so provocative.

In his exhibition review of *Black Male*, Donald Odita posed the following intriguing questions:

It is clear that Black Male identity needs to be realized separately from the codes that have previously formed representations of him. But how? Was the "Black Male" allowed his own voice, or are we hearing the same old ventriloquism? The question I have to ask is how does the Black Male represent himself outside of his "otherness" in historical representation and in America as an object of white fear and white desire?[44]

The act of ventriloquism provides an interesting way to think about representation in the case of *Black Male*. Golden could not speak for Black men on the representation of Black masculinity; however, her goal was not to present what Black men thought about their masculinity, but to present Black masculinity in contemporary art, whether the artist was a Black male or not. In Golden's own words,

I have said this about four million times. This show is *not* about representation. This is not a documentary survey on black men as they live and breathe today, it is not a catalogue of types. It is about the way in which contemporary artists have looked at black masculinity, especially how it has been portrayed in pop culture.[45]

What did *Black Male* add to the discipline of the representation of Black men in art and Black men in America? How could a curator think that she could present an exhibition of images of Black masculinity in pop culture at a major mainstream art institution in 1994 without making a statement about the state of Black masculinity through that exhibition? How could Golden say that an art show titled *Black Male: Representations of Masculinity in Contemporary American Art* was not about representation?

What *Black Male* added to the critical discourse of Black masculinity was another event to talk about. Although Golden designed the exhibition to "show how complex this topic and the notions of representation are and how there is no one way to depict black masculinity," unfortunately it did little to actually develop the debate between positive and negative representations, expand the discussion for alternative ways to think about Black masculinity, or deal with the prevailing notions about Black men.[46] To her credit, nonetheless, Golden was able to mount this ambitious exhibition and withstand

the criticism of her work. She also provided a project to learn from for future exhibitions of Black masculinity and race and gender in contemporary art.

In her book *Art on My Mind*, bell hooks calls for meeting a responsibility for representing the Black male body: "Any libratory visual aesthetics of the black male body must engage a body politic that critically addresses the way in which racist/sexist iconography refigured within the framework of contemporary fascination with the 'other' continues to be the dominant backdrop framing the way images are created and talked about."[47] Hooks says that there must be a grounding of images of the Black male body in the context of racist and sexist history that continues to inform viewers today. Art in the context of the *AARM* exhibitions worked to resist dominant stereotypes of Black men, yet some promoted a limited definition of Black masculinity.

For different viewers, the works in both exhibitions had the potential for multiple meanings. The question of interpretation is at the root of the struggle for representation in this case. *Black Male* stayed true to its subtitle as an exhibition of representations of masculinity in contemporary American art. But although some of the works in the exhibition were powerful in representing Black male self-determination, contributing to a thought-provoking exhibition and promoting the projects of examining history and the present moment, the exhibition failed to consistently challenge what is already popularly assumed about Black masculinity.

Both *Black Male* and the *AARM* exhibitions were concerned with a critique of the invisibility and objectification of Black masculinity. The *AARM* coalition approached its critique of *Black Male* with two strategies for changing what Stuart Hall has called "the relations of representation." First, it exercised the rights to access Black representation by organizing artwork by Black artists and exhibiting it in African American exhibition venues. Second, it contested the representations in *Black Male* "by the counter-position of a *positive* black imagery."[48]

Hall discusses a crucial shift in the politics of representation that deconstructs the notion of the essential Black subject, which can be represented through simplified categories of positive and negative. In organizing *Black Male*, Golden recognized the necessary shift from a strategy of representing Blackness as a group united by "the common experience of racism and marginalization."[49] Some of the works in *Black Male* were informed by postcolonial theory, feminism, and queer theory, and therefore utilized strategies for Black representation that displaced strategies for representing an

essentialized Black subject. Hall explains what is at stake in this shift of Black representation:

> What is at issue here is the recognition of the extraordinary diversity of sub-ject positions, social experiences and cultural identities which compose the category "black": that is, the recognition that "black" is essentially a politically and culturally *constructed* category, which cannot be grounded in a set of fixed trans-cultural or transcendental racial categories and which therefore has no guarantees in nature. What this brings into play is the recognition of the immense diversity and differentiation of the historical and cultural experi-ence of black subjects. This inevitably entails a weakening or fading of the notion that "race" or some composite notion of race around the term black will either guarantee the effectivity of any cultural practice or determine in any final sense its aesthetic value.[50]

The imbalance of representations of Black masculinity in *Black Male* was caused by a complicated strategy of Black representation replacing a more simplified one. This replacement is what caused the tension in the politics of representation that the *AARM* coalition responded to. Hall articulates this struggle between strategies for Black representation that reflect con-testing definitions of Blackness:

> There is no sense in which a new phase in black cultural politics could replace the earlier one. Nevertheless it is true that as the struggle moves forward and assumes new forms, it does to some degree displace, reorganize and reposi-tion the different cultural strategies in relation to one another. If this can be conceived of in terms of the "burden of representation," I would put the point in this form: that black artists and cultural workers now have to struggle, not on one, but on two fronts.[51]

Ideally, ideas explored in both exhibitions would have been exchanged. The *AARM* exhibitions could have complicated ideas of Black masculin-ity by presenting more works that used humor, irony, and more creative strategies to explore the subject. *Black Male* could have been more sensitive to the societal tensions concerning Black masculinity at the time and the consequences of the selection of work presented. The inclusion of works of art that explored some of the concerns that were important to the *AARM* coalition would have presented a more complete and diverse look at rep-resentations of Black masculinity in contemporary art. However, together both shows testified to the diversity of ideas about Black masculinity and the investment in the images of Black men in art and popular culture; each showed how Blackness operates in our culture as a limiting trope, instead

of an identity that has the freedom of infinite possibilities. The exhibitions provided opportunities for viewers to think through the social role of Black men in America through art. Kobena Mercer's articulation of the function of the Black male in the national psyche elucidates this issue,

> Overrepresented in statistics on homicide and suicide, misrepresented in the media as the personification of drugs, disease and crime, such invisible men, like their all-too-visible counterparts, suggest that black masculinity is not merely a social identity in crisis. It is also a key site of ideological representation upon which the nation's crisis comes to be dramatized, demonized, and dealt with—enter Willie Horton as apogee of the most *un*American Otherness imaginable.[52]

The presentation of images in *Black Male* and the *AARM* exhibitions allowed viewers to see the contradictions of race, sexuality, poverty, and violence around the discourse of Black masculinity. Controversy could not be avoided, nor did it need to be. The exhibitions forced anxieties about race, diversity, power, and the national body to the surface to be addressed. After the exhibitions Golden summarized the discourse about *Black Male*: "People were starving to see a show about African American art, but not necessarily what I was showing—but I never saw more people come into the Museum. They came to see what the controversy was about. Either way I'm just happy they came."[53]

CHAPTER 5

BACK TO THE FUTURE

The Quilts of Gee's Bend, 2002

Transgressing normalized boundaries of gender, class, race, and elitist investments in high versus low art, *The Quilts of Gee's Bend* was bound to be one of the most talked about exhibitions in American museum history. The exhibition featured seventy-one quilts made between 1930 and 1997 by forty-four women from the rural and isolated community of Gee's Bend, Alabama.[1] The show premiered in 2002 at the Museum of Fine Arts, Houston, before traveling for nearly six years to twelve other major American art museums on the East Coast and in the Midwest, West, and South (plate 14).[2] This serious validation of Black women's quilts by the mainstream art world was unprecedented. The transformation of the quilts from personal utilitarian objects to works of art proved to be an extraordinary challenge to some visitors and critics, although among the thousands of viewers, many of whom stood in long lines to see the quilts, the exhibition was deemed a compelling success.[3]

The making of quilts in America dates back to the British colonial immigrants of the eighteenth century. They have long been a part of American homes for warmth, individual expression, and storytelling in the seemingly endless improvisation of design, pattern, fabric, stitching, and embroidery. Although fans and collectors of quilts would not dispute their value as beautiful treasures, like many objects that have been relegated as "women's work" in the domestic sphere, quilts have largely been ignored by art museums until

recently in their history. The first serious exhibition of American quilts by a major American art museum was *Abstract Design in American Quilts,* curated in 1971 by quilt scholar Jonathan Holstein at the Whitney Museum of American Art. And in the last ten years, quilts have appeared in American art museums with greater frequency. In this period, no other quilts have received as much attention in American art museums as the quilts of Gee's Bend.[4]

The quilts have become a cultural phenomenon as a result of their exhibition. The quilts and their merchandising are remarkable. Beginning in 2002, catalogues, postcards, and calendars featuring the quilts were published and ties, scarves, magnets, and mugs were manufactured. In the same year, Tinwood Media released the Gee's Bend Singers' debut double CD called *How We Get Over: Sacred Songs of Gee's Bend* (2002), which consists of recordings made in 1941 and 2002.[5] But, there's more. In 2003 the clothing store Anthroplogie began selling reproductions of the quilts. In 2004, a former model turned entrepreneur, Kathy Ireland, launched products in her Gee's Bend Design Solution home furnishing line that transformed Gee's Bend quilt designs into rugs and lamps. In the summer of 2006, the United States Postal Service released the *Quilts of Gee's Bend* postage stamps, featuring ten quilts created between 1940 and 2001. The stamps were released at the largest annual philatelic event in the nation, and were the sixth release in the postal service's prestigious American Treasures Series established "to showcase beautiful works of American fine art and crafts."[6] In 2010, the home accessories retailer Pottery Barn included Gee's Bend quilt designs in its "Museum Craft Collection" created in collaboration with the American Folk Art Museum in New York and the Gee's Bend Collective.

In addition to the merchandising impact of the quilts, their exhibitions have inspired writers to create stories based on the quilts, the women, and their hometown. In 2007, playwright Elyzabeth Gregory Wilder debuted her critically acclaimed play *Gee's Bend* in Atlanta, and it has since toured nationwide. In April 2008, Republican presidential candidate John McCain visited the women on his "Straight Talk" campaign tour. Also in 2008, author Patricia C. McKissak published her children's book *Stitchin' and Pullin': A Gee's Bend Quilt* with illustrations by Cozbi A. Cabrera. In 2010, Irene Lathan published her novel *Leaving Gee's Bend,* which chronicles the story of a young Black girl in Gee's Bend named Ludelphia Bennett who travels to get help for her sick mother in 1932. The exhibitions, the quilters, and the story of Gee's Bend have been met with popular enthusiasm

across the country from individuals, institutions, and even the federal government.

Critical response to the quilts' first art museum exhibition, *The Quilts of Gee's Bend,* was controversial because of the unusual attention given to quilts, objects not originally made to function as artwork, by prestigious art institutions. The quilts were hung on the gallery walls like abstract paintings made by a group of women unknown to the art world and associated with a largely unknown and unfamiliar place. The art museum's appropriation of the traditional practice of quilting resulted in typical modernist discussions contesting the hierarchical boundaries of high and low art. This modernist practice is not new to the art world; however, the affinity comparisons explored in the catalogue and reviews of the exhibition are usually reserved for artifacts made by "non-Western" groups instead of contemporary African American women.

This chapter explores the persistence of limited critical frameworks for exhibiting and interpreting Black creativity in the American art museum. *The Quilts of Gee's Bend* brought together both anthropological and corrective approaches to understanding African American art in its curatorial goals and critical reviews. Despite the intent of the curators to simply share the exquisite beauty and tradition of quilting in Gee's Bend, the exhibition recalled the curatorial strategies of the museum exhibitions of African American art from the 1930s. Instead of contextualizing the women as pre-modern ancestors, art reviews separated the women's identities from their quilts in order to celebrate the objects as valuable because of similar visual abstractions found in modernist paintings by White male artists. *The Quilts of Gee's Bend* exhibited contemporary aesthetic objects by African Americans, similar to *Contemporary Negro Art* (1939), yet maintained the lens of anthropological discovery used to introduce the sculpture of William Edmondson in 1937.

Further, this chapter explores what is lost, gained, and learned by recontextualizing African American quilts in mainstream art museums. In some ways the quilts crossed over as artwork in the elite museum space, but the women who created them could not fully cross over as artists. Their gendered, raced, and classed reality appeared in the museum as different and odd compared to the usual painting, sculpture, and photography media expected in art museums. The colors and compositions of the quilts held their own against modernist paintings with which they were compared. Yet, hung as if they were abstract paintings, the quilts looked awkward as their edges

curved back and forth against the flat gallery walls. The different treatment of the quilts was evident in the way visitors reached out and fondled their edges—an unacceptable act that happens rarely with museum paintings, but that is more common in quilt festivals. Was this show the sacrificial lamb to destabilize binaries of high and low art, fine art and women's work, and art and craft in the mainstream art world? The race, class, and gender barriers of the museum remained strong enough to highlight the dislocation of the women and their work in the museum. Or perhaps, a different, more optimistic reading coexists with my historically informed, pessimistic interpretation. Did the exhibition's presentation of Black women's creativity—evidence of the profound will to live combined with the undeniable gift to create beauty—expose and stun the arbitrary and ridiculous criteria of quality that have excluded art made by poor Black people for generations?

Looking for the Real, Discovering Gee's Bend

William "Bill" Arnett, an eccentric and passionate collector of vernacular art, had been looking for quilts in a Black Southern vernacular. First encouraged by quilt scholar Maude Southwell Wahlman to look for Black vernacular quilts, he later found a contemporary photograph of quilter Annie Mae Young and her great-granddaughter Shaquetta standing beside two quilts spread over a wood pile in Roland Freeman's 1996 book *A Communion of the Spirits: African American Quilters, Preservers, and Their Stories*. Intrigued by the colors and composition of the quilts pictured, Arnett used the photo's caption as a guide as he headed out on Route 29 in southern Alabama to see if he could find the women who made the quilts. His journey into the communities of Gee's Bend, Alberta, and Rehobeth, Alabama, led to his discovery of the quilts made by four generations of Black women and their subsequent exposure in the mainstream art world. Arnett and his son Matthew began making regular visits to the Gee's Bend area to interview the quilters and document their work. The original plan was to publish a book of photographs of the quilts with information about them, their makers, and their cultural history. Based on experience working with museums in the past, the Arnetts had no confidence that the museum world would recognize the quilts as important works of art.

Three years before *The Quilts of Gee's Bend,* the Arnetts started their own press, Tinwood Books. In 2001, they published a serious two-volume tome about folk art titled *Souls Grown Deep: African American Vernacular Art of the South.* The book provides an encyclopedic overview of the hundreds of African American artists who create art outside the framework of formal artistic training. Not only does it contain important reference materials for learning about these African American artists, it gives the reader overwhelming evidence of how much is unknown about American art and how incomplete the story is about the contemporary art scene that is vetted and presented through art museums. *Souls Grown Deep* was originally designed to accompany the exhibition of the same name scheduled to open in 1996 at the High Museum in Atlanta and travel to the Whitney Museum of American Art and the National Museum of American Art. However, the book was published by Tinwood Books in 2001 after the publishing contract with Harry N. Abrams and plans to exhibit at all three museums fell through. The exhibition was saved through a contentious relationship between the Arnetts and an exhibition committee at the Carlos Museum at Emory University that formed to oversee the curatorial and installation aspects of the show off-campus.[7] The resulting 1996 *Souls* exhibition presented over 500 art works in Atlanta's City Hall East while the city hosted the Summer Olympic Games. Although it was slated to be part of the citywide programs in honor of the Olympics, the exhibition was not promoted with materials about the games, and was mistakenly left off the list of Olympic-related events on the official visitor map.[8] The Arnetts' experience of being marginalized by the mainstream art world left them with little faith that they would ever successfully mount an exhibition of vernacular art within the museum system.

After *Souls,* the Arnetts focused their efforts on Black vernacular quilts for two reasons. First, they were struck by the lack of women artists they found during their research for *Souls.* As Bill's son, Paul, explained, they "wanted to pursue where the female creative force went." Second, they wanted to show the depth and complexity of the Black vernacular tradition as well as demonstrate types of visual and thematic sources within Black culture.[9] In 2002, the Arnetts had seventy photographs of Gee's Bend quilts ready for their book project. They had a meeting with Alvia Wardlaw, then curator of modern and contemporary art, and Peter Marzio, director, both of the Museum of Fine Arts, Houston, to look at some of the vast Arnett vernacular art collection and brainstorm ideas

for two future exhibitions. Though the collection received mild responses from Marzio, Paul shared the plan for their upcoming book by showing the digital images of the quilts. Inspired by what they saw, Marzio asked the Arnetts to put an exhibition of the quilts together in eighteen months.

The three Arnetts, Wardlaw, Marzio, John Beardsley, former curator of the Corcoran Museum of Art, and Jane Livingston, former associate director of the Corcoran, became an exhibition team for *The Quilts of Gee's Bend*. Beardsley and Livingston had worked collaboratively with Marzio when he was the director of the Corcoran in 1982 to organize *Black Folk Art in America: 1930–1980*. For *The Quilts of Gee's Bend*, the two served as consultants and catalogue authors. Together the team selected seventy quilts for exhibition from the nearly four hundred in the Arnett collection. Within that abbreviated time frame, the selected number of quilts, exhibition catalogue, the CD of spirituals sung by women from Gee's Bend, *How We Got Over: Sacred Songs of Gee's Bend,* and the film *The Quilts of Gee's Bend* (directors: Matt Arnett and Vanessa Vadim, 2000) were ready for a show.

In the Exhibition—Defining Quilts as Art

The quilts in the exhibition were organized into thematic categories: Work-Clothes Quilts, My Way, Housetop, Family, Patterns and Triangles, and Sears Corduroy. These six divisions allowed viewers to understand the diversity of the spectacular quilting designs and begin to differentiate between the dozens of quilts and quilters represented. Work-Clothes Quilts described quilts made from clothes worn during the backbreaking labor of farming. The women made strips from shirttails, pant legs, socks, and denim overalls and sewed them together to make their quilts. Lutisha Pettway's *"Bars" work-clothes quilt* (c. 1950) is an incredible example of how pant legs were pulled together to make a quilt of denim and cotton (plate 15). This recycling shows Pettway's ingenuity born out of necessity and the level of poverty that her family lived in. The dark spaces where the denim was once covered by pockets emphasize the wear and stripped-down quality of what's left of the material. The exhibition text panel for this section of quilts articulately explained: "In their hands, drab-colored blue, brown, and gray trousers, occasionally inflected with a bit of white or color, become compelling works of art that speak volumes about Gee's Bend lives."

Here the text connects the value of the quilts to the evidence of the women's lives. This connection between the beauty of the quilts and the women is an important one that some critics were unable to reconcile.

My Way quilts refer to the freestyle quilt top compositions that express the improvisation and unique visions of the individual quilters apart from patterns or themes. In *My Way, bars and string-pieced columns* (c. 1950s) by Jessie T. Pettway, the rhythmic repetition of multicolored horizontal strips alternates between vertical red, orange, and gray bars (plate 16). The hypnotic composition seems to move like ripples of water, the impact of which is the seduction of the viewer into an extended encounter.

Housetop quilts are defined by a dominant pattern of concentric rectangles or squares. The resulting quilts shown in the exhibition are seemingly endless variants of this simple geometric pattern. One of the most mesmerizing examples is Lottie Mooney's *"Housetop"—four block "Half-Log Cabin" variation* (c. 1940) (plate 17). What immediately reads as an abstract figure, spider, or menorah follows the parameters of the housetop quilt. The top and bottom sets of gray, brown, and marigold right angles each make up half of a concentric square design. The innovation on the theme makes a strong case for the artistic value of the work. An object label for one of the Housetop quilts argued for the understanding of the women as artists, saying, "One of the qualities that defines an artist is the creativity to see beyond the mundane, the capacity to transform the ordinary into the extraordinary, an ability Gee's Bend quilters clearly share." As the exhibition presented the quilts as evidence of art, this label is an example of how some of the wall text specifically supported the thesis of the exhibition, and particularly the life work of the Arnetts, by breaking down the definition of an artist and arguing that the women are indeed artists.

The quilts in the Family section were set aside to highlight the significance of family relationships and the inheritance of quilting as bonding ritual and practical activity to ensure warmth for the women and their families. The compositions did not conform to any one pattern. The wall text provided extended accounts from the women about their families and the role of quilting within them. These primary texts of the women's own words privileged their perspectives within the exhibition.

Patterns and Triangles featured designs composed of repeating geometric forms, particularly triangles. The composition and colors of these quilts pulsate, making it hard to focus on the surface and necessary to look quickly

at the overall design instead. An example of this is Annie E. Pettway's *"Flying Geese" variation* (1935), in which the quilt is organized into six blocks divided by strips of orange fabric (plate 18). Each block is a grid filled with columns of triangles within differently colored rectangles. Difficult to describe, the quilt is even harder to look at because of the wide range of colors and patterns of the design all contained in the quiet pastels of its modest border.

The Sears Corduroy quilts reflect the contract between some of the quilters and Sears Roebuck in 1972. The company hired the Freedom Quilting Bee to sew corduroy pillow shams for mass marketing. Though the contract was short-lived, the quilters kept scraps from the shams and incorporated them into their own work. Compositions of these quilts vary, but the fabric demonstrates the continued desire for self-expression, the decision to adapt to newly introduced material, and the resistance to mass-produced, standardized sewing practices for themselves. The center pattern of Flora Moore's *"Log Cabin" variation* (c. 1975) combines dozens of square and rectangular corduroy pieces to create her interpretation of the traditional pattern (plate 19). The use of orange and blue, optical opposites on the color wheel, makes her design vibrate along its horizontal and vertical axes. The two-sided border of green ochre steadies the design. The formal frame of ocean blue and gray provided a sense of calm. Moore clarifies that the incorporation of corduroy into her quilts still allowed her the freedom of design: "When you sit, you don't know how it going to come out, and you don't think it will come out like that. I made that quilt out of corduroy. I just put it my way; I didn't put it the way the pattern went."[10]

The exhibition wall labels provided a history of Gee's Bend and reproduced some of the Farm Security Administration/Office of War Information (FSA/OWI) photographs taken by Arthur Rothstein in 1937 and Marion Post Wolcott in 1939. The diligent research that Paul and Matt Arnett conducted to obtain copies of the photographs and identify the people in them is remarkable. The photographs are archived by the Library of Congress with general descriptive names given by the photographers such as *Carrying Water* and *Pettway Family Group* (figures 27 and 28). Paul and Matt were able to show the FSA/OWI photographs to residents of Gee's Bend who identified the people pictured, so that museum viewers and future scholars could read that *Carrying Water* is a photograph of quilter Annie Bendolph, and *Pettway Family Group* is a photograph of Annie and Jacob Bendolph with several of their children, all misidentified as Pettways in the photograph's title. Some of the photo-

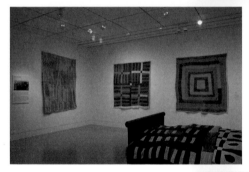

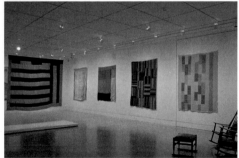

Plate 14.
Four installation views of *The Quilts of Gee's Bend*
at the Museum of Fine Arts, Houston.
Photographs by Thomas R. DuBrock.

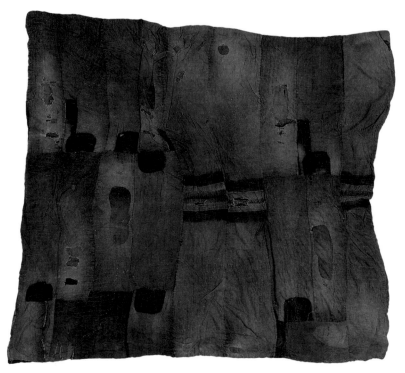

Plate 15.
Lutisha Pettway,
"Bars" work-clothes quilt (c. 1950).

Museum of Fine Arts, Houston.
Photograph by Steve Pitkin/Pitkin Studio. Courtesy of Souls Grown Deep Foundation.

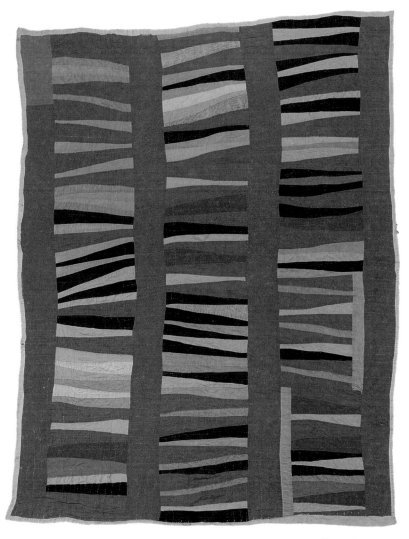

Plate 16.
Jessie T. Pettway,
My Way, bars and string-pieced columns (c. 1950s).

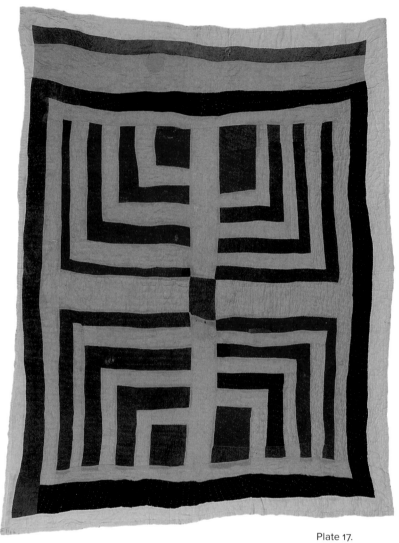

Plate 17.
Lottie Mooney,
"Housetop"—four block "Half-Log Cabin" variation (c. 1940).

William Arnett Collection of the Tinwood Alliance.
Photograph by Steve Pitkin/Pitkin Studio. Courtesy of Souls Grown Deep Foundation.

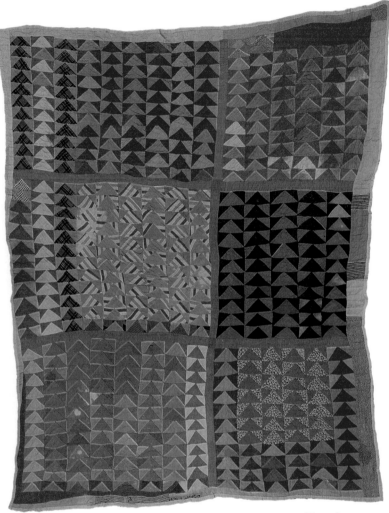

Plate 18.
Annie E. Pettway,
"Flying Geese" variation (1935).

William Arnett Collection of the Tinwood Alliance.
Photograph by Steve Pitkin/Pitkin Studio. Courtesy of Souls Grown Deep Foundation.

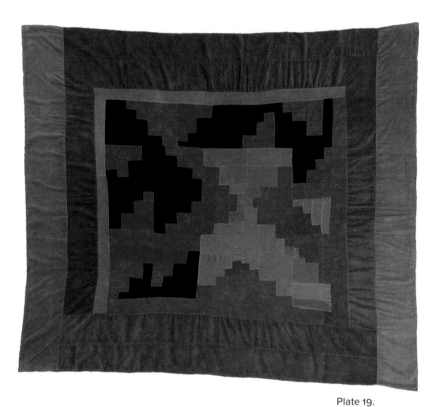

Plate 19.
Flora Moore,
"Log Cabin" variation (c. 1975).

Plate 20.
Linda Day Clark,
Gee's Bend Image No. 4, Mary Lee Bendolph (2003).
Ink jet print, 32 x 42".
Courtesy of Linda Day Clark.

Plate 21.
Tyree McCloud's Mural of Mary Lee Bendolph's
"Housetop" variation (1998) on the land beside her home.

Photograph by the author.

Plate 22.
Tyree McCloud's Mural of Annie Mae Young's
Blocks and Strips (c. 1970) on the land beside her home.

Photograph by the author.

Figure 27.
Arthur Rothstein, *Carrying Water.*
Gees Bend, Alabama, aka, Annie
Pettway Randolph (April 1937).
Library of Congress
Prints & Photographs Division, FSA/OWI
Collection, [LC–USF34–T01–025354–D]

Figure 28.
Arthur Rothstein,
Pettway Family Group. Gees Bend,
Alabama (April 1937).
Library of Congress
Prints & Photographs Division, FSA/OWI
Collection, [LC–USF34–T01–025385–D].

graphs from the Rothstein and Wolcott series record names; however, both Rothstein and Wolcott give the title Aunty or Uncle before the names of many of the adults. Although the subjects were someone's aunts and uncles, they did not have this relationship with Rothstein and Wolcott. These familial titles were used by whites to address Blacks during slavery as alternatives to Mr., Miss, and Mrs.—titles of respect expected for Whites.[11] The inaccurate and vague titles given to the photographs reflect the relationship between photographer and subject in the FSA/OWI project. Not identifying people by name in government-sponsored photographs was not uncommon, and it demonstrates a distance between photographer and subject that is legible in much of that work. This distance is particularly outstanding when the photographers are Whites from Northern cities sent by the government to document the lives of poor, rural, and Black subjects. Such is the case with Rothstein's and Wolcott's photographs of Gee's Bend, which were used to show Gee's Bend as the epitome of poverty in America and support President Roosevelt's 1935 Resettlement Administration to help sharecroppers and tenant farmers own the land on which they labored.

In the exhibition, the Rothstein and Wolcott photographs showed viewers a glimpse of the history of Gee's Bend's exposure to America's mainstream consciousness. However, the history of the FSA/OWI photographs, their careless titles, and the power relationship between subject and photographer depicted in the images required some explanation. The photo-

143

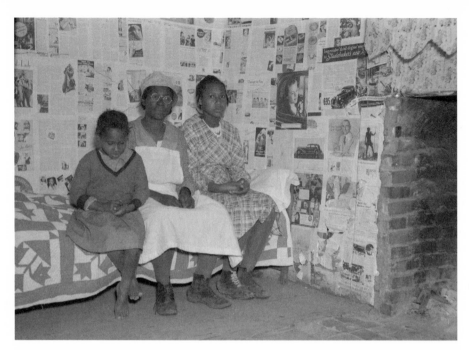

Figure 29.
Arthur Rothstein, *Negroes at Gees Bend, Alabama.*
Descendants of Slaves of the Pettway Plantation.
They are Still Living very Primitively on the Plantation (February 1937).

graphs are saturated with the historical content of race relations, class differences, and federal politics of uplift. Additionally, their loaded historical context disavows any function to speak for themselves as objective documentary images to illustrate wall texts for the Gee's Bend quilts. The inclusion of the photographs did not address the encounter of unequal power between White photographers and Black subjects in the 1930s. Instead, it reproduced that encounter in the context of the exhibition. I am not arguing that the Arnetts' research identifying the people in the Rothstein and Wolcott photographs was not important. Nor am I ungrateful for the accurate additional identification information about who is pictured. I am arguing that some critical commentary about the photographs was necessary to address the historical context in which they were taken, and explain the stiffness, fear, and resistance of the faces of many of the people imaged.[12]

For example, one of the photographs taken by Rothstein overwhelms me with sadness. I am so affected by the image that I cannot concentrate on

the quilts that the photograph is supposed to help me understand. Titled by Rothstein *Negroes at Gees Bend, Alabama. Descendants of Slaves of the Pettway Plantation. They are Still Living very Primitively on the Plantation,* the photograph is captioned by Paul Arnett "Lucy Mooney and granddaughters Lucy P. Pettway and Bertha Pettway on a bed in Lucy's house" (figure 29). The photograph depicts the elder Lucy Mooney sitting between her grandchildren so closely that each of their bodies overlaps another. The younger girl slouches barefoot, legs crossed, looking down at her hands clasped in her lap. She looks nervous, uncomfortable, and perhaps shameful as if she has just been disciplined. Lucy Mooney sits bespectacled with her hands in her lap, and looks away from the camera. She wears a modest cap on her head, an apron over her simple dress, and laced work boots. On the right, young Bertha Pettway looks at the camera wide-eyed and perhaps startled. Like her sister, she holds her hands in her lap, and like her grandmother she wears work boots, hers with mismatched laces. Bertha's direct gaze at the camera reads like a look of resistance, perhaps to the stranger who photographs her and her family clustered in the corner of the room. The collage of newspaper pages on the wall, showing advertisements of beauty products and luxury cars, emphasizes the class differences between American consumer culture and the reality of the family's poverty. The grid patterns of the wall, in the fabric of young Lucy's dress, and the quilt underneath the three figures are secondary to their presence. Transfixed by the facial expressions and body language of the two generations of women pictured, I want to read an acknowledgment of the intrusion of the photographer, the power of the photograph, and the circumstances in which it was taken before I can attempt to enjoy the beauty of and skill involved in making the quilt that the three sit on, and the quilt beside the label in the exhibition.

Not all of the FSA/OWI photographs have the impact of the one that pricks me. There is some diversity among the Rothstein and Wolcott images. Other photographs powerfully counter the sadness of the photograph I describe. In fact, another photograph of Lucy Mooney shows her standing confidently in the center of her porch with a slight smile (figure 30). The photograph relays Mooney's likely feelings of confidence and pride in her home, as well as her guarded protection of it. However, the FSA/OWI photographs are jarring enough to require some discussion within the exhibition not only to educate the viewers about the historical relationship between the people of Gee's Bend, modernism, and the government

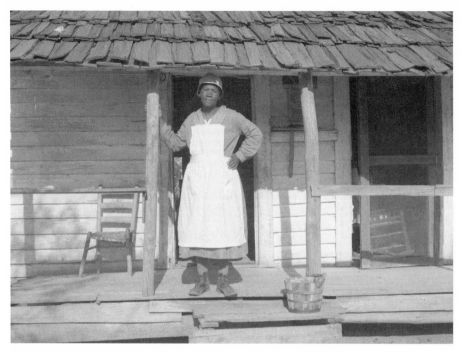

Figure 30.
Arthur Rothstein, *Woman on the Gees Bend Plantation. Wilcox County,
Alabama* (April 1937).
Library of Congress Prints & Photographs Division,
FSA/OWI Collection, [LC–DIG–fsa–8b35945].

photography project, but also to help viewers understand the relationship
between the quilts and the intimate context in which they were made.
Instead, I fear that without explanation, these black and white photographs
supported a nostalgic presentation of old negroes on the plantation, in a
way that did not center the lives and perspectives of the quilters, but in-
stead showed them from an outsider's point of view, one that did not re-
spect the women enough even to record their names. The anthropological
approach to the photographs influenced a similar anthropological percep-
tion of the quilters in the exhibition. *The Quilts of Gee's Bend* film, which
was looped in one of the galleries of each venue, showed several quilters
talking and singing in the twenty-first century. This contemporary repre-
sentation of the women was an alternative to the nostalgic effect of the
black and white FSA photographs.

Although the women's names were provided on each object label, the ex-
hibition title did not refer to the quilters by name, but instead by place. The

women are the producers of quilts from a region renamed Boykin in 1949, but still known by its plantation name, that of the bend in the Alabama River once owned by the nineteenth-century planter Joseph Gee.[13] Practically speaking, a title that includes all of the quilters' names would not make sense; however, *The Quilts of Gee's Bend* encourages an interpretation of the quilts as anonymously made as it privileges the name of the place where the women live over the names of the artists in the show. The title succinctly communicates the type of objects that were on view in association with a place that was new to most audiences. If the title could have somehow referenced the names of the women, it might have helped bring a level of recognition and esteem to them that is still uncommon among women and African American artists in the art world.[14]

From the Arnetts' perspective, the word quilt in the exhibition title was an obstacle because of how entrenched categories of art and craft are. Their original title for the book was *Gee's Bend: Masterworks from a Lost Place.* Omitting the word quilt avoided the association of the work with craft and collectibles. The term masterworks denoted the works as art in the common language of art history and museums. The original title strategically masculinized the work and the women and cloaked their Blackness[15]

What is at stake in the quilts being defined as art? Why is it important for the quilts to be reclassified as art and for whom is it important? Is the point of this reclassification to "elevate" the quilts to the level of art in order to render them valuable? Before the Arnetts arrived in Gee's Bend, the quilters understood quilts and art as being different things. Mary Lee Bendolph remembers a conversation with Bill Arnett about the quilts being art: "Bill, well Bill was telling us it was art work. I never did think that work was worth nothing. You talking about art? He told me, yeah"[16] (plate 20).

Arlonzia Pettway recalls the first discussion about the quilts as art:

I never thought I would get praise and honor about a quilt. Ten or twelve or fifteen years ago I didn't think this would happen. We was selling quilts but we didn't think this would happen. Until Bill came along. He told us that we had artwork. And I didn't know what artwork was. He said "Y'all have all this beautiful artwork hidden under mattresses and things." He just go under the mattresses and try to pull out old quilts we had up under there. He said "This is fine artwork." I said "Artwork?" "Yeah, this is artwork."[17]

Likewise, Nettie Young shares her thoughts on the introduction of the art concept:

I ain't thought about no artists for quilts but it came to be so and I know it's so because I seen them on the wall [laughter] in the museum. That makes it so beautiful to see these old quilts on the wall. It brings memories back. Bill's another person in our lives, 'cause Bill started this whole thing about the Gee's Bend Quilts. Now that's his foundation. He made the Gee's Bend Quilts. And I tell you the truth, I thought he was crazy about all those old quilts. Said "What's wrong with this man?" [laughter]. These quilts aren't good for nothing. But when you don't know, just stand back and look and wait.[18]

For both women the idea of the quilts as artwork was unfamiliar. They understood the personal and practical value of the quilts, but did not realize how other people might understand them. Pettway and Young have become witnesses to the reclassification and commodification of the quilts as artwork through Bill Arnett's nonprofit foundation, Tinwood Alliance, which is "dedicated to advancing the work of vernacular artists into the public domain."[19] The conceptualization of the quilts as a body of work did not come from the quilters but from Bill Arnett. The inflection of Young's voice as she states "Bill started the Gee's Bend Quilts" indicates the phrase is not her own and does not describe the private community tradition of quilting that she participates in, but a new identity given to the quilts. Moreover, Pettway's disbelief as she questioned Arnett about his perception of the quilts as artwork, along with Young's laughter as she talks about seeing the quilts in the museum and thinking Arnett was crazy, indicates the distance between the definitions of art for two different audiences.

Although at first the idea of their quilts as art seemed strange, the women were overwhelmed emotionally when they first saw the quilts on the gallery walls. In response to my question, "What was your experience seeing these quilts in the museum and how do you feel about them becoming art?" Louisiana Bendolph replied,

You know, I remember we said "Wow." [laughter] We think about something that kept us warm now hanging on the museum wall. And when we got there we walked in . . . and you know you couldn't help but to cry because it was from the older women that were in Gee's Bend. My great-grandmama's quilt was hanging there. It was just something that we never thought we'd see.[20]

The recognition of the quilts as art was a validating one for the quilters. As art in the museum, the quilts were given a new space in which to be appreciated. This perspective helped the people in Gee's Bend step back and find new respect for these everyday objects that had been part of their culture for genera-

tions. Reverend Clinton Pettway, Jr., of the Ye Shall Know the Truth Baptist Church in Gee's Bend explained that the phenomenon of the Gee's Bend Quilts brought a new realization in the community: "We didn't know we were throwing away history. We didn't know we were throwing away art."[21]

For curator Alvia Wardlaw defining quilts as art contests the foundational assumptions about the identity of the artist: "These quilts are important as contemporary art for several reasons. The first being that they represent a tradition that has been passed on for a number of generations in a very small area in America, Gee's Bend, Alabama. The quilts reflect the history of that area and of this country in their making, and it asks all of us about genius and where does it reside."[22] Locating artistic genius in Gee's Bend opens up the definition of who can be an artist and what genius is. It expands the parameters of the exclusionary mold of the artist who is traditionally and exclusively White and male, but at the same time it reinscribes the term genius.

For Bill Arnett, defining quilts as art and presenting the quilts in major art museums exposes the quilts to a mainstream public and provides an opportunity to break through an elitist network of gatekeepers to show hundreds of thousands of people what quilts can look like and who makes them.[23] And yet, for some critics there is a need to separate the women from the quilts in order to consider them valuable works of art.

In her catalogue essay "Reflection on the Art of Gee's Bend," Jane Livingston is torn between finding value in the quilts because of the women's creativity and innovation or because they remind her of modern paintings. She states, "To a certain audience, they may reverberate with the rhythms and patterns of other twentieth-century art, whether the German Bauhaus–inspired work of Josef Albers or Paul Klee, some of Barnett Newman's compositions, or more contemporary painters such as Sean Scully. Yet these parallels quickly seem irrelevant."[24] However, after she has summarized the cultural history of Gee's Bend and influences within the culture, her descriptions of the quilts revert to comparisons with modern painters. Though it is human nature to recollect familiar images and compare them to new ones, Livingston's evaluation of the quilts often depends upon their similarities to modern art in the "strikingly 'minimalist' aesthetic personified in the corduroy quilts" or the originality which "ranks with the finest abstract art in any tradition."[25] She reveals other quilts to be "as deliberately monolithic and clearly formulated as a Barnett Newman painting" with surfaces as rich as work by Gustav Klimt and exciting as a Robert

Rauschenberg.[26] Her comparisons pose and provide an answer for the following question: Are the quilts valuable because they look like paintings by modern artists? If the answer is yes, it seems that the author has missed the point of the potential to open up the art world to artists who do not fit the celebrated modern art mold. Accepting the quilts as art because they look like the work of other modern artists merely re-centers the exclusionary paradigm that the Arnetts and Wardlaw wanted to dismantle through the exhibition. Lastly, in what reads as a backhanded compliment, Livingston surmises, "It is difficult, aside from tribal models, to think of American art traditions that involve as much free interplay among groups of highly gifted artists as is true of these quiltmakers." The patronizing comment stirs affinity comparisons between modern art and "non-Western" art and exploits the strategy of incorporating racial difference into the art museum by considering the quilters ancestors of modernism, similar to the treatment of William Edmondson. Livingston argues that the validity of the quilts is found in the women's authenticity because the women communicate and create so freely it is as if they are a "tribe."[27]

Bedbugs and Miracles

Some press about *The Quilts of Gee's Bend* claimed the show as evidence of the sublime in art, and others saw it as the downfall of America's art museums. The first mention of the upcoming exhibition was published in the *Wall Street Journal* with some alarm. Journalist Brooks Barnes began the article with the question: "Museum curators have a lot to worry about in these tough times: attendance, security, damaged art. And now . . . bedbugs?"[28] The high art/low art discussion was posed with a warning of literal and figurative infestation, and a caution to the public that museums are preparing to con them into thinking quilts are art. Barnes goes on to explain that quilt shows like *The Quilts of Gee's Bend* are becoming more common because they cost "peanuts" in comparison to conventional forms of art, as if to assure readers that there is a financial justification for the exhibition and their definition of art is not at risk. To substantiate the danger of the upcoming quilt show, the author quotes a Dallas schoolteacher who fears that her reputation will be damaged if she takes her students to see *The Quilts of Gee's Bend*. She states, "Quilts that keep you warm, in an art museum? I'd lose all my credibility."[29]

The review in *Newsweek* encouraged visitors to see the show at the Whitney Museum of American Art by announcing, "quilters and modern-art fans need not be mutually exclusive groups" and "could be joyfully united" by the exhibition. In an approach parallel to Livingston's, Peter Plagens provides an abbreviated history of the Gee's Bend community and then writes "It's as if something in the local water has produced a whole villageful of Paul Klees who create their vibrant work on a bed-size scale instead of in tiny watercolors."[30] References to tribal life re-emerge through the terms "local water" and "villageful." Plagens's review demonstrates the difficulty he has in reconciling Black identity and artistic ability. Instead, he jokingly decides that the quilt designs were produced by an unexplainable transformation that made the Black women derivatives of Paul Klee. Unable to stand in the art world on their own creativity, inspiration, and cultural history, the artists are validated through metaphor.

Reporter Patricia Leigh Brown's article about the Gee's Bend "Soulful Stitches from the Bottomlands" was printed in the "House and Home" section of the *New York Times*. The article begins with a nostalgic tone to introduce the ongoing quilting that takes place in Gee's Bend stating, "At this time of year, when the shadows grow long and pecans fall heavy on the red earth, the memories of old women in this loop of land encircled by the Alabama River turn to quilting."[31] Drenched in sentimentality, the poetic opening sets up the discussion of the quilts as a journey back in time instead of the discussion of a living tradition by contemporary Black women. Unlike other articles, Brown's relays the history of Gee's Bend as recounted by quilter Arlonzia Pettway, who was one of the historians of the community. Moreover, Brown connects the history of the community to the quilts: "Despite countless forays by sociologists, photographers and writers from the 1930s onward, Gee's Bend's isolation served to preserve an idiosyncratic style of quilt making that is as direct and unvarnished as the landscape itself." She recognizes the political history of the quilters' isolation and its impact on the style of their quilts, instead of suggesting affinities to modern painters.

Appearing the following week in the "Arts" section of the *New York Times*, Michael Kimmelman's review described the quilts in terms of the "off-kilter stroke" of painting and the "imperceptible riff" and "syncopation" of jazz. His description of the quilts as "some of the most miraculous works of modern art America has produced" is frequently quoted in promotions of the quilts. Of interest is Kimmelman's identification of the quilts as modern art; he does not

describe them as being *like* modern art. But, he continues, "Imagine Matisse and Klee (if you think I'm wildly exaggerating, see the show) arising not from rarefied Europe, but from the caramel soil of the rural South in the form of women, descendants of slaves when Gee's Bend was a plantation."[32] This requires some mind-bending. Kimmelman is unable to imagine the women as modern artists; instead he asks readers to imagine Matisse and Klee in the form of Black Southern women. It seems difficult, if not impossible, for art critics to understand the quilts as modern art *and* the women as modern artists.

Regardless of the challenge of deciphering the meaning of the quilts in the art world, for the quilters the meaning is quite clear: the important thing for the quilts to express is not modernity or artistic value—it's Christianity.

Joy on the Wall

Many of the quilters have talked about their processes for making quilts as not limited to gathering scraps of fabric and piecing them together. The processes include singing, praying, crying, and meditating. Quilter Nettie Young explains her process and articulates the profound significance of the rituals of quilting:

> Prayer changes things. What's going on wrong, if you go to God he changes things. They [slaves] trusted God for everything. They believed in God, they had faith that God would take care, and he did. You see the slaves, they sang. And that's where they got their joy from. They did sing . . . them old slave gospel songs. They were proud of themselves to be able to sing with one another. That was their joy. That was part of their way of living. You sing you forget. It made joy in their heart. It brings peace to themselves. And singing and praising God was the best way to get there. Through all them years, having joy by singing and praying. Now we got joy up on the wall to look at. It's a blessing. It's a good feeling. What my mother taught me to do. Look where they at. All in Texas, all in New York, all in Mobile, every which way. Look where it at. That's a good thing. That's a blessed thing.[33]

For Young, the joy in quilting, singing, escaping, and finding peace are all one thing. She feels these things when she sees the quilts. Having the quilts in the museum was a way for the women to share their Christian faith because of the spiritual practices that are a part of the process of making the quilts. Moreover, when a group of the quilters traveled to the openings of the exhibition and related programs, they would sing gospel songs for the audience as part of the celebration. The quilters wanted to share their

Christian fellowship, the joy of singing and praying, that went into making the quilts in the exhibition. What may have been interpreted as unusual at the museum (it is not common for artists to sing at their openings) was an act of intervention and evangelism.[34] Through this spiritual expression that was integral to making the quilts, the women used their voices to create a familiar space for themselves in an unfamiliar place.

The spiritual inspiration of William Edmondson—cited so frequently in statements about his work—was perceived by the art world as a testament to his naïveté. There was no place in the art world for Edmondson's expression of Christianity except as excess to the true modern artist. Christianity also plays an important role for the quilters in the process of making the quilts. Their faith gives them the strength and inspiration to suffer through poverty, to care for their families, and to make beautiful textiles from rags. The quilts are evidence of the quilters' insistence on surviving modernity and making aesthetic objects in resistance to it. Did exhibition visitors receive this message? Did art museum professionals and visitors interpret their singing performances at the museums as proof of their presumed primitiveness? Or, were their songs heard as explanations of the journeys they took in order to produce the extraordinary quilts from meager means?

The Difference It Makes

After all of my research and this discussion of *The Quilts of Gee's Bend,* I think that what is at stake is not whether the quilts belong in an art museum but, instead, the opening up of the exclusionary criteria of artists in the mainstream art world. Measuring the value of the quilts as art through definitions of masterworks and genius and the quilts' visual affinities to modern art does not allow the quilts to enter the art world on their own terms.[35] A superficial narrative of visual sameness to modern painting displaces their context and important cultural history. Niether the quilts nor the women become more valuable or more important because they are transformed into art and artists as defined by art critics. Reclassifying the quilts as art does not change the objects' beauty, power, cultural history, use value, comfort, or preciousness. However, I do understand the advantages of claiming the quilts as art objects.

Calling the quilts art engages the network of art museums to present the quilts to a wider audience. Within the context of the art museum, the

quilts are revered as being more valuable than if they are regarded as craft. Validation of the quilts as art provides a nice source of income to the quilters. It has given them the opportunity to travel. It has enabled them to share their Christian values and evangelize through their singing performances at museums. However, until poor, Black, rural, isolated women are considered valuable, there will be no significant or long-term change in the way they or their work will be regarded by the art world. In the case of the critical reception of *The Quilts of Gee's Bend*, the split between art and artist is what concerns me. What is lost in the transformation of the quilts from craft to art is the identity, cultural history, and social context of the women. Their raced, gendered, classed, and geographic identities have precluded their entrance into the art world as artists, although their quilts have been accepted in some circles as art. Even with the reclassification of the quilts as art, the women's ontology and social value remains unchanged because the exclusive definition of who can be an artist is maintained.

The Quilts of Gee's Bend challenged the museum's criteria of art and artists by presenting objects usually dismissed as craft. Its reception proved that the culture wars around art, race, class, and gender are still alive in the twenty-first century. The work is not remarkable because it looks like modernist painting. It is remarkable because of its inherent aesthetic value, and because the quilts come from a group of women who have exercised their will to survive in the face of extreme poverty, exploitation, isolation and disfranchisement. Despite Johann Winckelmann's assessment that aesthetics are dependent upon a natural hierarchy of race, these women have made objects whose beauty is so awe-inspiring that it disrupts the racist foundations of art history. As long as art critics' appreciation of the quilts depends upon a separation from and blindness to the Black women who created them, they will miss out on the full beauty of the work and the opportunity to challenge their definition of a legitimate artist. The mainstream art world's acceptance of a new paradigm that would include artistic ability, racial Blackness, and the cultural context of race relations in America as a way to understand the evidence of beauty from multiple peoples and cultural contexts would depend on a change in relations of power that would constitute the women of Gee's Bend as subjects in the first place. The subjectivity of the quilters would displace the authority of the art museum as frame and presenter of aesthetics. To transgress this role would no doubt provide new knowledge for many visitors, critics, curators, and other museum professionals and potentially change the future of institutional and social racism in America.

CONCLUSION
African Americans after
the Art Museum

|

The history of the relationship between African
Americans and the American art museum is a study of American race rela-
tions, nationalist ideals, and contested investments in definitions of qual-
ity, beauty, and art. In light of the analysis of exhibitions discussed in the
previous chapters, I want to revisit the two methodological frameworks for
exhibiting art by African Americans: the approach that features the art of
African Americans within a anthropological paradigm of Black racial dif-
ference and White normalcy, and the corrective approach to redefining and
expanding American art.

The use of the anthropological model for exhibiting the work of African
American artists has been discussed in relationship to William Edmondson,
who was positioned at MoMA as a sculptor from an age gone by. His Black-
ness and his primitiveness were synonymous and facilitated a distinction
between authentic folk and contemporary modern artists. Examples of the
placement of exhibitions of art by Black artists in mainstream museums
have also expressed the hierarchy of racial difference and the trope of Black
inferiority through spatial delineation. The first art museum exhibition of
Negro artists, *The Negro in Art Week* (1927) was split into two parts: one
inside and the other outside the Chicago Art Institute. The part installed
in the museum was in the gallery reserved for children, and the other at

the Chicago Women's Club. The Harmon Foundation show, *An Exhibition of Paintings and Sculpture by American Negro Artists* (1929) was installed in the foyer of the National Gallery of Art apart from the museum's proper exhibition galleries. *Panorama* (1972), one of the exhibitions organized at LACMA to measure the interest in Black art in Los Angeles, was shown in the Art Rental Gallery located in the museum basement. And the series of corrective solo exhibitions of Black artists at the Whitney Museum of American Art from 1969 to 1974 were installed in the museum's lobby gallery and the auditorium.[1]

Most recently the traces of this perpetuation of racial hierarchy through exhibition have been seen in the Black resistance to this approach. The term "post-black" has been embraced by some artists at the turn of the twenty-first century as a way to strategically position their work to be viewed in terms that expand beyond racial determination. Launched by Thelma Golden's 2001 exhibition *Frequency* (2001) at the Studio Museum in Harlem and her catalogue essay "Post . . .", the term post-black has entered into common use in the contemporary art world.[2] The term reflected the answer to a question faced by Black artists that has persisted since the Harlem Renaissance: To be (or not to be) a Black artist? It recalls the story that Langston Hughes tells in his seminal 1926 essay "The Negro Artist and the Racial Mountain," of the young man who wants to be called a poet, not a Negro poet.[3] The desire to be identified as an artist, or a Black artist, is a personal and political issue concerning spectatorship and reception. The hope is that if the artist is identified as an artist (not a Black artist) and the work perceived as art (not Black art), viewers will interpret the work with a broader set of possible meanings than if the Black identity of the artist were known.

In the absence of information marking the artist's racial identity, the creator of a work is presumed to be White. Because Whiteness is pervasive and constructed as normal in the art museum, only the races of people of color are often indicated on object labels and in wall texts. (The exception to this rule is in modern and contemporary art when the content of the work depicts Black figures. It is generally presumed that a Black artist has made art depicting Black people.) The post-black position rests on the hope that without the marker of race in the information provided by the art museum, viewers' interpretation will not depend upon a lens of race that consists of a limiting understanding of Blackness.[4]

For Hughes, the poet's desire not to be identified as Black indicates racial

self-hatred and the wish to be as White as possible.[5] Contemporary artists who prefer to be called artists rather than Black artists do not necessarily fit the model that Hughes so vehemently condemns. Post-black acknowledges both the historicization of the term Black in the 1960s and '70s, and the frustration with racist limitations on what Black is. Inherent in the term post-black, as I am discussing it here, is a criticism of racist thinking, not denial of one's own racial identity. The desire for artists to make work that is seen in all of its intersections and engagements with art historical, formal, social, political, economic, and psychological discourses has to be considered in the future of art museum exhibition practices of art by African Americans. For this to happen, the limitations of racist thinking have to be dismantled. In fact, the challenge that African American artists bring to art institutions, critics, and visitors is bigger than the art world. The art museum is just one hermeneutic system in which change must take place in a large system of racial disparity.

Ideally, the Black identity of an artist would not inhibit museum curators and collections committees from exhibiting or collecting a work of art. Nor would the visual representation of a Black person in an artwork limit interpretation. Some viewers, however, will see a work with a Black figure in it and close down the semiotic process of interpretation. For these viewers, the Black figure does not mean person, the figure means Black, which, for them, is not the same as person (read White), but lesser than. Therein lies the problem of interpretation: that the representation of a Black figure *is* the representation of a person is not part of the interpretive process. Indeed, Blackness only signifies a difference so great that it belies humanity within the racist imaginary.

As long as Black people are interpreted as inferior, the art they make will also be so viewed. This issue proved to be central to the critical reception of four of the exhibitions discussed in the previous chapters. In the press about *The Art of William Edmondson,* references to his personal history as "Negro errand boy" to Whites defined him as lesser than, and his isolation from the art world highlighted his sudden artistic status as novel and strange.[6] The curatorial perception of art by Black artists as inferior precluded their inclusion in the *Harlem on My Mind* exhibition. The desire to deny Black self-representation in the exhibition planning, particularly after the appearance of the museum's interest in Black involvement through the formation of consultation committees, affirmed the hierarchy of White authorship of quality, value, and art over Blacks even further. Critical reviews of *Two Centuries* that defined the art solely as documents of social

history and outside of the definition of art demonstrate that the visual representation of Blackness is a challenge to the struggle to maintain racially exclusive parameters of what art is. *The Quilts of Gee's Bend* also challenged critics who were unable to accept the women as modern and contemporary artists even as the quilts were critically acclaimed as art.

The corrective approach to exhibitions of Black art is still used today, but it has been explored with more frequency through solo exhibitions of Black artists such as Romare Bearden, Sam Gilliam, Lorna Simpson, Kara Walker, and Martin Puryear, and not through large surveys.[7] The corrective approach is still relevant to twenty-first-century mainstream museum practices and vital to the treatment of African American artists as American artists. It is a viable approach to including African Americans in the museums, but not the only one. The inclusion of Black artists in group exhibitions with artists of other racial identities must be an exhibition practice as well. The separate group show for Black artists as the preferred exhibition strategy in mainstream art museums merely continues the approach of the Harmon Foundation from the 1920s and '30s. I am not arguing for a formulaic quota system of integration, but for art by Black artists to be collected and exhibited in art museums through focused solo shows and thematic exhibitions as relevant to the art historical and contemporary art topics at hand.

II

Realizing the complexity of the history of African Americans and the American art museum, we can consider what the future of the relationship between Black artists and the American art museum may be. This history can also entice us to examine and to begin to answer the following questions: Is there a future for the all-Black show in the mainstream American art museum? Has the racial thinking within American art museum administration changed enough for the institution to reflect the contribution of African Americans in American art? Do exhibitions of art by African Americans serve a symbolic function in mainstream art museums to prove that America is a democratic nation?

The time when mainstream art museums enforced racial segregation through token group exhibitions of art by African Americans has passed. This arrangement was not preferred by Black artists in the past, nor should it be

tolerated in the future. In Chapter 1, I cite artist Charles Alston's resentful comments on these shows and the Harmon Foundation's role in setting the precedent for this practice. Like Alston, I would like to emphasize the difference between the art museum's enforcement of the racially segregated show and the choice of self-representation by Black artists through exhibition. The all-Black show has a future at mainstream art museums in the case of self-representation, which will likely focus on art from a particular formal concern or thematic focus that may or may not be centered around racial issues. Being Black is not enough of a commonality to be a platform for exhibition.[8] With the additional thematic focus, these exhibitions have a future because they have the exciting potential to offer visitors a look at the diversity and compelling creativity from a range of artists—desirable elements in any innovative group show. This all-Black show involves Black people in the organizing process. The need for large survey exhibitions like *Two Centuries* has passed. David C. Driskell has already done the work of showing the art world the historical depth and variety of Black art from the eighteenth to the mid-twentieth centuries. His exhibition has provided a foundation for group exhibitions with smaller themes and fewer artists, as well as solo exhibitions.

The contributions of African Americans (as museum professionals, guards, artists, activists, scholars, and critics) have impacted the practices of art museum exhibitions. The Black Emergency Cultural Coalition is one example, discussed in Chapter 2, of an organization that pressured the Whitney Museum of American Art and the Boston Museum of Fine Arts to organize exhibitions featuring Black artists. Likewise, the strategy of the response show from Black museums as a critique of racial exclusion from mainstream art museums openly contested and corrected the omission of Black artists. This kind of effective activism in the 1960s and '70s led to the "new black show" in art museums. Guards at LACMA instigated three exhibitions of Black art in the 1970s and involved thousands of Black Los Angelenos in the process. But do mainstream art museums understand the value of African American contributions enough to bring them into exhibition practices without controversy, shame, and protest? The answer to this question is not a resounding yes. Answers will necessarily vary from museum to museum depending on funding sources, base constituency, permanent collection, mission of the museum, and politics of the museum administration. However, we can look at some evidence amassed by artist/activist Howardena Pindell to measure how museums have changed over the last thirty years.

In 1987, Pindell conducted a survey with mainstream art museums in New York about how many of their exhibitions included non-White artists in group and solo exhibitions. Her findings indicated that between 82 and 100 percent of the exhibitions at the Guggenheim, the Met, MoMA, and the Whitney featured White artists exclusively.[9] In 1997, she approached the museums again with the same request for lists of exhibitions in the ten years since her last survey; she also contacted a number of artists, critics, art historians, and members of museum administration for personal statements on their view of changes in the art world. She found that there was little improvement for artists of color in their exhibitions and no substantive changes in the incorporation of or perspectives about including work by artists of color.[10] In 2007, she revisited her project by calling several mainstream art museums in New York for updated information for her survey. She found the percentage of exhibitions that featured only White artists was between 88 and 100 percent.[11]

Whether or not African American artists continue to serve a symbolic role in mainstream art museums to prove that America is a democratic nation remains to be seen. Jacob Lawrence's unprecedented validation by the art world through *The Migration of the Negro* while he was a soldier during World War II, and the organization of *Two Centuries* as part of a national bicentennial celebration, should garner skepticism about the sporadic, yet strategic, appearance of Black artists in mainstream art museums. Although some topical exhibitions are appropriately timely, the use of exhibitions of Black artists simply to fulfill multicultural goals indicates poor understanding of what Black artists have to offer to the art museum.

This historical perspective on the engagement between African Americans and American art museums provides an analysis of the struggle for Black recognition and validation in the past. Although I cannot say what important shows will happen in this future discourse, I do hope that mainstream art museums offer more exhibitions of art by Black artists so that no one exhibition bears the burden of Black representation. Instead, frequent exhibitions will expand not only the perception of what Black Americans are creating and who Black Americans are, but also the museum's definition of art and artists. Within these exhibitions, the resolution will not simply be Black inclusion by addition, but the challenge of eliminating the exclusive racial paradigm that set African Americans apart as anything but equal.

EPILOGUE

Harlem on My Mind

I

In January 2008, a friend and fellow art historian
sent me an e-mail telling me that *Harlem on My Mind* was currently on
view. Confused, I read the forwarded information about the exhibition be-
ing remounted at South Carolina State University, the historically Black
university in Orangeburg. The exhibition was being installed in two parts
over a six-month period. I knew I had to go see the show.

After the initial heat of the original 1969 exhibition subsided, the pho-
to murals were donated to the Schomburg Center for Research in Black
Culture in Harlem, where some were displayed as decoration in one of the
reading rooms. Other panels were donated to the I. P. Stanback Museum
and Planetarium at South Carolina State, where professors used them as
illustrations in their teaching for many years. In 2008, the recently hired di-
rector and assistant professor in the Department of Visual and Performing
Arts, Ellen Zisholtz, remounted the exhibition. As part of the celebration of
the reinstallation, the exhibition catalogue was printed for the fourth time,
this time including a quotation of approval on the cover from President
Bill Clinton and a new introduction by New York Congressman Charles B.
Rangel. Opening events included a book signing of the new catalogue with
Allon Schoener.

I went to Orangeburg to see the second half of the exhibition. It was

incredible to see so many of the images in person after studying the photographs during my research. The missing and peeling corners on many of the panels that bowed away from the walls told of their discarded history and journey away from the Met. I was pleased that the photographs were on view at an educational institution where students could learn firsthand from the objects in the first blockbuster exhibition in America, and one of the most provocative. However, I was surprised and disappointed to see that there was no wall text that informed viewers about the embattled discourse surrounding the exhibition. The director's statement didn't tell of the opportunity available in the reinstallation to learn about the culture wars, Black artists, activism, institutional racism, and the art world. Walking through the exhibition, one could see no sign that its history had ever happened. Void of context, the show was a celebration of mid-century pictures of riots, Black protest, 1960s icons, and closely cropped portraits of Harlem residents. It was Schoener's and Hoving's Harlem after all. The Black voices of the exhibition were silenced again.

The installation and republication of the catalogue made an attempt nearly forty years after the original exhibition to validate the show—this time in a historically Black institution. What was at stake in remounting this exhibition in 2008? Why is it important to insist on a White vision and authorship of Harlem even at this historically Black university? Zisholtz's statement for the exhibition was printed on a text panel. In it she wrote:

> . . . I have always felt that there is an affinity between the Jewish and Black communities. The controversy surrounding this exhibit in 1969 has made me think. Some of the distress resulted from an article written by a 17-year-old girl, which was said to have anti-Semitic overtones. It is interesting that the first exhibition of Harlem on My Mind and this exhibition were both curated by Jewish persons, and one of the major photographers in the exhibition is Aaron Siskind. It strikes me that if someone other than a liberal Jew was the editor of the first edition, the comments which were taken as anti-Semitic would not have made it to publication. Freedom of speech is important to us. . . . If, as I believe, the Jewish and the African American peoples have much in common and an affinity of values, what causes the rifts? Are we being manipulated into not working together? We can be powerful. Will we ever get together and stop those who seek to prevent us from uniting?

Zisholtz's statement was both a way of introducing herself to visitors and introducing the show. The controversy that she refers to only points toward part of the story. Framed in a "Can we all get along?" question about rela-

tionships between Jewish and African American cultures, the voice of the Black artist was lost. Unless the history of the exhibition were made part of its reinstallation, there couldn't be a forum at the museum to address the potential collaborations between Black artists and art museums. Maybe as an art and cultural historian I was expecting too much.

The majority of the panels of *Harlem on My Mind* have found a home in a museum, but not an art museum. In this new context, the exhibition has taken on another function, as a show of a group of photographs of Harlem. In the museum and planetarium, there isn't any responsibility to address the role of the Black artist, and in fact the curator is absolved of expectations about considering the history of Black artists and activism. The occasion for the museum to encourage an opportunity for learning was simply sidestepped.

Viewing the reinstallation of *Harlem on My Mind,* visitors may think that the issues which were so important for Black artists in the 1960s have become irrelevant. Perhaps, rather, the absence of recognition of Black artists in the 2008 exhibition is a testimony to how relevant issues of exclusion and discrimination continue to be. The recent exhibition emphasizes the serious responsibility of art historians, curators, cultural activists, and critics to be vigilant researchers, and continue to strive for comprehensive literacy in the critical study of Black visual culture and art history.

II

In May 2009, I went to Gee's Bend to witness the place that had become famous for its quilts. Specifically I wanted to see the Gee's Bend Collective, meet its director, quilter Mary Ann Bendolph, and spend some time with quilter Mary Lee Bendolph and photographer Linda Day Clark. I had met some of the quilters earlier in the year at a performance of the play *Gee's Bend* by Elyzabeth Gregory Wilder at the Taproot Theater in Seattle. In my conversation there with quilter Loretta Bennett, she told me that when I went to Gee's Bend, I would see billboards of the stamps of the quilts that were issued by the U.S. Postal Service in 2006. I had a hard time imagining exactly what this would look like.

I was taken aback when I saw the billboards for myself (plates 21 and 22). The quilt paintings by Gee's Bend native Tyree McCloud are larger than

the original quilts and equally vivid. They stand as markers of these women's talents, accomplishments, and recognition by the art world and the Southwest Alabama Tourism Office. They look like a kind of mysterious hieroglyphics in their rural community setting. I immediately thought of the provocative theory about the role of quilts in the Underground Railroad which suggests that runaway slaves could identify safe houses by the quilts that hung in front of them. There is something inspiring about this theory. However, it is nice for me to imagine these houses as new safe houses, not in a slavery imaginary, but conceptually as houses where remarkable things happen, where people help each other survive and create beauty in the process. Mary Lee Bendolph told me that she is very proud of the mural of her quilt that stands on the land she owns beside her home.

The billboard-like quilt paintings are another part of the phenomenon of *The Quilts of Gee's Bend*. The paintings would not have been made, nor would the stamps have been issued, if the quilts had not been recognized by the art world. Indeed, the result of the art museum exhibitions has literally changed the landscape of Gee's Bend in a way that makes the women feel validated.

NOTES

Introduction

1. Alan Wallach, *Exhibiting Contradiction: Essays on the Art Museum in the United States* (Amherst: University of Massachusetts Press, 1998), 1.

2. A small number of African Americans had been exhibiting their art at private studios, galleries, regional art clubs, abolitionist fund-raising events, and world's fairs since the mid-nineteenth century. The earliest exhibitions of African American art were presented in Chicago in 1917 at the Arts and Letters Society of Chicago and in 1923 at the Wabash YMCA. Beryl J. Wright, "The Harmon Foundation in Context: Early Exhibitions and Alain Locke's Concept of a Racial Idiom of Expression," in *Against the Odds: African American Artists and the Harmon Foundation,* ed. Gary A. Reynolds and Beryl J. Wright (Newark, N.J.: Newark Museum, 1989), 17.

3. Chicago Woman's Club, *The Negro in Art Week, November 16–23: Exhibition of Primitive African Sculpture, Modern Paintings, Sculpture, Drawings, Applied Art, and Books* (Chicago: Chicago Woman's Club, 1927); Daniel Schulman, "'White City' and 'Black Metropolis': African American Painters in Chicago, 1893–1945," in *Chicago Modern, 1893–1945: Pursuit of the New,* ed. Elizabeth Kennedy (Chicago: University of Chicago Press/Terra Museum of American Art and Terra Foundation for the Arts, 2004), 46. "The Negro in Art Week" exhibition followed the establishment of Negro History Week in 1926 by the historian Carter G. Woodson and his Association for the Study of Negro Life and History. Although similarly named, the exhibition was not held during the same week in February as Negro History Week. Instead, it was mounted by the Chicago Art Institute November 16–December 1, 1927 (16 days) and the Chicago Woman's Club November 16–23 (8 days).

4. Alain Locke, "The New Negro," in *The New Negro: Voices of the Harlem Renaissance,* ed. Alain Locke (1925; rpt., New York: Touchstone Press, 1999), 15.

5. As art historian Lisa Meyerowitz explains, the exhibition revealed the "inherently paradoxical nature of the exhibition of works by black artists in white institutions" and "problems of defining a race through art exhibition, problems which still persist today." Lisa Meyerowitz, "*The Negro in Art Week:* Defining the 'New Negro' through Art Exhibition," *African American Review* 31 (Spring 1997): 75.

6. The African presence was represented through the Blondiau Collection of African Art from the Belgian Congo owned by the Harlem Museum of African Art. European Cubist paintings were first exhibited in the United States in the infamous Armory Show of 1913, an exhibition that the Chicago Art Institute sought to present. Meyerowitz, "*The Negro in Art Week,*" 80.

7. Robert B. Harshe to Miss Zonia Baber, October 12, 1927, Chicago Woman's Club Papers, box 52, *The Negro in Art Week Scrapbook.* Research Center, Chicago History Museum.

8. Some African Americans shared this belief also. Archibald Motley, an accomplished

Chicago-based artist who did not participate in *The Negro in Art Week,* stated that he chose not to submit anything "because Negroes were putting out such poor work." Wendy Greenhouse, "Motley's Chicago Context, 1890–1940," in *The Art of Archibald J. Motley Jr.,* ed. Jontyle Theresa Robinson and Wendy Greenhouse (Lincoln, Mass.: Sewall Co., 1991), 51.

9. Lowery Stokes Sims, *Challenge of the Modern: African American Artists, 1925–1945, Volume 1* (New York: The Studio Museum in Harlem, 2003), 13–14. This conformity to European aesthetics extended to the exhibition programs also. At this exciting time for jazz music, particularly in Chicago, the exhibition's musical program consisted of traditional Negro spirituals, chorales and concertos by Bach, and vocal and piano accompaniment of Handel, Delibes, Vitali, Chopin, and others.

10. Ironically, "Negro Types Found in Haiti," an exhibition of drawings made by the Russian artist Vladimir Perfilieff at the Carson-Pirie-Scott Galleries, was reviewed in the art section of the *Chicago Daily News* during the run of *The Negro in Art Week* exhibition. The first sentence of the article refers to *The Negro in Art Week,* but the author does not go on to review the exhibition. The drawings of Negro people exhibited at a gallery by a Russian artist were considered worthy of review in the art section of the mainstream press, but the art by Negroes that conformed to Eurocentric standards on view at the city's premier art museum was not. Marguerite B. Williams, "Here and There in the Art World," *Chicago Daily News,* November 16, 1929.

11. Carol Duncan, Introduction to *Civilizing Rituals: Inside Public Art Museums* (New York: Routledge, 1995), 6.

12. Ibid., 9.

13. Hugh Honour, *The Image of the Black in Western Art,* vol. 4: *From the American Revolution to World War I,* part 2: *Black Models and White Myths* (Cambridge: Harvard University Press, 1989), 13.

14. Evidence of these customs in American art museums has been examined by several authors. Alan Wallach discusses the collection and exhibition of casts of Western European masterpieces by early museums in the United States to cultivate a Eurocentric taste for fine art in America after the Civil War. The function of exhibiting the canonical replicas was to construct an authentic Greco-Roman heritage for Americans through museums. See *Exhibiting Contradiction.* The presence of Eurocentric art as central to American art museums is addressed by various authors in the volume *Exhibiting Cultures: The Poetics and Politics of Museum Display,* ed. Ivan Karp and Steven D. Lavine (Washington, D.C.: Smithsonian Institution Press, 1991). In his essay "Art Museums, National Identity, and the Status of Minority Cultures: The Case of Hispanic Art in the United States" Lavine asks, "Can one imagine the comprehensive art museum without an authoritative European canon at the center? Would it be possible to rethink the sum of world art as a set of parallel lines of development, with ongoing processes of negotiation among them? Or is the dominance of a set of historically determined Euro-centered ways of seeing and imagining so strong, so central to the 'museum effect' (as Alpers describes it), that inclusion in a comprehensive art museum can only be in relation to that tradition?" 83. In Tomas Ybarra-Frausto's review of the diversity of Chicano art and its relationship to art institutions in the same volume, he discusses a paradigm in which pluralistic and democratic efforts to incorporate Chicano art fail to bring about change as these alternative visions are commodified, disarmed, and deflected. "What remains in place as eternal and canonical are the consecrated idioms

of Euro-centered art." See "The Chicano Movement/The Movement of Chicano Art," 146. Thomas DaCosta Kaufmann discusses the tradition of national and racial prejudice regarding validity and quality in art history since the eighteenth century: see his "National Stereotypes, Prejudice, and Aesthetic Judgments in the Historiography of Art," in *Art History, Aesthetics, Visual Studies,* ed. Michael Ann Holly and Keith Moxey (Williamstown, Mass.: Sterling and Francine Clark Art Institute, 2001), 71–86.

15. For a revealing discussion on the possible visual sources selected for the portrait and Wheatley's role in constructing her visual image, the first of any colonial American woman to appear with her writings, see Gwendolyn DuBois Shaw, "*On deathless glories fix thine ardent view:* Scipio Moorhead, Phillis Wheatley, and the Mythic Origins of Anglo-African Portraiture in New England," in her *Portraits of a People: Picturing African Americans in the Nineteenth Century* (Seattle: University of Washington Press, 2006), 26–43.

16. African American photographers were able to find training and establish galleries earlier than painters and sculptors. For example, the daguerreotypist Augustus Washington opened his first photography studio in Hartford, Connecticut, and J. P. Ball opened the popular Ball's Daguerrean Gallery of the West in Ohio to great success in 1847. It is important to note the significance of early African American photographers in the artistic tradition of the nation despite the fact that the daguerrean profession was considered an applied art rather than the more prestigious fine art. See Deborah Willis's books *J. P. Ball: Daguerrean and Studio Photographer* (New York: Garland, 1993) and *Reflections in Black: A History of Black Photographers, 1840 to the Present.* (New York: W. W. Norton, 2002). Lewis arrived at Oberlin College in 1859 and was expelled in 1862. Romare Bearden and Harry Henderson, *A History of African-American Artists: From 1792 to the Present* (New York: Pantheon Books, 1993), 56, and Charmaine A. Nelson, *The Color of Stone: Sculpting the Black Female Subject in Nineteenth-Century America* (Minneapolis: University of Minnesota Press, 2007), 17. It has been reported that Robert Douglass, Jr., attended the Philadelphia Academy of Fine Arts; however, art historian James A. Porter is unable to confirm the acceptance of Douglass in the Pennsylvania Academy of Fine Arts and further recounts Douglass's being prevented from attending an exhibition at the Academy because of his race. Anna Bustill Smith, "The Bustill Family," *Journal of Negro History* 10 (October 1925): 643; and James A. Porter, *Modern Negro Art* (1943; rpt., Washington, D.C.: Howard University Press, 1992), 23–24. Henry Ossawa Tanner attended the Philadelphia Academy of Fine Arts in the years 1879–1885: Dewey F. Mosby, *Henry Ossawa Tanner* (New York: Rizzoli, 1991), 36. Meta Warrick Fuller attended Pennsylvania Museum School of Industrial Art (now University of the Arts) in 1897–1899: Renee Ater, "Making History: Meta Warrick Fuller's 'Ethiopia,'" *American Art* 17 (Autumn 2003): 14.

17. In the nineteenth century, several African Americans studied and many exhibited their art in Europe (primarily England and Italy) such as the Philadelphia-based painter and daguerreotypist Robert Douglass, Jr., at the National Gallery of Fine Arts, London, and the British Museum in London in the 1840s (Smith, "The Bustill Family," 643); Robert S. Duncanson in England, Italy, Greece, Scotland, and Canada in the 1850s (Porter, *Modern Negro Art*, 35); Edmonia Lewis in London, Paris, Florence, and Rome in 1865–66. (Nelson, *The Color of Stone*, 8); Henry Ossawa Tanner in London, Paris, and Rome beginning in the 1890s (Mosby, *Henry Ossawa Tanner*, 38); and Annie E. Walker, who graduated from Cooper Union in 1895, attended the Académie Julien in

Paris in 1896, and exhibited her work in the 1896 Paris Salon (Henderson and Bearden, *A History of African-American Artists*, 113).

18. Juanita Marie Holland, "To Be Free, Gifted, and Black: African American Artist Edward Mitchell Bannister," *International Review of African American Art* 12.1 (1995): 18, 21.

19. Wright, "The Harmon Foundation in Context," 15.

20. Fuller exhibited at the Pennsylvania Academy of Fine Arts in 1906, 1908, 1920, and 1928. Howard exhibited at the Corcoran Gallery in 1915 and the National Academy of Design in 1916 and 1928. Tanner exhibited in the Pennsylvania Academy of the Fine Arts nearly every year between 1880 and 1909. His paintings were exhibited in several major art institutions including the Chicago Art Institute, which showed his work 1896–1898, 1905, 1907–1908, 1910, 1912–1914, 1916, 1923, 1924, 1926–1929 (twice in 1928 in *The Negro in Art Week* and in a group exhibition with White artists), and 1933. The first museum to collect Tanner's work was the Pennsylvania Museum and School of Art, which purchased his painting *The Annunciation* (1898) in 1899. This is the earliest record I have found of an acquisition of art by a Negro for a museum's permanent collection.

21. Tuliza K. Fleming, "Breaking Racial Barriers," in *Breaking Racial Barriers: African Americans in the Harmon Foundation Collection*, exhib. cat. National Portrait Gallery, Smithsonian Institution (San Francisco: Pomegranate Books, 1997), 8.

22. Two examples of this awkward social occurrence are demonstrated through exhibitions of paintings by Edward Mitchell Bannister in 1876 and Aaron Douglas in 1936. After reading in the newspaper that his painting *Under the Oaks* had won the first-place award at the art competition of the Centennial Exposition, Bannister went to claim his prize. Members of the crowd and an official in the Committee Rooms received him with hostility. In his own words he could hear some people "actually commenting within my hearing in a most petulant manner, what is that colored person in here for? . . . I was not an artist to them, simply an inquisitive colored man." Kenkeleba House, *Edward Mitchell Bannister: 1828–1901* (New York: Kenkeleba House/Harry N. Abrams, 1992), 34. At the exhibition of Aaron Douglas's painting *Into Bondage* (1936) in the lobby of the Hall of Negro Life at the 1936 Texas Centennial Exposition, a racial identification was added as a wall label because White viewers doubted that a Negro had created such high-quality work. Object label for *Into Bondage* in the exhibition *Aaron Douglas: African American Modernist*.

23. For example, the September 15, 1955, issue of *Jet* and the September 17, 1955, issue of the *Chicago Defender* published Ernest C. Withers's chilling open-casket photograph of Emmett Till, the young Negro boy lynched in Money, Mississippi, in 1955. The insistence of these Negro presses on the mass distribution of visual evidence of White brutality against Blacks etched the horrifying image of Till's unrecognizable corpse in the minds of an American generation and of future generations of civil rights advocates. Another example is the strategic use of television news coverage by the Southern Christian Leadership Conference and the civil rights leader Andrew Young to disseminate images of White terrorism. Moving images of unarmed Blacks being attacked by government officers with high-powered water hoses exposed the contradictions of American democracy and racial difference for national and international audiences. See Sasha Torres, *Black, White, and in Color: Television and Black Civil Rights* (Princeton: Princeton University Press, 2003), and Christine Acham, *Revolution Televised: Prime Time and the Struggle for Black Power* (Minneapolis: University of Minnesota Press, 2004).

24. *Harlem on My Mind: Cultural Capital of Black America, 1900–1968,* ed. Allon Schoener (New York: New Press, 1995), unpaginated.

1. Negro Art in the Modern Art Museum

1. The tour included the Butler Art Institute, Youngstown, Ohio; Athenaeum, Hartford, Connecticut; Chicago Art League; Herron Art Institute, Indianapolis; J. B. Speed Museum, Louisville; Fisk University, Nashville; Spelman College and the Y.M.C.A., Atlanta; National Gallery of Art, Washington, D.C.; National Council of Congregational Churches, Detroit; Cleveland Art Centre; and the St. Louis Museum of Art.

2. *Catalogue of an Exhibition of Paintings and Sculpture by American Negro Artists at the National Gallery of Art* (Washington, D.C.: Smithsonian Institution, 1929), 3.

3. Mary B. Brady to Hale Woodruff, August 21, 1930, Harmon Foundation Papers, Library of Congress, Manuscript Division, Washington, D.C. Quotation printed in Gary A. Reynolds, "'An Experiment in Inductive Service': Looking Back at the Harmon Foundation," in *Against the Odds: African-Americans Artists and the Harmon Foundation,* ed. Gary A. Reynolds and Beryl J. Wright (Newark, N.J.: Newark Museum, 1989), 34–35.

4. *1928–1929 Yearbook, International House.* International House Archives.

5. This number was gathered from conversations between Brady, Romare Bearden, and Harry Henderson beginning in July 1966, and an interview with Brady conducted by Bearden and Henderson on October 8, 1969. The information was recorded in Bearden and Henderson, *A History of African-American Artists: From 1792 to the Present* (New York: Pantheon Books, 1993), 252 and 502. The authors note that attendance for the three Harmon Foundation exhibitions held at the International House in 1927, 1928, and 1929 averaged 2,000–3,000. See ibid., 502, and Reynolds and Wright, *Against the Odds,* 35.

6. In 1933, the National Gallery of Art was the institution now known as the Smithsonian American Art Museum, Smithsonian Institution. What is now the National Gallery of Art took its current name from its Smithsonian namesake in 1937 before opening in 1941. In 1937 the original National Gallery of Art became the National Collection of Fine Arts. In 1980 it changed its name to the National Museum of American Art and then again to the Smithsonian American Art Museum in 2000.

7. The fringe placement of art by Black artists in mainstream museums lasted for several decades. Most of the series of six solo exhibitions of Black artists at the Whitney Museum of American Art from 1969 to 1974 (the first, by Alvin Loving, was the first solo show ever of a Black artist at the museum) took place in the lobby gallery. As Kellie Jones has noted, the Loving exhibition was installed in the museum's second floor auditorium, not a gallery, and "still a relatively marginal space within the Whitney." See Kellie Jones, "'It's Not Enough to Say 'Black is Beautiful'": Abstraction at the Whitney, 1969–1974," in *Discrepant Abstraction,* ed. Kobena Mercer (London: Institute of International Visual Arts/MIT Press, 2006), 160. John Yau has written about the obscure and irreverent location of *The Jungle* (1943) by Wilfredo Lam "in the hallway leading to the coatroom of the Museum of Modern Art. Its location is telling. The artist has been allowed into the museum's lobby, but, like a delivery boy, has been made to wait in an inconspicuous passageway near the front door." See John Yau, "Please Wait by the Coatroom," in *Out There: Marginalization and Contemporary Culture,* ed. Russell Ferguson et al. (New York: New Museum of Contemporary Art/MIT Press, 1990), 132–39.

8. Porter was included in *Thirty-Second Annual Exhibition of the Washington Water Color Club,* Washington, D.C., Gallery Room, National Gallery of Art, Smithsonian Institution, April 7–May 6, 1928.

9. Ada Rainey, "Negro Art Exhibition Has Merit," *Washington Post,* Sunday, May 19, 1929: 9.

10. Romare Bearden, "The Negro and Modern Art" *Opportunity* 12 (December 1934): 372.

11. Ibid. Bearden does not name particular artists, but the painter William H. Johnson spent time in Scandinavia from 1930 to 1938 and painted various landscapes and cityscapes of life there, particularly of Kerteminde, Denmark. He exhibited *Garden, Kerteminde* (c. 1930–31) in the 1931 Harmon annual exhibition. It is notable that along with this Scandinavian landscape, Johnson exhibited *Landscape from Florence, South Carolina, Jacobia Hotel* (1930) in the same Expressionist style executed in his Scandinavian-themed landscapes, demonstrating the European influence in his domestic and foreign scenes. Landscape paintings of European settings were not uncommon for any Negro painters who studied abroad during the Harlem Renaissance. In the 1929 Harmon Foundation exhibition alone, Palmer C. Hayden, Albert Alexander Smith, and Hale Woodruff exhibited European landscape paintings. These artists also painted domestic landscapes, cityscapes, still lifes, and portraits. See exhibition catalogue *Exhibit of Fine Arts by American Negro Artists Presented by The Harmon Foundation and The Commission on the Church and Race Relations, Federal Council of Churches* (1929).

12. Art historian Mary Ann Calo lists the various names of Boykin's enterprise: Boykin's Art and Craft Studio (1929), Boykin's School of Art (1930–31), the Boykin School of Art and Research Center for the Promotion and Development of Negro Art (1932), Boykin's School of Arts and Crafts (1933), and Boykin's School of African Arts and Crafts (1935). Mary Ann Calo, *Distinction and Denial: Race, Nation, and the Critical Construction of the African American Artist, 1920–40* (Ann Arbor: University of Michigan Press, 2007), 78.

13. Savage went on to direct the Harlem Community Art Center in 1937–39, and become the first Negro to receive a commission, for her monumental work *The Harp* (1939), from the 1939 New York World's Fair commission.

14. The exact organization of the Harlem Art Workshop is unclear. Aron Bement reports that Wells was the director in his article "Some Notes on a Harlem Art Exhibit," *Opportunity* 11 (November 1933): 340. Calo (*Distinction and Denial,* 87) states that Wells was a teacher there in 1933, but does not list him as director. Art historian Sharon Patton writes that Augusta Savage was the first director, followed by Charles Alston, Henry W. Bannarn, and then Wells: Sharon F. Patton, *African-American Art* (Oxford: Oxford University Press, 1998), 147.

15. This list is a combination of two lists in Lisa E. Farrington, *Creating Their Own Image: The History of African-American Women Artists* (Oxford: Oxford University Press, 2005), 104, and Patton, *African-American Art,* 147.

16. In 1936, six murals designed by African American artists Charles H. Alston, Georgette Seabrooke, Vertis Hayes, Sara Murrell, Elba Lightfoot, and Selma Day were submitted for execution at Harlem Hospital in New York. The designs, which explored African folklore, traditional African medicine, modern medicine, community recreation activities, and a story of African American progress, were approved by the FAP; however, hospital superintendent L. T. Dermody rejected four of the murals for reasons he revealed in conversation with Alston, including that "the murals had too much Negro matter . . . and that the hospital was not a Negro hospital but a city institution." "Race Bias Charges by Negro Artists," *New York Times,* February 22, 1936: 13.

17. Objects from the French Sudan, French Guinea, Upper Volta, Sierra Leone, Liberia, Ivory Coast and Gold Coast, Dahomey, British Nigeria, Cameroon, Gabon, French Congo, Belgian Congo, Angola, and British East Africa were included in the exhibition. James Johnson Sweeney, ed., *African Negro Art* Exhibition Catalogue (New York: Museum of Modern Art, 1935). The contemporary listing for the peoples whose work was exhibited is Asante, Baule, Benin, Boki, Dogon, Fang (Pahouin), Ijo, Kuba, Lumbu, Mama, Mende, Mponwe, Punu, and Yoruba. See Smithsonian Institution Research Information System (SIRIS) entry for Walker Evans 1935 photographs, http://siris-archives.si.edu/ipac20/ipac.jsp?uri=full=3100001~!97730!0#focus.

18. See Josef Helfenstein's illuminating essay "From the Sidewalk to the Marketplace: Traylor, Edmondson, and the Modernist Impulse," in the catalogue *Bill Traylor, William Edmondson and the Modernist Impulse*, ed. Helfenstein and Roxanne Stanulis (Seattle: University of Washington Press/Krannert Museum, 2005), 45–86.

19. Patton, *African American Art*, 133.

20. Bobby L. Lovett, "From Plantation to the City: William Edmondson and the African-American Community," in *The Art of William Edmondson* (Jackson: University Press of Mississippi/Cheekwood Museum of Art, Nashville, 1999), 23–24.

21. The best known portraits of Negro artists in the 1930s were taken by Carl Van Vechten in a formal photography studio. The artists were not shown with their work, but alone against an ornamental backdrop. The exception to this rule was Van Vechten's 1941 portrait of the untrained artist Horace Pippin, taken outside in front of a tree. Here what has become the most famous portrait of Edmondson shows him not in a conventional pose of a contemporary artist but with the work. I am suggesting that it was important to have photographs of Edmondson include his work and that this treatment differed from the presentation of other contemporary artists in the 1930s.

22. The first photograph, *William Edmondson, Sculptor, Nashville, Tennessee* (1941), was accessioned in 1946. The second photograph, of the same title and date, was accessioned in 1952. The photographs appear to have been taken in the same photo shoot. Although Edmondson's sculptures are not represented in MoMA's collection, they have been acquired by the following major American art museums: Hirshhorn Museum and Sculpture Garden, Washington, D.C.; Brooklyn Museum of Art; Philadelphia Museum of Art; Smithsonian American Art Museum, Washington, D.C., and the Newark Museum, Newark, New Jersey.

23. Undated MoMA Press Release, William Edmondson File, MoMA Archives.

24. October 18, 1937 MoMA Press Release, William Edmondson File, MoMA Archives. This description was criticized by one reviewer in the *New York Evening Post*. The author follows the quotation from the press release with "You don't say! I hope this signal honor of a show at the Museum of Modern Art does not 'spoil' the fellow. Next thing you know he may be wanting to read and write." "Art World Feels Wall St. Tremors, but Shows Go On," *New York Evening Post*, October 28, 1937.

25. Negro whittler Lester Garland Bolling exhibited his wood sculptures carved with a jack-knife through the Harmon Foundation at the William D. Cox Gallery in New York in 1937. Reviews of his exhibition do not include quotations from Bolling, or highlight his race as an odd presence in the art world. They do mention that painter Thomas Hart Benton and photographer and author Carl Van Vechten are fans of his work. At age 38 when he had his Cox show, Bolling was not old enough to fit into the sambo stereotype projected on Edmondson. His figurative work is roughly yet realistically modeled and does not exhibit

the same degree of primitive qualities associated with Edmondson's work. In the 1930s, Bolling's sculptures were included in several exhibitions, including solo exhibitions at the Richmond Academy of Arts in 1935. See "Whittler Creates Life from Block of Wood," *New York Amsterdam News,* June 19, 1937: 24; "New Shows: Group and One-Man Events of Week," *New York Times,* June 20, 1937: 143; Reynolds and Wright, *Against the Odds,* 159.

26. *Life,* November 1, 1937; *New Orleans Item,* October 11, 1937; *Birmingham News,* October 9, 1937; *Detroit News,* October 10, 1937. All in William Edmondson clipping file at MoMA.

27. "Negro Primitive," *The Art Digest,* November 1, 1937; *New York Times Sunday,* October 24, 1937; "Sculpture in the Modern Tradition by a Tombstone Carver," *The Art News,* October 23, 1937.

28. "Negro Sculptor's Work Acclaimed by Art Museum," *Birmingham News,* October 9, 1937; "Negro's Carvings to Be Exhibited," *Macon News,* October 9, 1937.

29. "Brief View of Art Today," *Baltimore Sun,* December 9, 1937; "Cheers and a Plea," *The Art Digest,* November 1, 1937.

30. Lowery Stokes Sims, "The Self Taught among Us: William Edmondson and the Vanguardist Dilemma," in *The Art of William Edmondson,* 76–77.

31. Ibid., 74.

32. James A. Porter, *Modern Negro Art* (New York: Dryden Press, 1943. Rpt., Washington, D.C.: Howard University Press, 1992), 138. Sims analyzes Porter's statement suggesting, "[Porter] may reveal some familiarity with those 'unclear' symbols": "The Self Taught," 76.

33. Reynolds notes that the Harmon Foundation owned most of the Negro art that it exhibited in the 1920s. The foundation capitalized on its collection by exhibiting the works of art without regard to the artists. This disconnect between the Harmon Foundation and the artists it represented was particularly significant in the second half of the 1930s, as resentment of the foundation's patronizing views of the role of Negro art grew among Negro artists. See Reynolds, "'An Experiment in Inductive Service': Looking Back at the Harmon Foundation," in *Against the Odds,* and Calo, *Distinction and Denial.*

34. Locke, Foreword to *Contemporary Negro Art,* unpaginated.

35. These organizations represented a diverse cross-section of the city, "accountants, florists, paint dealers, Elks, Moose, Masons, Poles, Italians, Germans and many others": *Newsweek,* February 6, 1939: 26.

36. Other committee suggestions resulted in *Art of the Medici* (1939) and *A Souvenir of Romanticism in America* (1940) among others.

37. Three letters from the planning stages and after the exhibition express approval and gratitude to Rogers and Treide. Letter from Fernandis to Rogers, January 16, 1939; Letter from Fernandis to Treide, undated but before the exhibition opened; Co-Operative Women's Civic League secretary J. W. Haywood, and Fernandis to Treide, February 24, 1939. Library and Archives, Baltimore Museum of Art.

38. Locke, Foreword to *Contemporary Negro Art,* unpaginated.

39. Evelyn S. Brown to Henry Treide, January 9, 1939, Library and Archives, Baltimore Museum of Art.

40. Ibid.

41. Alain Locke, "Advance on the Art Front," *Opportunity* 17 (1939): 136.

42. Ibid., 133.

43. Ibid., 133–34.

44. "Baltimore Museum Becomes the First in the South to Stage Large Show of Negro Art," *Newsweek,* February 6, 1939: 26.

45. I am drawing on the term "value" from Marxist economics, defining Negro art here as a commodity that could be bought and sold on the open market. I am also using the term as developed by Lindon Barrett, as a measurement of privilege and principle of hegemonic logic of defining racial categories. Barrett is concerned with "the way in which the disjunctive dynamics of value as force and value as form illuminate the socialities of race." See Lindon Barrett, *Blackness and Value: Seeing Double* (Cambridge: Cambridge University Press, 1999), 55.

46. Gary A. Reynolds, "American Critics and the Harmon Foundation Exhibitions," in Reynolds and Wright, *Against the Odds*, and Calo, *Distinction and Denial*. Calo points out that this criticism of the positioning of Negro art from a sociologic rather than an aesthetic standpoint was first asserted by the Harlem Artists Guild in "Harlem Artists' Guild: A Statement," *Art Front*, July–August 1936: 4–5.

47. Porter, *Modern Negro Art*, 100.

48. See John Ott's insightful essay "Labored Stereotypes: Palmer Hayden's *The Janitor Who Paints*," in *American Art* (Spring 2008): 110–11.

49. Locke, "Advance on the Art Front," 132. Cornel West, "Horace Pippin's Challenge to Art Criticism," in *Keeping Faith: Philosophy and Race in America* (New York: Routledge, 1994), 62.

50. Specific examples from "The Legacy of the Ancestral Arts" use language from racial science and eugenics that support inherent biological differences between Negroes and Whites. Locke argues that the "racial blood" and "sensitive mind" of the Negro are what hold the key to distinctive racial contribution through the arts. Locke, "The New Negro," 256.

51. "Negro Contemporary Art on Exhibition at Museum," February 5, 1939: 3; and A. D. Emmart, "Modern Negro Art Is Shown," February 5, 1939, Section 1: 1.

52. Emmart, "Modern Negro Art Is Shown." Lawrence's work is listed in the Contemporary Negro Art catalogue as *General Toussaint L'Ouverture*, but is known today as *The Life of Toussaint L'Ouverture*. It is unclear when the name was changed and by whom. The scholar Margaret Rose Vendryes, consulting curator of the Amistad Research Center, surmises that Mary Brady probably changed the title after the work entered the Harmon Foundation. E-mail correspondence, August 2, 2010.

53. Margaret Howser at the BMA to Brown at Harmon states that most visitors are Black, February 1, 1939. Ruth Lawrence, curator, University of Minnesota University Gallery, to the BMA, inquires about the availability of the exhibition, October 12, 1939. Harriette Walker at State Teachers College in Glassboro, N.J., to the BMA requests information about the exhibition for an exhibition of Negro accomplishments show in 1941, January 14, 1941. Reply from Margaret M. Powell, registrar at the BMA, to Walker indicates that none of the works were bought by the museum, January 22, 1941. All letters located in the Library and Archives, Baltimore Museum of Art.

54. Elton Fax to Rogers, March 4, 1939. Library and Archives, Baltimore Museum of Art. Fax writes for himself and as a representative of all contemporary Negro artists, "All of the artists here who were represented, as well as those who were not represented, are pleased with the manner in which the exhibit was presented and received."

55. Oral history interview with Charles Henry Alston by Al Murray, October 19, 1968. Archives of American Art, Smithsonian Institution.

56. Ibid.

57. Lawrence stressed the importance of Savage in his development as an artist. "Because she thought that I should be on the Project [Federal Art Project] at this time. I remember

she took me down to try to get me on the Project. And I was a little too young. I think I was about nineteen going on twenty. So I didn't make it that time. But the next year she took me down again. This was something she didn't forget; she took me down to the Project and I was finally accepted on the Project. . . . I was in the easel division. So she was greatly responsible. . . . That's what I meant when I said really my first professional experience as an artist came through Augusta Savage." Oral history interview with Jacob Lawrence, October 26, 1968, Archives of American Art, Smithsonian Institution.

58. "Art Reaches the People," *Opportunity* 17 (December 1939): 376.

59. The essay was authored by unnamed staff writers for *Fortune Magazine. Fortune* 24 (November 1941): 102. In a letter to his friend Peter Pollock, director of the South Side community Center in Chicago, Locke expressed his pleasure with the text, "I have seen the Lawrence Fortune lay-out. It is one of the most imposing things I have seen. The story, stressing social significance of the migrations is a masterpiece. Was done by the whole staff at several of our suggestions. The new masses [*New Masses*] couldn't have done this thing better, and in this plutocratic magazine, I just can't believe it." The decision for the magazine staff to write the text rather than Locke may have been strategic. If the authoritative text about Negro life and the ignorance of Whites about that life was credited to Locke, the essay may have been received defensively by readers rather than with interest. Letter from Alain Locke to Peter Pollack, October 1941. Alain Locke Papers, Manuscript Department, Moorland-Spingarn Research Center, Howard University. Thank you to Patricia Hills for her assistance with this documentation.

60. Howard Devree "A Reviewer's Notebook," *New York Times,* November 9, 1941: X10.

61. The Phillips Memorial Gallery changed its name in October 1948 to The Phillips Gallery, and changed it again to its present name, The Phillips Collection, in 1961.

62. *1942:* Vassar College, Poughkeepsie. New York (October 1–22); Kalamazoo Institute, Kalamazoo, Michigan (November 1–22); Currier Gallery of Art, Manchester, New Hampshire (December 1–22); *1943:* Addison Gallery of American Art, Andover, Massachusetts (January 1–31); Wheaton College, Norton, Massachusetts (March 12–April 2); California Palace of the Legion of Honor, San Francisco (April 16–May 7); Downtown Williams Avenue Y.W.C.A., Portland, Oregon (May 16–22); Portland Art Museum, Portland, Oregon (May 17–June 7); Crocker Art Gallery, Sacramento (September 3–24); Mr. William Hill, Los Angeles (December 12–January? 1944); *1944:* The Principia, St Louis (January 21–February 5); Indiana University, Bloomington (February 14–March 6); West Virginia State College, Institute, West Virginia (March 20–April 10); Lyman Allyn Museum, New London, Connecticut (April 24–May 15); Harvard University (May 29–June 19); Museum of Modern Art, New York (October 10–November 5).

63. "Jacob Lawrence," *Bulletin of the Museum of Modern Art* 12 (November 1944), 11.

64. Miller was later promoted up to Mess Attendant, First Class, and then Cook, Third Class, also Lawrence's rank.

65. Frank B. Wilderson III, "'The Position of the Unthought': An Interview with Saidiya V. Hartman," *Qui Parle* 13 (Spring/Summer 2003): 185.

66. Aline B. Louchheim, "Lawrence: Quiet Spokesman," *Art News* 43 (October 1944): 15.

67. The public was invited to hear views from local Negro artist Fred Perry; Nathaniel George, Director of the Williams Avenue USO; Colonel R. F. Bessey, counselor, National Resources Planning Board; and George Sheviakow, assistant director,

Vanport Grade School. Catherine Jones, *"Migration of the Negro* to Be Shown for Two Weeks More at Art Museum," *The Oregonian,* Sunday, May 23, 1943. Portland Art Museum Clipping Book, 1943.

68. "Director's Report for 1943," Portland Art Museum Library Archives, 5.

2. Black Artists and Activism: *Harlem on My Mind* (1969)

1. The title of the exhibition was taken from the song of the same title written by Irving Berlin in 1933, performed in the musical *As Thousands Cheer* (1933). This Broadway production was the first to feature an African American woman; singer Ethel Waters was given star billing in the production. Waters sang "Harlem on My Mind," which told the story of a woman who left Harlem for stardom but missed her home. Borrowing this musical reference as the title of the exhibition invoked the importance of Harlem as a home to Black Americans and suggested the separate worlds of Black and White America.

2. Deborah Willis-Braithwaite points out that the root of the problem and the subsequent protests developed because the Met, "a museum ostensibly dedicated to art[,] suddenly adopted a documentary stance when confronted with the visual presence of the 'other' within its walls." Deborah Willis-Braithwaite "They Knew Their Names," in her *VanDerZee: Photographer, 1886–1983* (New York: Harry N. Abrams/National Portrait Gallery, Smithsonian Institution, 1993), 8.

3. Steven C. Dubin, "Crossing 125th Street: *Harlem on My Mind* Revisited," in his *Displays of Power: Memory and Amnesia in the American Museum* (New York: NYU Press, 1999).

4. The inclusion of African Americans in major museum exhibitions was not a new or innovative concept. As discussed in the previous chapter, other major art institutions had successfully organized several exhibitions of artworks by African American artists before *Harlem on My Mind.* The Phillips Memorial Gallery and the Catholic Inter-Racial Council exhibited *Three Negro Artists: Horace Pippin, Jacob Lawrence, Richmond Barthé* in 1946; in 1960 Lawrence had a traveling solo retrospective organized by the Brooklyn Museum, and in 1968 The Minneapolis Institute of Art held an exhibition *Thirty Contemporary Black Artists* that traveled to several museums nationwide. However, the difference between those examples and *Harlem on My Mind* was that the Met was an art museum representing African Americans without their artworks.

5. Jane Anna Gordon, *Why They Couldn't Wait: A Critique of the Black-Jewish Conflict over Community Control in Ocean Hill–Brownsville, 1967–1971* (New York: Routledge, 2001), 63.

6. Ibid., 130n46.

7. Ibid., 24.

8. See William J. Sloan, "The Documentary Film and the Negro," in *The Documentary Tradition,* ed. Lewis Jacobs, 2nd ed. (New York: Norton, 1979), 425.

9. Edward Steichen, *The Family of Man: The Photographic Exhibition created by Edward Steichen for the Museum of Modern Art* (New York: Simon and Schuster, 1955).

10. In 1970 Tom Wolfe published an essay/exposé on the Radical Chic phenomenon among the upper classes. In his essay, "Radical Chic," he describes a party that the composer Leonard Bernstein threw at his apartment for his elite friends and members of the Black

Panther Party for Self Defense. The event gave Bernstein and his wealthy cohort the opportunity to temporarily identify with the Panthers by meeting with the racial, economic, and political other, and writing checks in support of their activities. See Tom Wolfe, *Radical Chic and Mau-Mauing the Flak Catchers* (New York: Farrar, Straus, and Giroux, 1970). Although Wolfe is the leading author on the topic, the journalist Gail Sheehy also wrote about the Panthers and Radical Chic in her book *Panthermania: The Clash of Black against Black in One American City* (New York: Harper & Row, 1971).

11. See "The Panthers and the Law," *Newsweek*, February 23, 1970: 30.

12. Jozefa Stuart, "How Hip Should a Museum Get?" *Life Magazine*, February 21, 1969: 14.

13. Hoving, Preface, *Harlem on My Mind* (New York: Random House, 1968), unpaginated.

14. Cathy Aldridge, "Exhibit on Everybody's Mind," *New York Amsterdam News*, February 1, 1969: 38. In his 1994 "Introduction to the New Edition," Schoener states that the exhibition filled fifteen galleries covering 18,000 square feet of the museum's second floor. See Schoener, *Harlem on My Mind* (New York: The New Press, 1995), unpaginated.

15. "Sunday Morning with Mandrake: Harlem on the New York Mind," *Sunday Telegraph*, January 12, 1969 [Metropolitan Museum of Art Library, *Harlem on My Mind* clipping book. Page number omitted]. Schoener states that there were 700 photographs and 500 projected images. See Schoener, *Harlem on My Mind* (1995), unpaginated.

16. Schoener, *Harlem on My Mind* (1995), unpaginated.

17. Ibid.

18. Although the 1995 edition of the catalogue includes three dark photographs from Allon Schoener's collection of the 1900–1919, 1920–1929, and 1960–1968 sections, it is not enough to get a sense of what it was like to visit the exhibition.

19. John Canaday, "Getting Harlem Off My Mind," *New York Times*, January 12, 1969: D25.

20. Cathy Aldridge, "*Harlem on My Mind*: A Boxed in Feeling," *New York Amsterdam News*, February 1, 1969: 38.

21. Grace Glueck, "Art: 'Harlem on My Mind' in Slides, Tapes, and Photos," *New York Times*, January 17, 1969: 28.

22. Aldridge, "Exhibit on Everybody's Mind," 38.

23. Allon Schoener, Preface, *Portal to America: The Lower East Side, 1870–1925*, ed. Schoener (New York: Holt, Rinehart, and Winston, 1967), 9.

24. The *Harlem on My Mind* catalogue also has a second designer, Ernie Smith.

25. The Metropolitan Museum of Art, "Harlem's Rich, Varied Sixty-Year History as Cultural Capital of Black America to be Presented in Major Exhibition by Harlem Community at Metropolitan Museum," Press Release, Thursday, November 16, 1967, 3. Cathy Aldridge, "Year-Long Show of Harlem History," *New York Amsterdam News*, November 18, 1967: 1. Sandy Shenker, "Museum Aided by AR in Unique Multi-Media Show," *Audio Times*, February 15, 1969: 4; Glueck, "Art: *Harlem on My Mind* in Slides, Tapes, and Photos," 28.

26. Glueck, "Art: 'Harlem on My Mind' in Slides, Tapes, and Photos," 28.

27. Allon Schoener, *The Lower East Side: Portal to American Life, 1870–1924* (New York: Jewish Museum, 1966).

28. Letter from Romare H. Bearden to Mr. Hoving, July 9, 1968. John Henrik Clarke Papers, box 42, *Harlem on My Mind* Folders, Schomburg Center for Research in Black Culture, New York Public Library.

29. The letter continues with addresses and phone numbers of Jacob Lawrence, Charles Alston, Ernest Crichlow, James Stead, Frank Dandridge, Mel Patrick, Norman Lewis,

and Hale Woodruff for Schoener to contact for input about the inclusion of artworks. Romare Bearden to Allon [Schoener], June 6, 1968. In September Bearden wrote Hoving expressing concerns about the museum's plan for a separate art exhibit "to be installed at some distance from the Special Galleries where the photographic material, and the memorabilia, are to be shown[;] we are anxious to learn how the different sections are to be coordinated." Romare Bearden to Thomas Hoving, September 27, 1968. John Henrik Clarke Papers, box 42, *Harlem on My Mind* Folders, Schomburg Center for Research in Black Culture, New York Public Library. There were no color transparencies of artwork included in the final exhibition although this was one of Schoener's ideas during the exhibition planning stages in 1968.

30. In anticipation of the opening of *Harlem on My Mind*, the Met held a symposium in which Harlem artists discussed the problems of the Black artist in America. Throughout the event, the importance of museum recognition for Black artists is discussed in relationship to the *Harlem on My Mind* exhibition and within a larger national context. The museum bulletin (27, no. 5 [January 1969]) published the transcription of the symposium: Romare Bearden (moderator), Sam Gilliam, Jr., Richard Hunt, Jacob Lawrence, Tom Lloyd, William Williams, and Hale Woodruff. "The Black Artist in America: A Symposium," 245–60. The Williams quotation appears on p. 246.

31. Schoener, *Harlem on My Mind* (1995), unpaginated.

32. McGhee was from Milwaukee, Harper was from Chicago, and Nelson was "a respected member of the Manhattan black community." Allon Schoener, "Introduction to the New Edition," in *Harlem on My Mind: Cultural Capital of America, 1900–1968* (New York: The New Press, 1995), unpaginated.

33. *Art of the American Negro*, organized by artist Romare Bearden, was mounted at Kenwood Reter's Furniture store on 125th Street in Harlem. Sharon F. Patton, *African-American Art* (Oxford: Oxford University Press, 1998), 210.

34. The other members of the Community Advisory Committee were: Mrs. Katherine Aldridge, William DeFosset, Andrew T. Hatcher, Mrs. Daisy Hicks, Dr. John L. S. Holloman, Robert Hooks, Charles Inniss, Hulan Jack, Arnold Johnson, Mrs. Thelma G. Johnson, Robert Jones, Carl Lawrence, Miss Dorothy Maynor, Mrs. Genevieve McClane, The Honorable Constance Baker Motley, Miss Joan Murray, Larry Neal, Gil Noble, George Norford, Mrs. Dorothy Orr, L. Joseph Overton, The Honorable Basil A. Paterson, C. Melvin Patrick, The Honorable Adam Clayton Powell, Jr., The Honorable Charles B. Rangel, Layhmond Robinson, Colonel John Silvera, James Sneed, The Honorable Percy Sutton, Edward Taylor, Dr. Wyatt T. Walker, The Honorable James L. Watson, Reverend M. Moran Weston, and Bruce McM. Wright. John Henrik Clarke Papers, box 42, *Harlem on My Mind* Folders.

35. Grace Glueck, "Harlem Cultural Council Drops Support for Metropolitan Show," *New York Times*, November 23, 1968: 62.

36. John Henrik Clarke Papers, box 42, *Harlem on My Mind* Folders.

37. Glueck, "Harlem Cultural Council Drops Support for Metropolitan Show," 62.

38. Ibid.

39. Schoener, *Harlem on My Mind* (1995), unpaginated.

40. Martin Arnold, "Museum Edited Essay by Girl, 17," *New York Times*, February 1, 1969: 29; Thomas Hoving, *Making the Mummies Dance: Inside the Metropolitan Museum of Art* (New York: Simon and Schuster, 1993), 176. This omission of the footnotes and quotations brought accusations that Van Ellison plagiarized parts of her catalogue essay

from *Beyond the Melting Pot: The Negroes, Puerto Ricans, Jews, Italians, and Irish of New York City,* by Nathan Glazer and Daniel Moynihan (Cambridge: MIT Press, 1963), a source for her term paper.

41. Birt, "A Life in Photography," in Willis-Braithwaite, *VanDerZee,* 59.

42. Van Ellison, Introduction in Schoener, *Harlem on My Mind* (1968), 13–14. It was later determined that some of Van Ellison's inflammatory quotes were paraphrased from the Glazer and Moynihan book, which was not considered a racist text. Van Ellison, Introduction in *Harlem on My Mind,* ed. Schoener (1968), 14; Hoving, *Making the Mummies Dance,* 176; Birt, "A Life in Photography," 60; Schoener, *Harlem on My Mind* (1995), unpaginated.

43. Schoener, *Harlem on My Mind* (1995), unpaginated.

44. Hoving, *Making the Mummies Dance,* 172.

45. "Mayor, Hoving Feud over 'Racism' at Met Show," *New York News,* January 17, 1969: 3.

46. Interview between Birt and Schoener, Birt, "A Life in Photography," 62.

47. Murray Schumach, "Harlem Exhibition Opens to Crowds," *New York Times,* January 19, 1969: 61.

48. Twenty-six thousand copies of the catalogue were stored in the basement of the Met for several years. Eventually they were donated to various Black organizations. Schoener, *Harlem on My Mind* (1995), 10.

49. "Museum Withdraws Controversial Catalog," *New York Amsterdam News,* February 8, 1969: 4. The Columbia discussion took place February 10, 1969.

50. Two later versions of the catalogue were published in 1979 and 1995. The 1979 version extended the years explored to 1978. In this version, Hoving's preface, Van Ellison's introduction, and Schoener's foreword were omitted. Schoener provided a different foreword along with a foreword by Black scholar Nathan Irvin Huggins. In the 1995 version, the original texts from the 1968 catalogue appeared along with a new foreword by scholar Henry Louis Gates, Jr., and a new introduction by Schoener.

51. See *New York Times,* "Letters to the Editor of The Times," January 22, 1969: 46; January 29, 1969: 40; and February 1, 1969, 28, for documentation of this conflict.

52. "The Black Artist in America: A Symposium," 245–60.

53. Allon Schoener, Editor's Foreword in *Harlem on My Mind: Cultural Capital of Black America, 1900–1968,* ed. Schoener (New York: Dell, 1979), 11.

54. Quoted in Schoener, *Harlem on My Mind* (1995), unpaginated.

55. James Clifford, *The Predicament of Culture: Twentieth-Century Ethnography, Literature, and Art* (Cambridge: Harvard University Press, 1998), 224.

56. Other original members of Spiral were Hale Woodruff, Charles Alston, and Merton Simpson. Later members were Emma Amos (the only woman), Reginald Gammon, and Richard Mayhew. See Ruth Fine, *The Art of Romare Bearden,* with contributions by Mary Lee Corlett et al. (Washington, D.C.: National Gallery of Art/Harry N, Abrams, 2003), 28.

57. Schoener, *Harlem on My Mind* (1995), unpaginated.

58. Ibid.

59. Letter from Romare Bearden to Allon Schoener, June 6, 1968. John Henrik Clarke Papers, box 42, *Harlem on My Mind* Folders, Schomburg Center for Research in Black Culture, New York Public Library.

60. In the words of Benny Andrews, the B.E.C.C. was organized "for the purpose of making sure there would be no more *Harlem on My Mind* exhibitions foisted on the pub-

lic, both black and white." Benny Andrews, "The B.E.C.C. Black Emergency Cultural Coalition," *Arts Magazine* (Summer 1970), 18–19; Patton, *African-American Art*, 211.

61. Andrews quoted in Richard J. Gruber, *American Icons: From Madison to Manhattan, the Art of Benny Andrews, 1948–1997* (Augusta, Ga.: Morris Museum of Art, 1997), 141.

62. The group of protestors included Benny, Mary Ellen, Christopher, Julia, Raymond, and Thomas Andrews, Romare Bearden, Vivian Browne, Zeb and Francesca Burgess, Barbara Carter, Bob Carter, Roy DeCarava, John Dobbs, Calvin Douglass, Bill Durante, Reginald Gammon, Henri Ghent, Leroy Henderson, Felrath Hines, Cliff Joseph, Norman Lewis, Alice Neel, Mel Roman, Mahler Ryder, Raymond Saunders, Tecla (Selnick), Ed Taylor, and Russ Thompson. See Andrews, "The B.E.C.C. Black Emergency Cultural Coalition," 19, and Gruber, *American Icons*, 142 and 241.

63. "Museum Pickets Assail Hoving over Coming Harlem Exhibition," *New York Times*, January 15, 1969: 41; Jozefa Stuart, "How Hip Should a Museum Get?" *Life Magazine*, February 21, 1969: 14.

64. "Harlem on Whose Mind," leaflet, Benny Andrews archives, Litchfield, Conn., quoted in Gruber, *American Icons*, 142, n. 190.

65. At the time of *Harlem on My Mind*, the only Black employees of the Met were janitors. Schoener, *Harlem on My Mind* (1995), 1. The Met hired its first Black curator, Lowery Stokes Sims, in 1979.

66. Gruber, *American Icons*, 142.

67. Schumach, *Harlem Exhibition Opens*, 61.

68. Schoener, *Harlem on My Mind* (1995), unpaginated.

69. Author's interview with Richard Mayhew, February 9, 2006, Soquel, California.

70. This is the visitor count according to Met Museum vice-director Joseph Noble. See Schumach, *Harlem Exhibition Opens*, 61.

71. Schoener, *Harlem on My Mind* (1995), unpaginated. Note that the Met dedicated the exhibition to King. "Agenda," Harlem Exhibition Research Committee Meeting, May 1, 1968. John Henrik Clarke Papers, box 42, *Harlem on My Mind* Folders, Schomburg Center for Research in Black Culture, New York Public Library.

72. Eugene D. Genovese, "An Historian Looks at Hoving's Harlem: Harlem on His Back," *Artforum* 7 (February 1969): 35.

73. Two examples of debates over representations of Malcolm X in more recent history are the film *Malcolm X* (1992) by Spike Lee, and the Malcolm X stamp issued by the U.S. Postal Service as part of its Black Heritage series in 1999. Lee's feature-length film showed different stages of Malcolm's life from his childhood to his death. It revived Malcolm X's popularity and piqued interest in him for a new generation of viewers. The heavily critiqued film represented Malcolm X as a complex man who was more than the popular image of an advocate of violence. The stamp caused nationwide discussions about whether or not Malcolm X was a suitable figure for a stamp, from which period of Malcolm's life the photograph should be taken, and the nature of Malcolm's relationship to the photographer.

74. Yearwood remembers that the Black photographer most represented in the exhibition was his friend James VanDerZee. Yearwood states, "After VanDerZee, I had the most photographs in the exhibition." Yearwood's photographs do not appear in the exhibition catalogue because it went to press before his work was selected by the exhibition organizers. Author's interview with Yearwood, December 15, 2005, Harlem, New York.

75. Author's interview with Yearwood. The advertisement was placed in the *World Telegram and Sun.*

76. Author's interview with Yearwood.

77. Author's interviews with Yearwood and Mayhew.

78. Interview with VanDerZee conducted by Reginald McGhee and Candice Van Ellison in *The World of James VanDerZee: A Visual Record of Black Americans,* compiled and with an introduction by Reginald McGhee (New York: Grove Press, 1969).

79. McGhee co-founded the institute with Charles Inniss. James Haskins, *James VanDerZee: The Picture-Takin' Man* (New York: Dodd, Mead, 1979), 247; Birt, "A Life in Photography," 64. Ironically, although *Harlem on My Mind* marked a "discovery" of VanDerZee's work outside of Harlem, VanDerZee did not receive any great financial benefit from his inclusion in the exhibition. He reports that the Met paid him "more than three thousand dollars" for permission to use his photographs. In financial debt and caring for his ailing wife, VanDerZee lost his house/photography studio shortly after the exhibition closed. Birt, "A Life in Photography," 65.

80. Deborah Willis-Thomas, *Picturing Us: African American Identity in Photography* (New York: New Press, 1996). Willis also wrote the monograph about James VanDerZee cited above and an encyclopedic history of African American photographers, *Reflections in Black: A History of Black Photographers, 1840 to the Present* (New York: W. W. Norton, 2000), among her several publications.

81. David Vestal, Roy DeCarava, Ray Francis, and Margery Mann, "Can Whitey Do a Beautiful Black Picture Show?" *Popular Photography,* May 1969: 122. Quoted in Peter Galassi, Introduction, *Roy DeCarava: A Retrospective* (New York: Museum of Modern Art, 1996), 33.

82. Galassi, Introduction, *Roy DeCarava,* 19.

83. See Christopher Phillips, "The Judgment Seat of Photography," in *The Contest of Meaning: Critical Histories of Photography,* ed. Richard Bolton (Cambridge: MIT Press, 1989) for a discussion of *The Family of Man* in relationship to a post–World War II humanist project and the role of photography as a medium used to promote a universalist image. See also John Szarkowki, "The Family of Man," *Studies in Modern Art 4* (New York: Harry Abrams, 1994), 12–37; Bernard Dufour, "The Family of Man," *Art Press* 233 (March 1998): 49–53; and Eric J. Sandeen, *Picturing an Exhibition: The Family of Man and the 1950s* (Albuquerque: University of New Mexico Press, 1995), for critical analyses of Steichen's exhibition.

84. Hoving, *Harlem on My Mind* (1968), unpaginated.

85. Hoving, *Harlem on My Mind* (1993), 168.

86. This pretentious play with distance and proximity between Hoving's elite environment "down the avenue" and the Harlem world is in keeping with the reinforcement of racial and class stratification through Radical Chic as discussed by Wolfe.

87. Weusi (Swahili for Black) was a group of artists interested in abstraction based on African forms and rhythms. Formed in 1967, Weusi consisted of young emerging artists concerned with Black nationalist ideology: Abdullah Aziz, Falcon Beazer, Kay Brown, Gaylord Hassan, Bill Howell, Rudy Irwin (Saba Kachenga), Otto Neals, Ademola Olugebefola, Okoe Pyatt, James Phillips, James Sepyo, Taiwo Shabazz, and Nii Ahene Mettle Nunoo from Ghana. Kay Brown, "The Weusi Artists," *Weusi: The Movement, a Renaissance Retrospective* (New York: Jamaica Arts Center, 1995), 8. Author's interview with Richard Mayhew.

88. Author's interview with Richard Mayhew.
89. Aldridge, "'Harlem on My Mind': A Boxed in Feeling," 38.
90. See Romare Bearden to Thomas Hoving, June 6, July 9, and September 27, 1968. John Henrik Clarke Papers, box 42, *Harlem on My Mind* Folders.
91. Andrews, "The B.E.C.C.," 19.
92. Ibid.
93. Andrews, "The B.E.C.C.," 19–20. A later account of the meeting between the B.E.C.C. and the Whitney explained that the coalition made the following four demands to the Whitney, which the museum rejected: "1. The Museum should put on an exhibition of Black artists with a Black guest curator. 2. Put more Black artists in the Whitney's Annual. 3. Hire a Black curatorial staff to coordinate these endeavors and other activities in the future. 4. Stage five or more solo exhibitions of Black artists during the year." Gruber, *American Icons,* 144.
94. Andrews, "The B.E.C.C.," 19.
95. Artist Faith Ringgold took on the battle against racism and sexism beginning in the late 1960s. In 1971, Ringgold co-founded "Where We At," an artist group for women, as an alternative to the male-dominated artist group "Spiral" led by Romare Bearden. Patton, *African-American Art,* 197.
96. One artist who was involved in the coalition's protest against the Whitney, Raymond Saunders, was included in the exhibition. Fifteen other artists withdrew from the Whitney exhibition, choosing instead to be in the exhibition "Rebuttal to the Whitney" at the Black-owned Acts of Art Gallery. Ibid., 212.
97. Edmund B. Gaither, Introduction in *Afro-American Artists: New York and Boston* (Boston: Museum of Fine Arts, 1970).
98. Ibid.
99. Dubin, "Crossing 125th Street: *Harlem on My Mind* Revisited," 49.
100. Dr. Lowery Stokes Sims is currently Curator at the Museum of Arts and Design. Between 2000 and 2007 she served as Executive Director and later President of the Studio Museum in Harlem. See Lowery Stokes Sims's essay "Discrete Encounters: A Personal Recollection of The Black Art Scene of the 1970s," in Kellie Jones, *Energy/ Experimentation: Black Artists and Abstraction, 1964–1980* (New York: The Studio Museum in Harlem, 2006), 50.
101. As quoted in Dubin, *Displays of Power,* 54. Golden is currently Director and Chief Curator at the Studio Museum in Harlem.
102. Ibid.
103. Romare Bearden was on the advisory board that conceived of the Studio Museum in Harlem in 1969. He co-founded Cinque Gallery with Ernie Crichlow and Norman Lewis.
104. I am grateful for the work of Sharon F. Patton through her book *African-American Art* and its helpful timeline for much of this information.
105. Willis-Braithwaite, *VanDerZee,* 8.
106. In the case of the Met, thirteen exhibitions, beginning in 1976, have featured African American artists in group and solo shows. The first three were traveling shows organized by the Met but not on view at the museum: *Black Artists from The Metropolitan Museum of Art,* April 14–June 4, 1976 (traveling); (this exhibition was the first show of Black art and was organized by Sims). *Selected Works by Black Artists from the Collection of The Metropolitan Museum of Art,* February 7–March 30, 1979 (traveling)

(Sims recalls the experience of organizing this exhibition: "That project resulted in my first lesson in institutional politics" ["Discrete Encounters," 48]); *Faces and Figures: Selected Works by Black Artists, The Metropolitan Museum of Art,* February 16–April 1, 1988 (traveling); *Jean-Michel Basquiat,* October 19, 1992–April 22, 1993; *I Tell My Heart, The Art of Horace Pippin,* February 1–April 30, 1995; *Barbara Chase-Riboud: The Monument Drawings,* June 22–September 5, 1999; *African-American Artists, 1929–1945: Prints, Drawings, and Paintings in The Metropolitan Museum of Art,* January 15–July 6, 2003; *Modern Storytellers: Bearden, Birch, Lovell, Ringgold,* May 6–December 1, 2003; *Romare Bearden at the Met,* October 19, 2004–March 6, 2005; *Kara Walker at the Met: After the Deluge,* March 21–August 6, 2006; *Closed Circuit: Video and New Media at the Metropolitan,* February 23–April 29, 2007; *Provocative Visions: Race and Identity— Selections from the Permanent Collection,* August 19, 2008–March 22, 2009; *Romare Bearden's "The Block,"* January 15–August 8, 2010.

3. Filling the Void: *Two Centuries of Black American Art* (1976)

1. In 1976, the national recognition of Negro History Week was extended to the entire month of February to demonstrate the national unity of America's diverse racial and cultural body. Symbolic gestures like these received attention over the demand for legal and social changes toward making America's democratic ideal a reality.

2. Hilton Kramer, "Black Art or Merely Social History?" *New York Times,* June 26, 1977: 71.

3. Grace Glueck, "2 Centuries of Black Art at Brooklyn," *New York Times,* June 24, 1977: C14, and Kramer "Black Art or Merely Social History?" 71.

4. One significant exhibition happened outside of the museum system and the nation. *Ten Negro Artists from the United States* was held at the First World Festival of Negro Arts, Dakar, Senegal. This event marked a new era of travel for Black American artists to West Africa and the continued transnational and pan-African interest among people of African descent in Africa and the United States. This exhibition was particularly important in the late 1960s, and Black American interest in Africa became vital to the Black Arts Movement. The artists who participated were Barbara Chase-Riboud, Emilio Cruz, Sam Gilliam, Richard Hunt, Jacob Lawrence, William Majors, Norma Morgan, Robert Reid, Charles White, and Todd Williams. The National Collection of Fine Arts, Smithsonian Institution, was the American institutional sponsor for the exhibition.

5. The exhibitions were: *Alvin Loving: Paintings* (December 19, 1969–January 25, 1970; 1970: *Melvin Edwards: Works* (March 2–29); *Fred Eversley: Recent Sculpture* (May 18–June 7); 1971: *Marvin Harden* (January 5–February 4); *Malcolm Bailey* (March 16–April 25); *Contemporary Black Artists in America* (April 6–May 16); *Frank Bowling* (November 4–December 6); 1972: *Alma W. Thomas* (April 25–May 28); 1974: *Jacob Lawrence* (May 16–July 7); *Jack Whitten* (August 20–September 22); 1975: *Betye Saar* (March 20–April 20); *Minnie Evans* (July 3–August 3). For analytical discussion of these exhibitions, see Kellie Jones, "'It's Not Enough to Say 'Black is Beautiful'": Abstraction at the Whitney, 1969–1974," in *Discrepant Abstraction,* ed. Kobena Mercer (Cambridge: MIT Press), 154–80. The exhibition *Contemporary Black Artists in America* in 1971, was protested because of the absence of Black museum staff in the organization of the exhibition.

6. Woodard lived from 1895 to 1955 in Los Angeles, and organized the Los Angeles Negro Art Association in 1937. *Museum Magazine* 52 (Museum of Art and Archaeology, University of Missouri, Columbia: Winter 2008): 17. The Los Angeles County Museum of Science, Natural History, and Art disbanded into three separate museums in 1951: The Los Angeles County Museum of Science, the Natural History Museum of Los Angeles County, and the Los Angeles County Museum of Art.

7. Quotation by Sergeant William Knight in *Los Angeles County Museum of Art Annual Report, 1968–1969*, 46.

8. The Tishman Collection exhibited at LACMA in 1976 is now The Walt Disney–Tishman African Art Collection. Its holdings primarily consist of objects from West and Central Africa, places from which Africans were taken and enslaved in the Trans-Atlantic Trade.

9. Sharon E. Fay, "Black Culture Festival: Some Firsts at the Museum of Art," *Los Angeles Times*, December 31, 1968: B5.

10. Ibid.

11. Two years after the festival, at the 1970 meeting of the Volunteer Committees of Art Museums held at LACMA, Franklin Murphy, Chancellor of UCLA and chairman of the Board of Trustees of the *Times Mirror*, made statements in his keynote address indicating that this lesson was learned: "In the United States for the first time in our society we are making the effort to bring minorities into the mainstream of our society. We are beginning to understand that their civilizations created extraordinary artistic achievements." See Mary Lou Loper, "Boosting the Art Museumgoing Habit," *Los Angeles Times*, October 30, 1970: I1.

12. Fay, "Black Culture Festival," B5.

13. Ibid., B6, and in *Los Angeles County Museum of Art Annual Report, 1968–1969*, 46.

14. See Henry J. Seldis, "N.Y. Shows: From the Ghetto to the Guggenheim," *Los Angeles Times*, February 23, 1969: T50.

15. Core members of the Black Arts Council included: Gloria Bohanon, Al Cannon, Dan R. Concholar, Alonzo Davis, Donald Dowd, West Gale, David Hammons, Bob Heliton, Raymond Lark, Leon Leonard, John Outterbridge, Arthur Price, John Riddle, Stan Sanders, Jerome Scott, Arenzo Smith Jr., Donald Stinson, John Stinson, Curtis Tann, Jackie Troup, Ruth G. Waddy, and Timothy Washington. However, membership included as many as 3,000. Interview of Cecil Fergerson by Karen Anne Mason, from the *African-American Artists Collection*, Center for Oral History Research, UCLA Library, 1999, 190; "Second Arts Lecture Set," *Southwestern Sun*, October 16, 1969 [Los Angeles County Museum of Art Library, 1969 clipping book. Page number omitted]; "Black Arts Council Hosts Bernie Casey, Dr. Lewis," *Los Angeles Sentinel* [Los Angeles County Museum of Art Library, 1969 clipping book. Page number omitted].

16. "Art News: Pictures and Photos of L.A. Landmarks," *Los Angeles Times*, September 21, 1969: U54.

17. "Black Arts Council Plans Joint Lecture," *Inglewood Morningside News*, October 23, 1969 [Los Angeles County Museum of Art Library, 1969 clipping book. Page number omitted].

18. "Paintings to Be Interpreted by Black Musicians," *Los Angeles Times*, December 5, 1969: G24.

19. Interview with Cecil Fergerson, 177.

20. The only mention of the protest in the city newspapers is in an article about Compton

artist Van Slater in which he remembers, "Several years ago 30 or so of us picketed the County Museum of Art for an exhibition of black artists. They finally exhibited the works of three black artists, and later there was a larger exhibition—but that was a slap in the face. They put us in the basement." *Los Angeles Times,* "Battle for Awareness: Compton Instructor Seeks Equality for Black Artists," August 8, 1976: SE5. Timothy Washington remembers the picketing, but he didn't understand its substance: "It was one of those crabs in a barrel situations. The show was a breakthrough for Black artists in L.A." Author's interview with Timothy E.Washington, February 12, 2009, Los Angeles. Fergerson remembers that *The Sentinel,* the main Black press in Los Angeles at the time, preferred to cover socialite events rather than social issues. Interview with Fergerson, 213.

21. Henry J. Seldis, "Black Trio Blends Art, Anger in Graphics," *Los Angeles Times,* January 26, 1971: J1.

22. William Wilson, "County Museum Showing Work by Local Blacks," *Los Angeles Times,* February 13, 1972: V50.

23. Wilson's comment expresses the same sentiment, nearly word for word, that the character Mrs. Ellsworth in Langston Hughes's short story "The Blues I'm Playing" voiced. In the narrative, Mrs. Ellsworth, wealthy White benefactor, "adopted" Oceola Jones, a young gifted pianist, as her cultivation project. Of all of her young protégés, Mrs. Ellsworth was most intrigued with Oceola; "At such times the elderly white woman was glad her late husband's money, so well invested, furnished her with a large surplus to devote to the needs of her protégés, especially Oceola, the blackest—and most interesting of all. "The Blues I'm Playing," in *Vintage Hughes* (New York: Vintage Books, 2004), 182. The story was originally published in *The Ways of White Folks* (New York: Alfred A. Knopf, 1934).

24. Claude Booker, "Critic Criticized," *Los Angeles Times,* February 27, 1972: X4.

25. Letter from Rexford Stead to David Driskell, April 3, 1974. David C. Driskell Archives, Hyattsville, Md.

26. Author's interview with David C. Driskell, March 17, 2007, Santa Monica.

27. Interview with Fergerson, 227.

28. "Artist, Negro Named Trustees of Art Museum," *Los Angeles Times,* March 3, 1971: B8; Author's interview with Robert Wilson, December 19, 2008, West Hollywood.

29. Hilton Kramer, "Critic's Notebook: On Museum Volunteers, 'Sexism' and Money," *New York Times,* June 28, 1975: 16. The exhibition was announced as one of the museum's three bicentennial exhibitions: *American Folk Sculpture, 1776–1976; Black American Artists, 1750–1950;* and *The World of Franklin and Jefferson.* Josine Ianco-Starrels, "Museum Plans Bicentennial Exhibits," *Los Angeles Times,* August 3, 1975: J71.

30. I have included these installation photographs to provide the reader with an idea of what the exhibition looked like. However, these three photographs are of the installation of *Two Centuries* at the Brooklyn Museum. Very few archival materials from the LACMA exhibition exist because of extensive water damage to the museum's Los Angeles storage facilities in April 1992.

31. Rexford Stead, Introduction in *Two Centuries of Black American Art* (New York: Alfred A. Knopf/Los Angeles County Museum of Art, 1976), 10.

32. While he was a Ph.D. candidate at Stanford University, he interviewed for a job at LACMA but was told that he could not have a curatorial position because he did not have his doctorate. At the time most curators and curatorial assistants did not have

doctorates. Infuriated by the discrimination, he met with Booker and Fergerson, who knew he was there for the interview. At that point, Simon joined the Black Arts Council and later participated in the picketing of Three Graphic Artists. Author's interview with Leonard Simon, January 20, 2009, Claremont, California.

33. Author's interview with David C. Driskell.

34. Driskell, "Black Artists and Craftsmen in the Formative Years, 1750–1920," *Two Centuries of Black American Art*, 19.

35. "Art Group Meets," Los Angeles Sentinel, January 24, 1976: A11.

36. Ibid.

37. Author's interview with David C. Driskell. Letter from Walter Audubon to David C. Driskell, 1977. "Kook" File, David C. Driskell Archives.

38. Letter from Prof. Francis B. Randall, "Audubon's Ancestry," New York Times, September 2, 1977: 61.

39. Fergerson recalls the conversation in which he confronted Driskell about his inclusion of Audubon and other bi-racial artists in *Two Centuries*: "And I said, 'Plus, I don't understand your catalog.' [Driskell asked Fergerson] 'What don't you understand about it, Cecil?' I said, 'Are you doing a show of two centuries of black American art, or are you doing a show of two centuries of mulatto and black American art?' He said, 'I don't understand what you mean.' I said, 'You referred to all the black artists in the first part of the book as mulatto and not as black people. You don't start referring to black people till you get to Henry O. Tanner.' And he was going to try to show me where it had been documented that they were mulattos so that he had to keep it up in terms of history. I said, 'Bullshit, David. It's your book. You can do anything you want with it. You can right the lies.'" Interview with Fergerson, 229.

40. Author's interview with David C. Driskell.

41. For example, in Los Angeles Leonard Simon moderated an artist panel with Selma Burke, Claude Clark, and Charles White about the exhibition and each of their careers. The films Cabin in the Sky (Dir. Vincente Minnelli, 1943), Emperor Jones (Dir. Dudley Murphy, 1933), Black Shadows on the Silver Screen (Dir. Thomas Cripps, Stephen Henriques, and Fred Bowman, 1975), Scar of Shame (Dir. Frank Peregini, 1927), Stormy Weather (Dir. Andrew L. Stone, 1943) and Nothing But a Man (Dir. Michael Romer, 1964) were screened. Songs by William Grant Still, Howard Swanson, and Ulysses Kay were performed by the Rene Chamber Ensemble. The Legends of Jazz musical group performed on the plaza, and the Gospel Choir of UC San Diego sang. The local department store The Broadway hosted Black Artists Week and exhibited photographs of the artworks in the exhibition. It also hosted art demonstrations by local Black artists. "Black Art Exhibit to Feature Show" Los Angeles Times, October 10, 1976: WS4; Ara Guzelimian, "Black Composers' Works at Museum," Los Angeles Times, November 2, 1976: E11. "The Week Ahead" Los Angeles Times, October 10, 1976: WS2, and "Black Art Exhibit to Feature Show." Los *Angeles Times,* October 10, 1976: WS4; "Black Artists Honored" *Los Angeles Sentinel,* October 21, 1976: A5.

42. The high level of production for the 16mm, 26 minute and 45 second film extended even beyond Moss, whose film *The Negro Soldier* (1943) is considered largely responsible for the racial desegregation of American troops in 1949. The still photographer for the film was Frank Stewart, who is known for his images of people of the African Diaspora, especially Romare Bearden. The cinematographer was UCLA film professor John Wesley

Simmons, the first Black person to receive an MFA in Cinematography in the nation. The film was produced by Pyramid Films.

43. Conversation with Steven L. Jones, March 7, 2008, College Park, Maryland.

44. Author's interview with David C. Driskell.

45. Amy Goldin, "'Two Centuries of Black American Art' at the Brooklyn Museum," *Art in America* 66 (1978): 116.

46. Ibid.

47. Lawrence Alloway, *The Nation,* July 23, 1977.

48. Glueck, "2 Centuries of Black Art at Brooklyn," C14.

49. Kramer, "Black Art or Merely Social History?" 71. Kramer is known for his hostility toward social history in art. Shortly after *Two Centuries,* he became co-founding editor of the neo-conservative *New Criterion* with Samuel Lipman in 1982.

50. In her essay "'The Evolution of a Black Aesthetic, 1920–1950: David C. Driskell and Race, Ethics, and Aesthetics," *Callaloo* 31.4 (2008), Julie L. McGee comments on these same two remarks in her analysis of Driskell's essay. See p. 1181.

51. Harold Rosenberg, "The Art World: Being Outside," *New Yorker,* August 22, 1977: 84.

52. Ibid.

53. Kramer, "Black Art or Merely Social History?" 71.

54. C. Gerald Fraser "'Black Art' Label Disputed by Curator," *New York Times,* June 29, 1977: 63.

55. Driskell, "Black Artists and Craftsmen in the Formative Years, 1750–1920," 11.

56. Tom Brokaw and David C. Driskell on *The Today Show,* July 5, 1977. NBC News Archives.

4. New York to L.A.: *Black Male: Representations of Masculinity in Contemporary American Art* (1994–1995)

1. Okwui Enwezor, "Black Male: Representations of Masculinity in Contemporary American Art," *Third Text* 9.31 (1995): 67.

2. In April 1995, Johnnie Cochran, Simpson's chief lawyer, gave $5,000 toward funding *Black Male.* The funds helped to underwrite a public forum on issues relating to the show when it was on view at the Hammer Museum at UCLA. *ARTnews* (Summer 1995). Whitney Museum of American Art Clippings File.

3. Author's interview with Golden at the Studio Museum of Harlem. March 23, 2001.

4. Jorge Daniel Veneciano, "Invisible Men: Race, Representation and Exhibition(ism)," *Afterimage* 23 (September/October 1995): 15.

5. References to these statistics were included in reviews of *Black Male* and the *AARM* exhibitions. See Nick Charles, "Black Men in White Society," *Daily News, CitySmarts New York,* Sunday, November 6, 1994: 2; Whitney Museum of American Art Clipping File; and Betty Brown, "'Black Male': An Imaginary Dialogue on the Consequences of Images," *ArtScene,* June 1995. www.artscenecal.com/ArticlesFile/Archive/ Articles1995/Articles0695/Brown.html.

6. Thelma Golden, "My Brother," in *Black Male: Representations of Masculinity in Contemporary American Art,* ed. Thelma Golden (New York: Harry Abrams, 1994), 19, 20.

7. Ibid., 20.

8. Devon W. Carbado, "Introduction: Where and When Black Men Enter," in *Black Men*

on Race, Gender, and Sexuality: A Critical Reader, ed. Carbado (New York: New York University Press, 1999), 4.

9. In an essay discussing views of Black churches on homosexuality, Lewis R. Gordon explains: "African-American communities suffer from disintegrated family structures—where normal family structures are monogamous, heterosexual households modeled after the bourgeois nuclear family—which call for a struggle against values that will contribute to further deterioration . . . most African-American churches' mission is the cultivation of healthy families of faith, which puts advocacy of gay lifestyles—lifestyles that do not foster the nuclear heterosexual family—in opposition to that mission." Gordon, "Three Perspectives on Gays in African-American Ecclesiology and Religious Thought," in *Sexual Orientation and Human Rights in American Religious Discourse,* ed. Saul M. Olyan and Martha C. Nussbaum (New York: Oxford University, 1998); Also see Cheryl J. Sanders, "Sexual Orientation and Human Rights Discourse in the African-American Churches," in the same volume. For a discussion of sexuality and homophobia in hip-hop, see Tricia Rose, *Black Noise: Rap Music and Black Culture in Contemporary America* (Hanover, N.H.: University Press of New England, 1994).

10. Golden, "My Brother," 20.

11. Ibid., 25.

12. From a talk by Golden at the program "Reimagining Museums for New Art: A Symposium," Clark Art Institute, Williamstown, Massachusetts, September 26, 1997.

13. Veneciano, "Invisible Men," 12.

14. See James Smalls, "Public Face, Private Thoughts: Fetish, Interracialism, and the Homoerotic in Carl Van Vechten's Photographs," in *The Passionate Camera: Photography and Bodies of Desire,* ed. Deborah Bright (New York: Routledge, 1998).

15. Uncited quotation, bell hooks, *Art on My Mind: Visual Politics* (New York: New Press, 1995), 212.

16. Ibid., 210.

17. Kobena Mercer, "Imaging the Black Man's Sex," in his *Welcome to the Jungle* (New York: Routledge, 1994), 173.

18. Ibid., 176–77.

19. Wyatt Closs, "A Personal View: Seeing and Being Seen," *The Independent Weekly,* Durham, N.C., February 22, 1995. Luce Press Clippings.

20. During the time that he was creating his paintings of groupings of Black men, he made some of his most powerful and disturbing works, such as *Mercenaries III* (1980), *White Squad V* (1985), and *Interrogation,* as well as *Riot IV* (1983), *Horsing Around III* (1983), *Threnody* (1986), and *Two Black Women and A White Man* (1986), which depict interracial violence and sexual tension.

21. Painter and curator Donald Odita describes *Night Rap* as taking on "menacing significance" in light of the crisis of police brutality against Black men in America. He also recounts observing two White visitors who spoke into the phallus/handle part of the artwork and pretended to make announcements on the museum's intercom system. After witnessing this performance Odita comments, "This institutionally sanctioned glimpse of the black male is a rare one indeed and for it to be turned into this cheap joke only reinforces the idea that black life is not taken seriously, or that it is taken serious enough to demystify it into the ridiculous." Odita, "This Exhibition Was Made Possible By . . . ," *Nka: Journal of Contemporary African Art* (Spring/Summer 1995): 52.

22. Golden talk at the Clark Art Institute symposium.

23. Michael Kimmelman, "Constructing Images of the Black Male," *New York Times,* November 11, 1994: C1.

24. Enwezor, "Black Male," 67.

25. Closs, "A Personal View: Seeing and Being Seen."

26. Jen Budney, "Black Male," *Flash Art,* February 1995: 91.

27. Mark Stevens, "Black—and Blue," *New York Magazine,* November 21, 1994: 68.

28. Ibid., 69.

29. Kobena Mercer, "Black Art and the Burden of Representation," in *Welcome to the Jungle,* 234.

30. See Chapter 2 for more information about protests against the Whitney in 1969 and Chapter 3 for information on the Whitney's twelve exhibitions of art by Black artists.

31. Sandra Hernandez, "Approaching 'Black Male' Agitates L.A," *L.A. Weekly,* January 6–12, 1995: 10.

32. The exhibition was originally offered to the Museum of Contemporary Art in Los Angeles (MoCA), but rejected because then chief curator Paul Schimmel decided it did not include enough California-based artists. Because of the rejection, Peter Norton, one of the main funding sources of *Black Male,* resigned from the museum's board of directors after serving for only eight months.

33. Fergerson wrote to Peter Norton, then a board member of the Whitney, to let him know about the exhibition he had planned. The Norton Family Foundation sent Fergerson $5,000 for support.

34. Author's interview with Fergerson, May 26, 1999, Los Angeles.

35. Joe Lewis, "More *Black Male* for L.A.," *Art in America* 83 (April 1995): 25.

36. Fergerson says, "They wanted to kill the controversy by inviting community activists in." Author's interview with Fergerson, March 14, 2001.

37. One of Fergerson's questions about Colescott's work is, since Colescott is part Black and part Jewish, why does he insist on degrading Blacks and not address his Jewish heritage also? Fergerson asks, "Would a Jewish artist make a satire out of the Holocaust?" Author's interview with Fergerson, March 14, 2001.

38. He was known to wear a sign while he worked that read, "This museum is racist." Author's interview with Fergerson, May 26, 1999.

39. This is an excerpt from the longer statement. The opening statement was repeated in the exhibitions and in printed matter including invitations and flyers about the exhibitions. Cecil Fergerson, *African American Representations of Masculinity,* ed. Miriam Fergerson, Exhibition booklet, 1995, 2.

40. Joe Lewis, "Mural SPARCs Censorship Debate," *Art in America* 83 (January 1995): 29.

41. Conversation with John Outterbridge, June 11, 2001, Los Angeles.

42. Ibid.

43. Susan Kandel, "Another Way of Picturing Black Men" *Los Angeles Times,* May 25, 1995: F4.

44. Odita, "This Exhibition Was Made Possible By . . . ," 42.

45. Diane Haithman, "As Defiant as Always," *Los Angeles Times,* April 23, 1995: 84.

46. Charles, "Black Men in White Society," 2.

47. hooks, *Art on My Mind,* 205.

48. Hall, "New Ethnicities," in *Stuart Hall: Critical Dialogues in Critical Studies,* ed. David Morley and Kuan-Hsing Chen (New York: Routledge, 1996), 442.

49. Ibid., 441.

50. Ibid., 443.

51. Ibid., 442.
52. Kobena Mercer, "Black Masculinity and the Sexual Politics of Race," in *Welcome to the Jungle*, 160.
53. "Career Profile" *Black Enterprise,* February 1996: 96. Whitney Museum of American Art Clippings File.

5. Back to the Future: *The Quilts of Gee's Bend* (2002)

1. Seventy-one quilts were in the original plan for the exhibition. Not every venue had room to show all of them, and those that did not selected a smaller number of quilts for their exhibitions.
2. The show was exhibited at: *2002:* Museum of Fine Arts, Houston (September 8–November 10); Whitney Museum of American Art (November 21–March 9, 2003); *2003:* Mobile Museum of Art (June 14–August 31); Milwaukee Art Museum (September 27–January 4, 2004); *2004:* Corcoran Gallery of Art (February 14–May 17); Cleveland Museum of Art (June 27–September 12, 2004); Chrysler Museum of Art, Norfolk, Virginia (October 15–January 2, 2005); *2005:* Memphis Brooks Museum of Art (February 13–May 8); Museum of Fine Arts, Boston (June 1–August 21); Julie Collins Smith Museum of Fine Art, Auburn, Alabama (September 11–November 4); *2006:* High Museum of Art, Atlanta (March 25–June 18, 2006); de Young, Fine Arts Museums of San Francisco (July 15–December 31); *2007:* Museum of Art, Fort Lauderdale (September 7–January 7, 2008).
3. See Brooks Barnes, "Art and Collecting: Museums Cozy Up to Quilts," *Wall Street Journal,* August 23, 2002: W12; and "Thelma Golden," *Art Forum,* December 2003: 125.
4. Since 2002, four separate exhibitions of Gee's Bend quilts have toured museums across the nation, breaking attendance records in some venues: *The Quilts of Gee's Bend* (2002–2008), *Mary Lee Bendolph, Gee's Bend Quilts, and Beyond* (2006–2010), *Gee's Bend: The Architecture of the Quilt* (2006–2008), and *A Survey of Gee's Bend Quilts* (2009–).
5. Singers from the 2002 recordings include Georgiana B. Pettway, Creola B. Pettway, Isabella Pettway Patton, Jessie T. Pettway, Paulette Pettway, Helen McCloud, China Pettway, Jacklin Young Bates, Arlonzia Pettway, Leola Pettway, Mary Lee Bendolph, and Esssie Bendolph Pettway.
6. USPS Press Release "Postal Service Celebrates Quilting Tradition with Quilts of Gee's Bend Stamps, Issued at Largest Annual United States Philatelic Event" www.usps .com/communications/news/stamps/2006/sr06_042.htm. It is noteworthy that the stamps did not include the names of the quilters, titles, or dates of the quilts. Under each image was the line "Gee's Bend Quilt 39 USA" (39 cents was the price of the stamp). The omission of the identification information for each quilt and its maker suggests an anonymous authorship and a mystery of the quilts' origins; however, the information is known and had already been documented in *The Quilts of Gee's Bend* catalogue.
7. See Sally Anne Duncan, "Souls Grown Deep and the Cultural Politics of the Atlanta Olympics," *Radical History Review* 98 (Spring 2007): 103.
8. Ibid., 106.
9. Conversation with Paul Arnett, May 5, 2009, Atlanta.
10. John Beardsley, William Arnett, et al. *The Quilts of Gee's Bend* (Atlanta: Tinwood Books/The Museum of Fine Arts, Houston), 170.

11. Author Deborah Gray White explains African American women's rejection of "Aunt" and "Mammy" and longing for the dignified appellation "Miss" instead: *Ar'n't I a Woman?: Female Slaves in the Plantation South* (New York: W. W. Norton, 1999), 173.

12. The Corcoran Museum of Art and the Cleveland Museum of Art mounted a related photography exhibition titled "Memory Quilts: Photographs of Gee's Bend," showing FSA photographs by Rothstein and Wolcott, to overlap with the respective dates of their *Quilts of Gee's Bend* installations.

13. The town was renamed Boykin after a racial segregationist Alabama congressman, Frank Boykin (1885–1969).

14. After *The Quilts of Gee's Bend* exhibition, the Arnetts organized *Mary Lee Bendolph, Gee's Bend Quilts, and Beyond* (2006), which featured quilts by quilter Mary Lee Bendolph.

15. Conversation with Matt Arnett, May 5, 2009, Atlanta.

16. *The Quiltmakers of Gee's Bend* (Dir. Celia Carey, 2004).

17. Ibid.

18. Ibid.

19. Website for Tinwood Ventures, www.tinwoodventures.com/pages/alliance.html.

20. Louisiana Bendolph during the Q&A session after the performance of the play *Gee's Bend* at the Taproot Theater, Seattle, February 21, 2009.

21. *The Quiltmakers of Gee's Bend* (Dir. Celia Carey, 2004)

22. Ibid.

23. Conversation with Bill Arnett, May 5, 2009, Atlanta.

24. Jane Livingston, "Reflections on the Art of Gee's Bend," in *The Quilts of Gee's Bend,* 53.

25. Ibid., 54.

26. Ibid., 58.

27. The exhibition team was not of one mind about the quilts. Shortly after the exhibition, Bill Arnett severed ties between Livingston and the Tinwood Media/Tinwood Alliance because of their different philosophical approaches to vernacular art. Conversation with Bill Arnett, May 5, 2009.

28. Barnes, "Art and Collecting," W12.

29. Ibid. Bill Arnett reports that no teacher by the name cited in the article had been found in the Dallas Independent School District. Conversation with Bill Arnett, May 5, 2009.

30. Peter Plagens, "A Quilting Bee Bounty," *Newsweek,* November 18, 2002: 78.

31. Patricia Leigh Brown, "From the Bottomlands, Soulful Stitches," *New York Times,* Thursday, November 21, 2002: 1.

32. Michael Kimmelman, "Jazzy Geometry, Cool Quilters," *New York Times,* Friday, November 29, 2002: 33.

33. *The Quiltmakers of Gee's Bend* (Dir. Celia Carey, 2004)

34. In addition to their museum performances, the Gee's Bend Singers have performed at other venues including the Cleveland Playhouse, Kansas City Repertory Theater, Davies Symphony Hall in San Francisco, and Symphony Hall and the Variety Playhouse in Atlanta.

35. Here my analysis of the meaning of the transformation of the Gee's Bend quilts into art differs from the scholarship of Sally Anne Duncan. She writes that the shift in the quilts' identity to high art "has been accomplished largely through the quilts' association with the modernist agendas of artistic genius, a time-honored system of cultural elevation; an engagement with their isolated rural geography and cultural history; and

an emphasis on the individual creators as artists, women indeed bent on individuality of mind and method." While this is true, my analysis of the critical reception of the quilts argues that not all of these elements have been incorporated smoothly or evenly into the art museum. I am skeptical, and less celebratory than Duncan, about this shift. My concern is what has been lost in the transformation of the quilts into art because of the perpetuation of the comparisons between the quilts and modern painting, and the nostalgic elements of the FSA photographs and art reviews. See Duncan, "Reinventing Gee's Bend Quilts in the Name of Art," in *Sacred and Profane: Voice and Vision in Southern Self-Taught Art*, ed. Carol Crown and Charles Russell (Jackson: University Press of Mississippi, 2007), 192–93.

Conclusion

1. See Chapter 1 in this text and Kellie Jones, "It's Not Enough to Say 'Black is Beautiful'": Abstraction at the Whitney, 1969–1974," in *Discrepant Abstraction*, ed. Kobena Mercer (London: Institute of International Visual Arts/MIT Press, 2006), 160.

2. Thelma Golden, "Post . . ." in *Frequency* (New York: The Studio Museum in Harlem, 2001), 14–15.

3. Langston Hughes, "The Negro Artist and the Racial Mountain," *The Nation*, June 23, 1926; rpt. in *The African-American Archive: The History of the Black Experience in Documents*, ed. Kai Wright (New York: Black Dog and Levinthal Publishers, 2001), 498–501.

4. For a discussion of the problem of spectatorship in terms of Black art and Black representational space, see Darby English, *How to See a Work of Art in Total Darkness* (Cambridge: MIT Press, 2007).

5. Hughes explains, "One of the most promising of the young Negro poets said to me once, 'I want to be a poet—not a Negro poet,' meaning, I believe, 'I want to write like a white poet'; meaning subconsciously, 'I would like to be a white poet'; meaning behind that, 'I would like to be white.' And I doubted then that, with his desire to run away spiritually from his race, this boy would ever be a great poet. But this is the mountain standing in the way of any true Negro art in America—this urge within the race toward whiteness, the desire to pour racial individuality into the mold of American standardization, and to be as little Negro and as much American as possible." Hughes, "The Negro Artist and the Racial Mountain," 498.

6. *New Orleans Item,* October 11, 1937.

7. Major solo exhibitions of these artists in the 2000s have been *The Art of Romare Bearden,* organized by the National Gallery of Art, Washington D.C. (2003); *Sam Gilliam,* organized by the Corcoran Museum of Art (2005); *Lorna Simpson,* organized by the American Federation of Arts (2006); *Kara Walker: My Complement, My Enemy, My Oppressor, My Love,* organized by the Walker Art Center (2007); and *Martin Puryear,* organized by the Museum of Modern Art, New York (2007).

8. My thoughts here are in solidarity with those expressed by author Susette S. Min, who addresses these issues for Asian American artists in her essay "The Last Asian American Exhibition in the Whole Entire World," in *One Way or Another: Asian American Art Now,* ed. Melissa Chu, Karin Higa, et al. (New York: Asia Society Museum, 2006), 34–41.

9. Howardena Pindell, "A Documentation: 1980–1988," in *The Heart of the Question: The Writings and Paintings of Howardena Pindell* (New York: Midmarch Press, 1997), 7–19.

10. Pindell, "Commentary and Update of Gallery and Museum Statistics, 1986–1997" and "Art World Racism," in *The Heart of the Question*, 19–28 and 2–6.

11. Pindell reported that her request for information in 2007 was met by hostility, and the person in the Communications Department of the Museum of Modern Art refused to give her the information. She gathered facts and figures for the latest survey from the museum websites. Information presented in "Artists of Color and Mainstream Museums" by Pindell on the opening panel "Black Artists and American Museums Now" at the conference *Here and Now: African and African American Art and Film*, New York University, November 15, 2008. The panel consisted of presentations by artist/author Howardena Pindell, and curators Jonathan Binstock and Valerie Cassell Oliver. I served as its chair and moderator.

INDEX

Page numbers in italics signify illustrations.